Jan Vermeer

WONDER

The Secret World of Mushrooms
Die geheimnisvolle Welt der Pilze

LAND

Jan Vermeer

WONDER

The Secret World of Mushrooms
Die geheimnisvolle Welt der Pilze

LAND

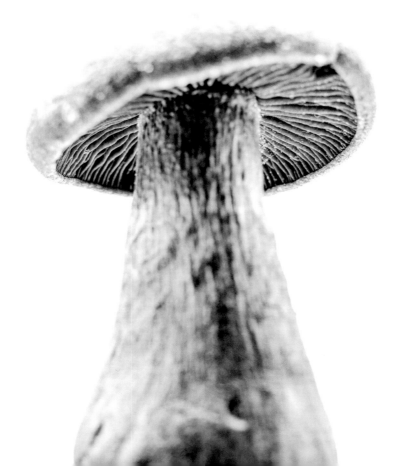

teNeues

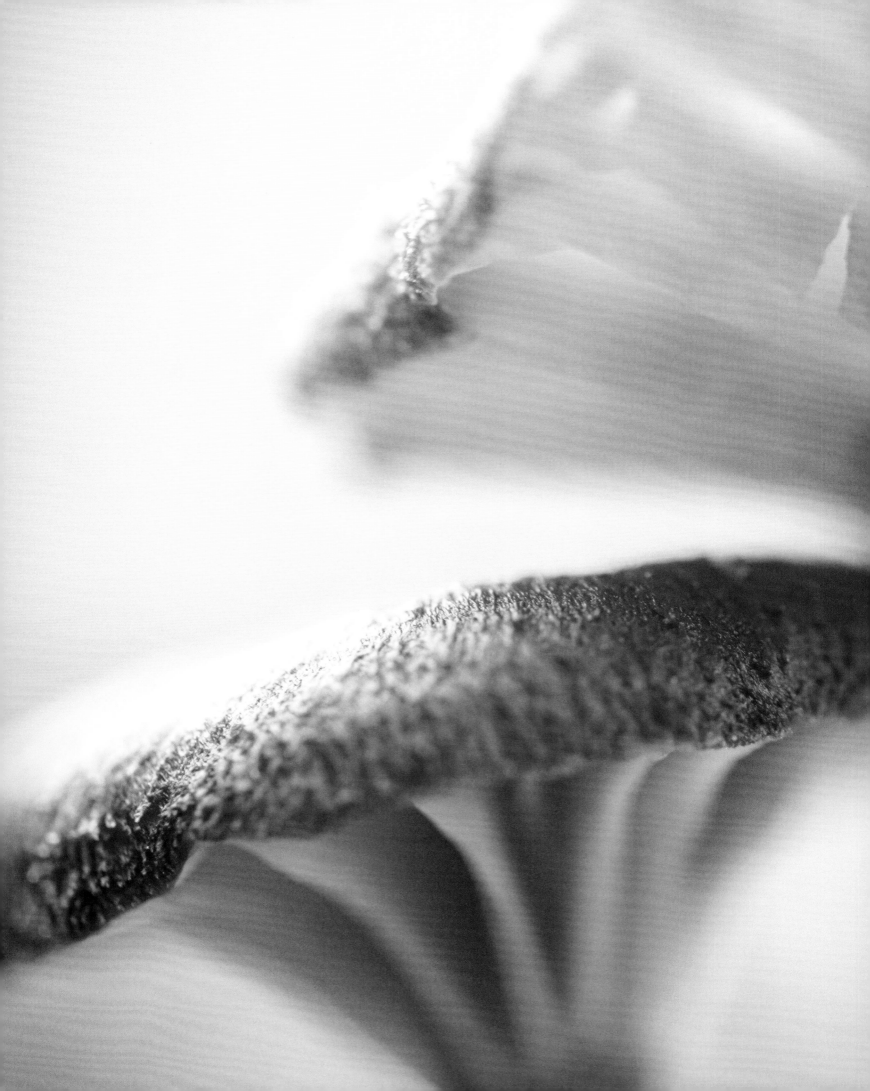

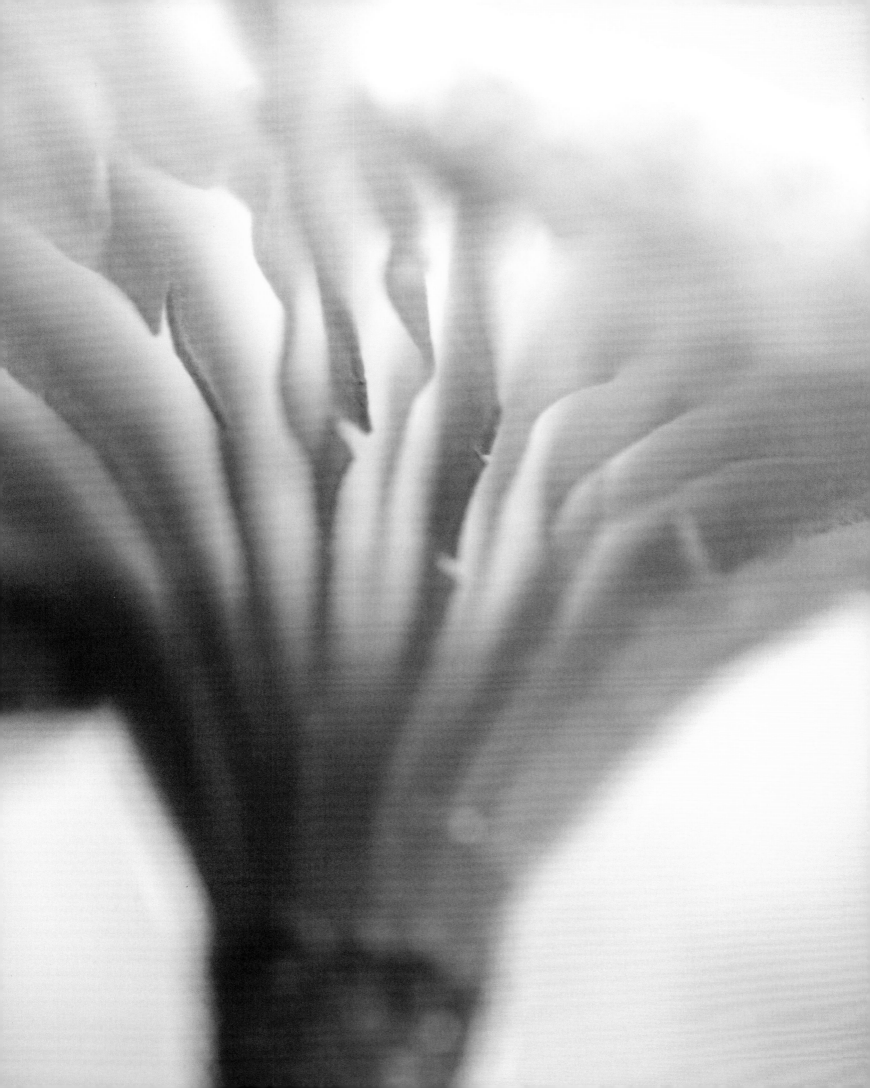

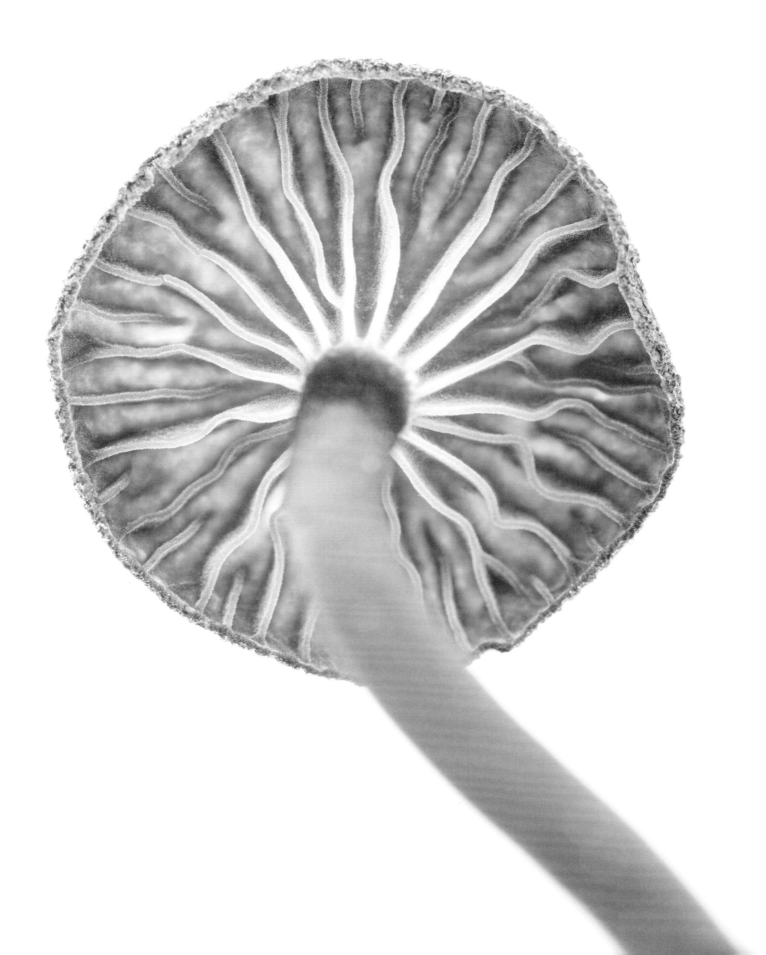

CONTENT
INHALT

Left and previous page: **Verdigris navel** | Linke und vorherige Seite: **Blaugrüner Nabeling** *Omphalina chlorocyanea*

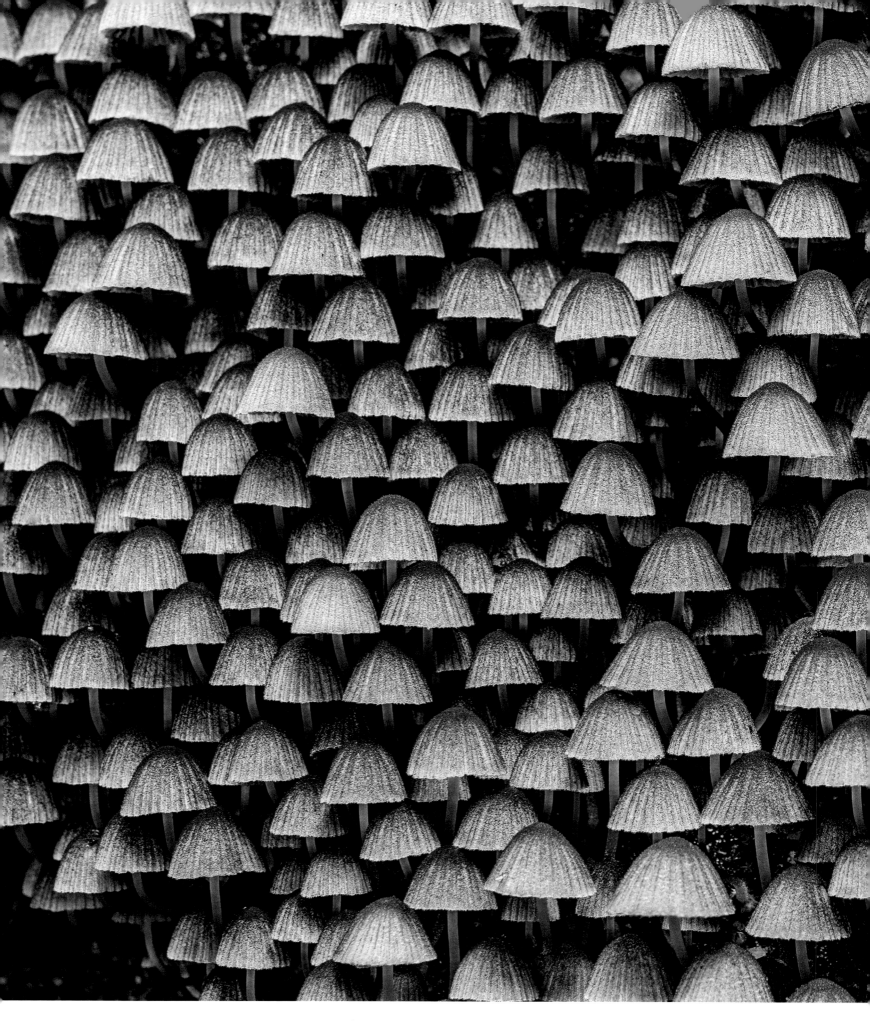

Fairy inkcap | Gesäter Tintling *Coprinellus disseminatus*

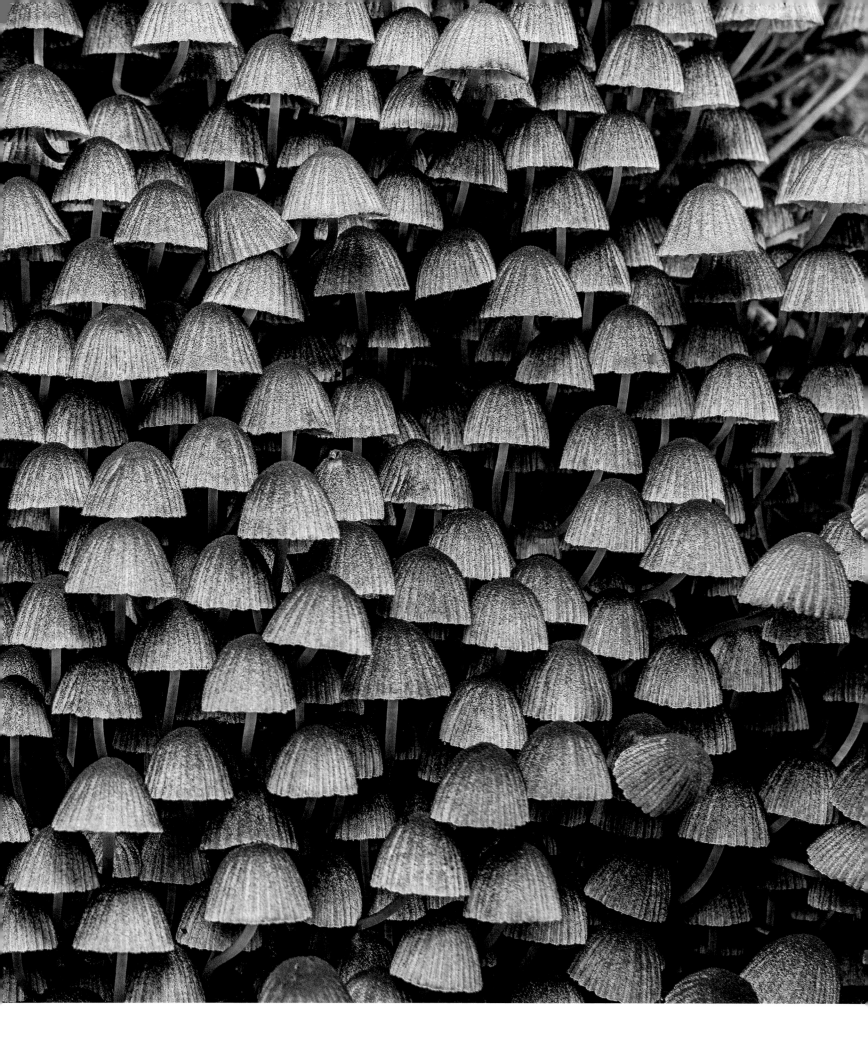

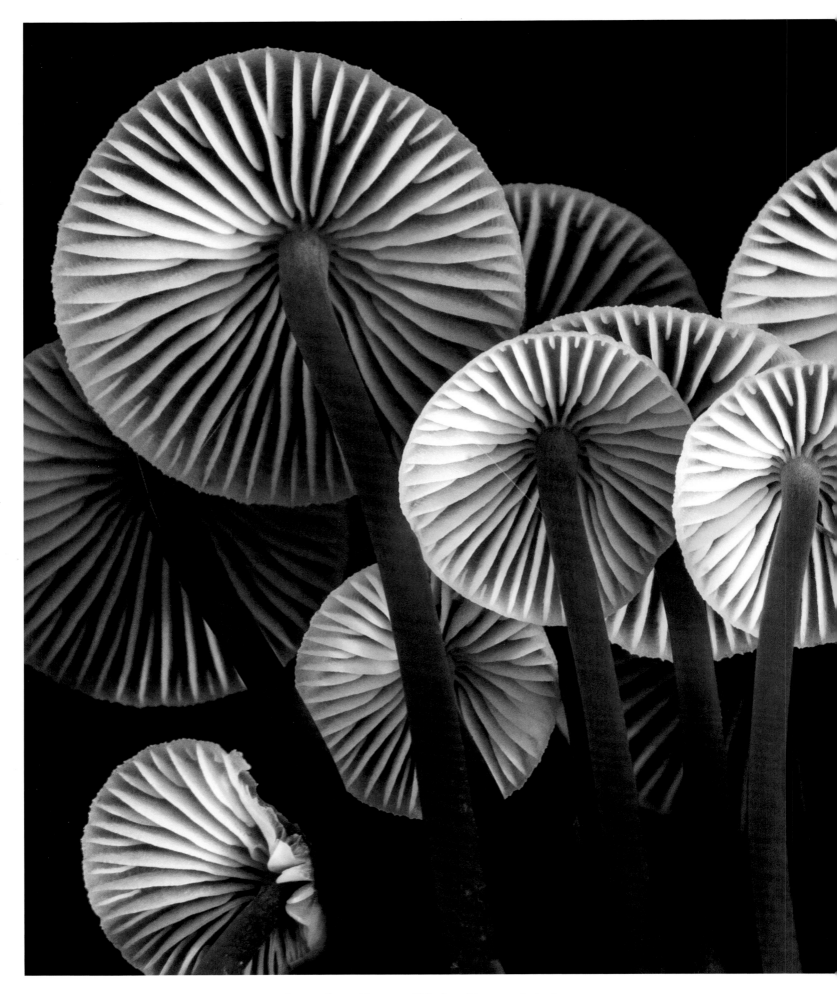

Common bonnet | Rosablättriger Helmling *Mycena galericulata*

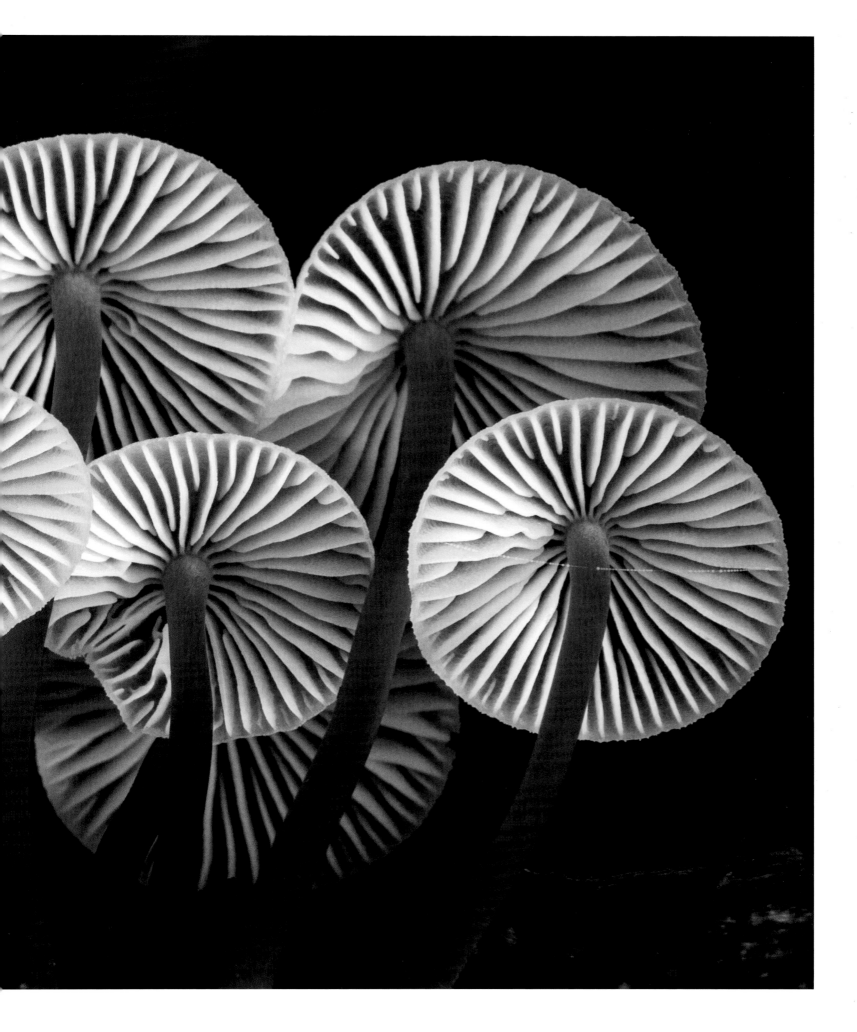

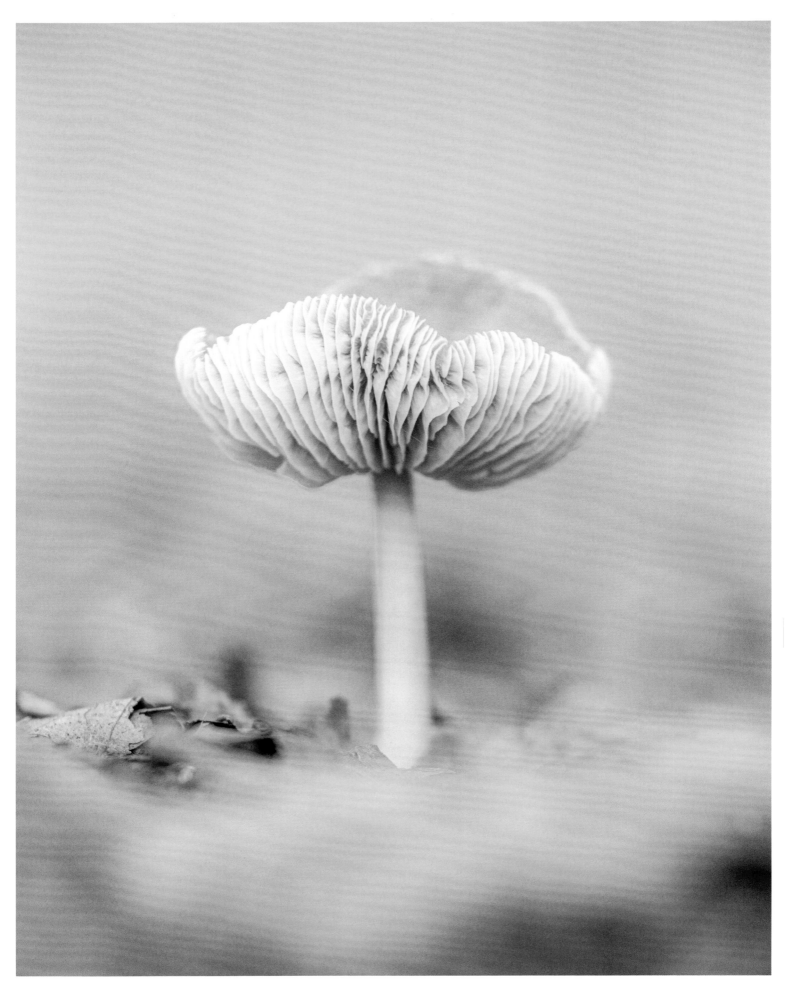

Rosy bonnet | Rosa Rettich-Helmling *Mycena rosea*

PREFACE
VORWORT

A number of years ago, I moved with my family into a house with what is – by Dutch standards, at least – a very large garden. With around 3,500 square meters of outdoor space at our disposal, we decided to leave a section of our new garden wild, allowing nature to take its course. It wasn't long before I discovered fly agarics growing in this evolving mini eco-system. The fly agaric is one of the most attractive mushrooms out there, and I monitored the development of the ones growing in my garden closely. I've been photographing mushrooms for as long as I can remember. I take pictures of fly agarics every single year, because they are just too beautiful to ignore and they're pretty easy to find. But this discovery felt different: I was intrigued by the fact that I had fly agarics in my very own garden.

As luck would have it, my brother Luuk turned out to be a walking encyclopedia on the topic of mycology. He began to send me more and more messages: "You might be interested in this, I'm not sure, but these are really stunning." My interest developed quickly and before I knew it, my newfound passion had almost become an obsession. If you really focus on a topic, your efforts always pay off – as I have since learned from my in-depth work on my *Antarctica* and *Arctic* book projects.

I PUT EACH AND EVERY MUSHROOM ON A METAPHORICAL PEDESTAL

During the photography process, I continuously scrutinized my mushroom photos, subjecting each one to a process of critical analysis. The constant sense of self-doubt that I have as a photographer helps to keep me on form. I quickly discovered that common "tricks" like using spray bottles and lighting didn't get me the images I was looking for. These tricks gave many of my photos the same atmospheric look

Meine Familie und ich zogen vor ein paar Jahren in ein Haus mit einem für holländische Verhältnisse riesigen Garten. Er ist über 3.500 Quadratmeter groß, und wir beschlossen, in einem Teil davon einfach der Natur ihren Lauf zu lassen. In diesem kleinen Biotop entdeckte ich schon bald einige Fliegenpilze. Der Fliegenpilz zählt zu den optisch schönsten Pilzarten und ich habe ihre Entwicklung im Garten genau beobachtet. Solange ich denken kann, fotografiere ich Pilze. Jedes Jahr schieße ich zahlreiche Bilder von Fliegenpilzen – sie sind nicht nur wunderschön, sondern auch verhältnismäßig leicht zu finden. Doch diese Entdeckung war etwas ganz Besonderes! Ich war fasziniert von der Tatsache, dass ich nun Fliegenpilze in meinem eigenen Garten gefunden hatte.

ICH MÖCHTE JEDEN PILZ AUF EIN EHRENPODEST STELLEN

Mein Bruder Luuk entpuppte sich als wandelndes Pilzlexikon. Immer öfter wies er mich auf besondere Schönheiten hin: „Vielleicht ist der etwas für dich, ich bin mir nicht sicher, aber ich finde ihn atemberaubend!" Mein Interesse war schnell geweckt, und bevor ich mich versah, war ich geradezu besessen von Pilzen. Intensive Beschäftigung mit einem Thema trägt immer Früchte. Diese Erfahrung habe ich auch bei meinen komplexen Buchprojekten *Antarktis* und *Arktis* machen dürfen.

Während des Fotografierens habe ich meine Pilzfotos ständig unter die Lupe genommen und jedes einzelne einer kritischen Analyse unterzogen. Doch ich denke, Selbstzweifel machen einen guten Fotografen aus, denn sie sorgen dafür, dass man sich weiterentwickelt. Ich merkte bald, dass mich Fototricks wie die Verwendung eines Pflanzensprühers oder der Einsatz von Lampen langweilten. Die Fotos bekamen dadurch alle die gleiche Atmosphäre – und genau das möchte ich vermeiden. Pilze gibt es in einer Vielzahl von Formen, Größen und Farben.

and feel, and that's exactly what I was trying to avoid. Mushrooms grow in a vast array of unique shapes, sizes, and colors. I realized that these unique "ingredients" needed to be the starting point for this book. In my photography, I put each and every mushroom on a metaphorical pedestal; sometimes the situation requires to emphasize the biotope around the mushroom, while other times I feel called to zoom in on the mushroom itself with my special macro lenses.

All of the photos in this book were taken in the Netherlands, often close to my home. Others were shot a little further away, such as on the Dutch coast, where I tracked down some special spring varieties.

Jan Vermeer, Hoenderloo

Ich beschloss, dass diese einzigartigen Merkmale der Ausgangspunkt für dieses Buch sein sollten. Ich möchte jeden Pilz auf ein Ehrenpodest stellen. Manchmal ist es notwendig, die Atmosphäre eines Biotops zu betonen, während in anderen Fällen ein Exemplar mit speziellen Makroobjektiven separat herangezoomt wird.

Alle Fotos in diesem Buch wurden in meiner Heimat, den Niederlanden, aufgenommen, oft in der Nähe meines Hauses. Andere entstanden etwas weiter weg, zum Beispiel an der niederländischen Küste, wo im Frühjahr besondere Arten zu finden sind.

Jan Vermeer, Hoenderloo

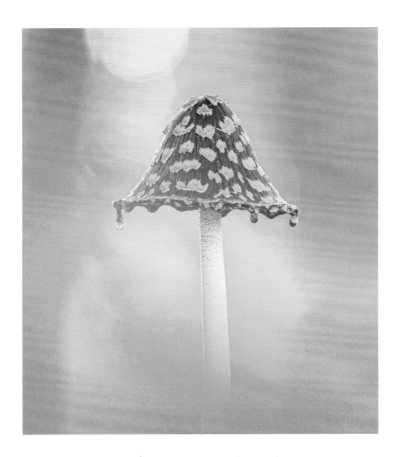

This page: **Magpie inkcap** | Diese Seite: **Specht-Tintling** *Coprinopsis picacea*

Right page: **Frosty fibrecap** | Rechte Seite: **Gefleckter Risspilz** *Inocybe maculata*

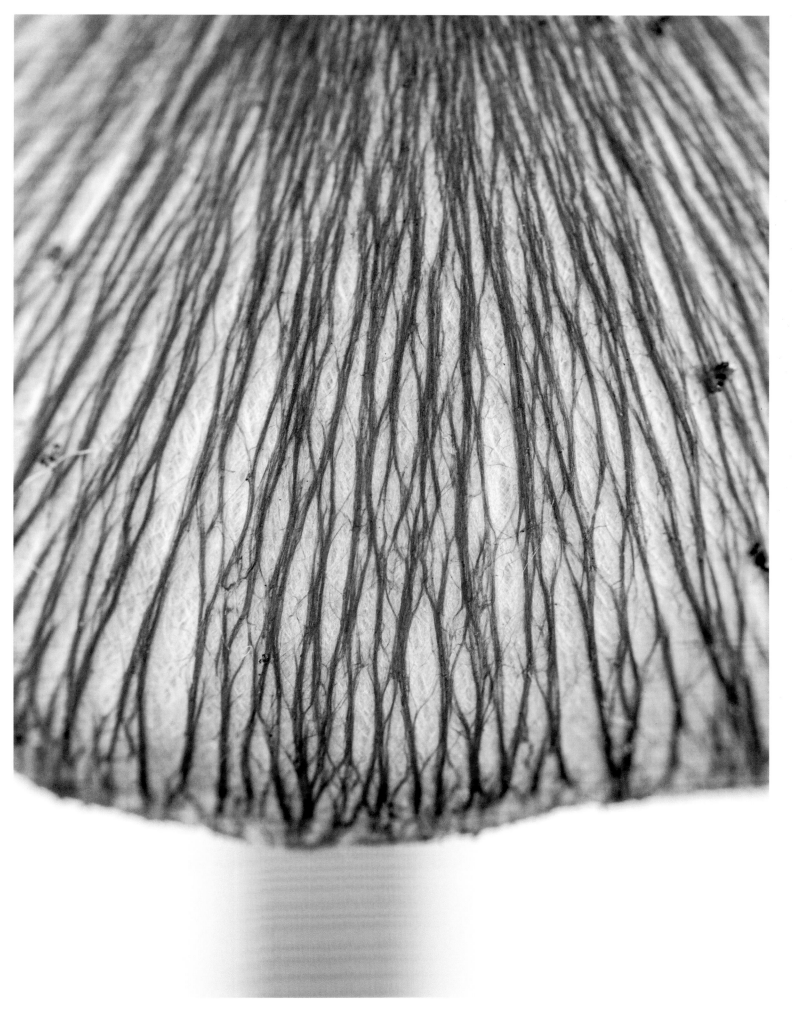

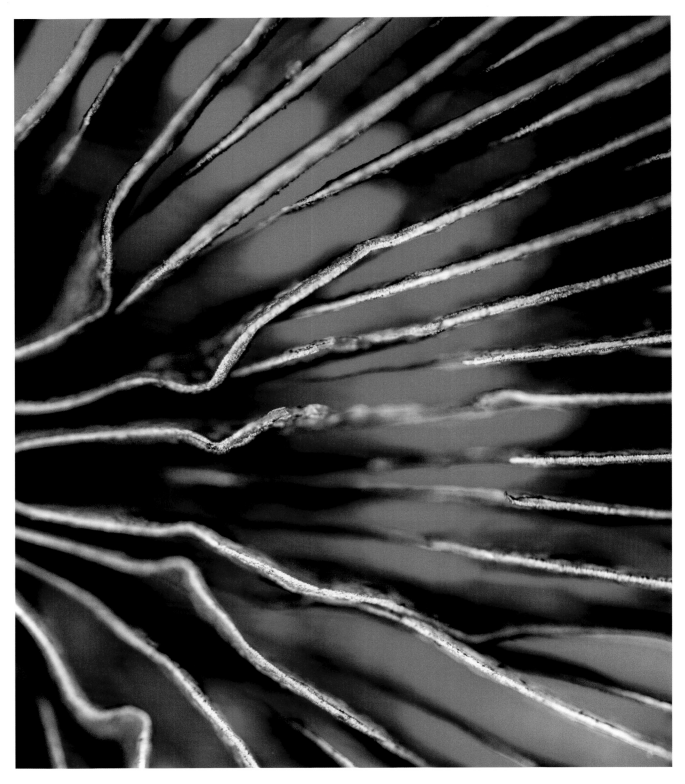

Wine roundhead | Riesenträuschling *Stropharia rugosoannulata*

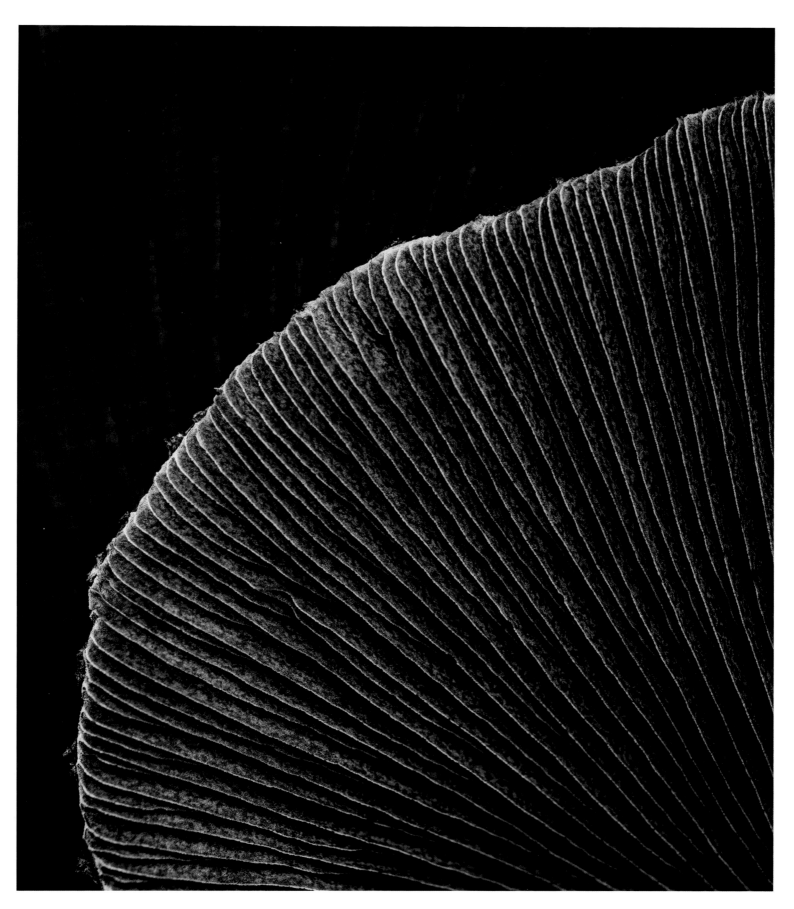

Wine roundhead | Riesenträuschling *Stropharia rugosoannulata*

Following page: **Wrinkled peach** | Nächste Seite: **Orangerötlicher Adernseitling** *Rhodotus palmatus*

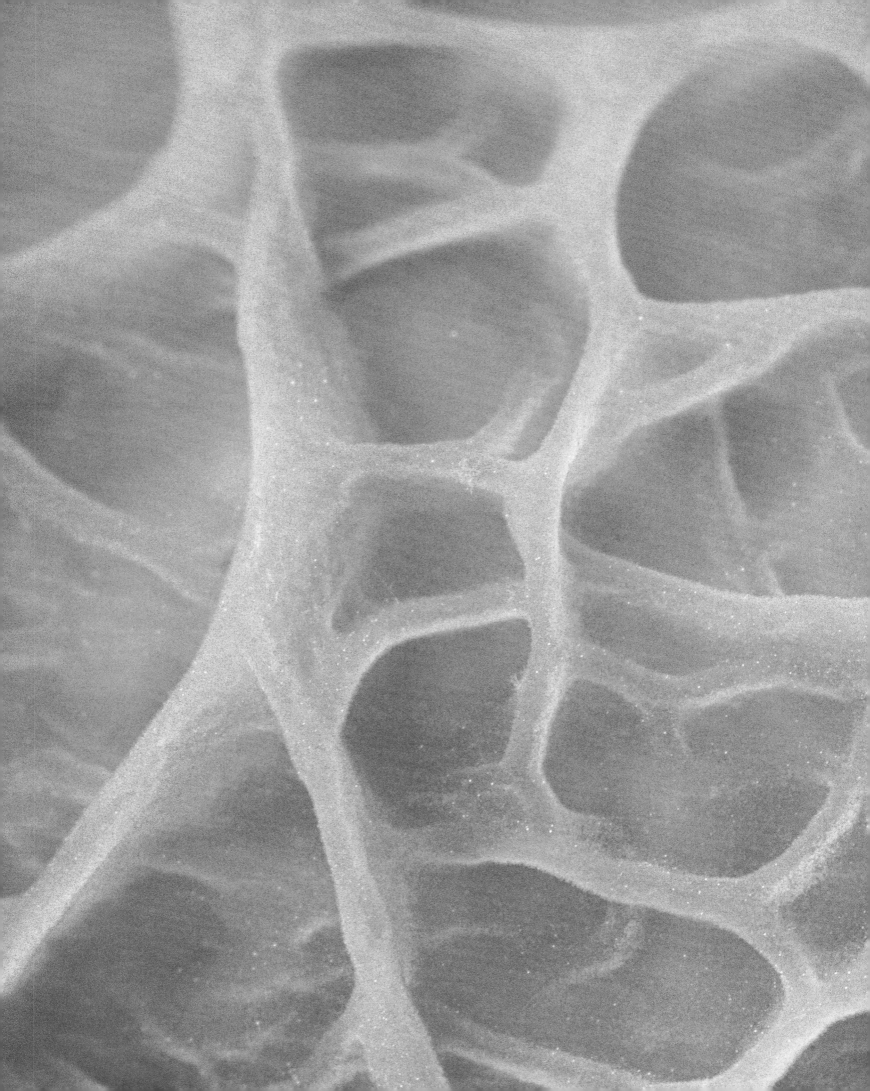

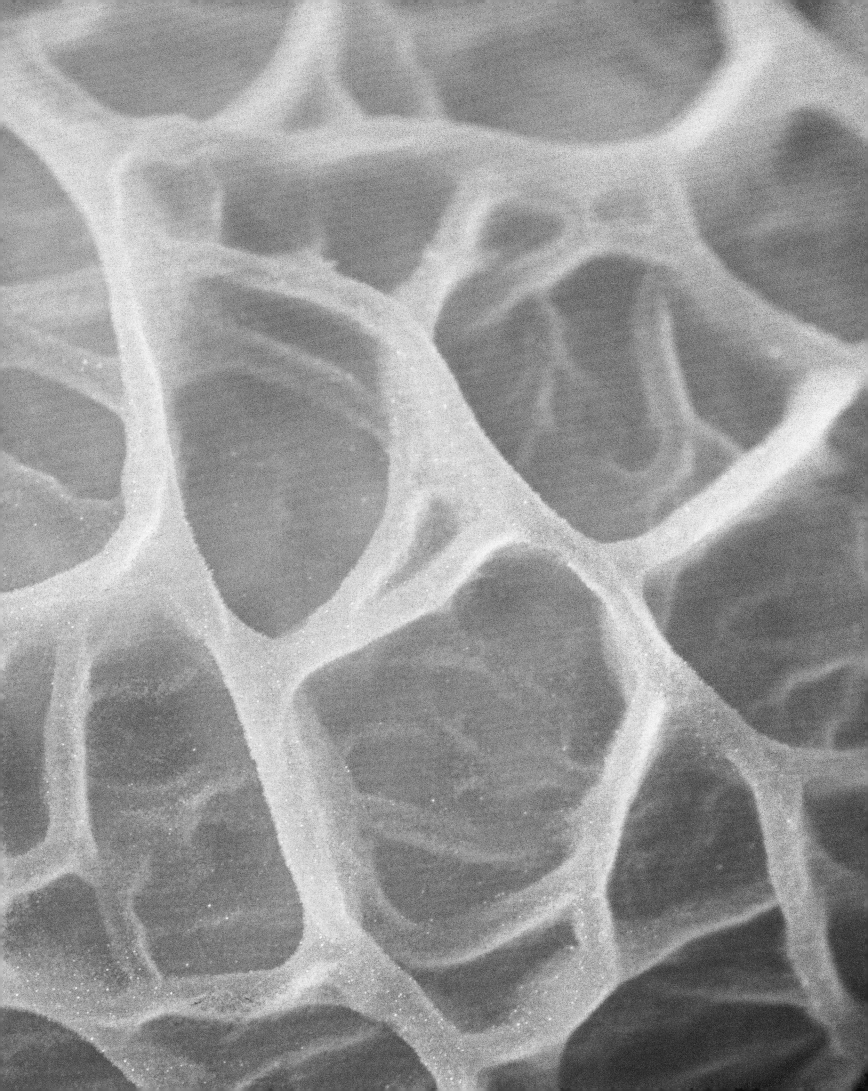

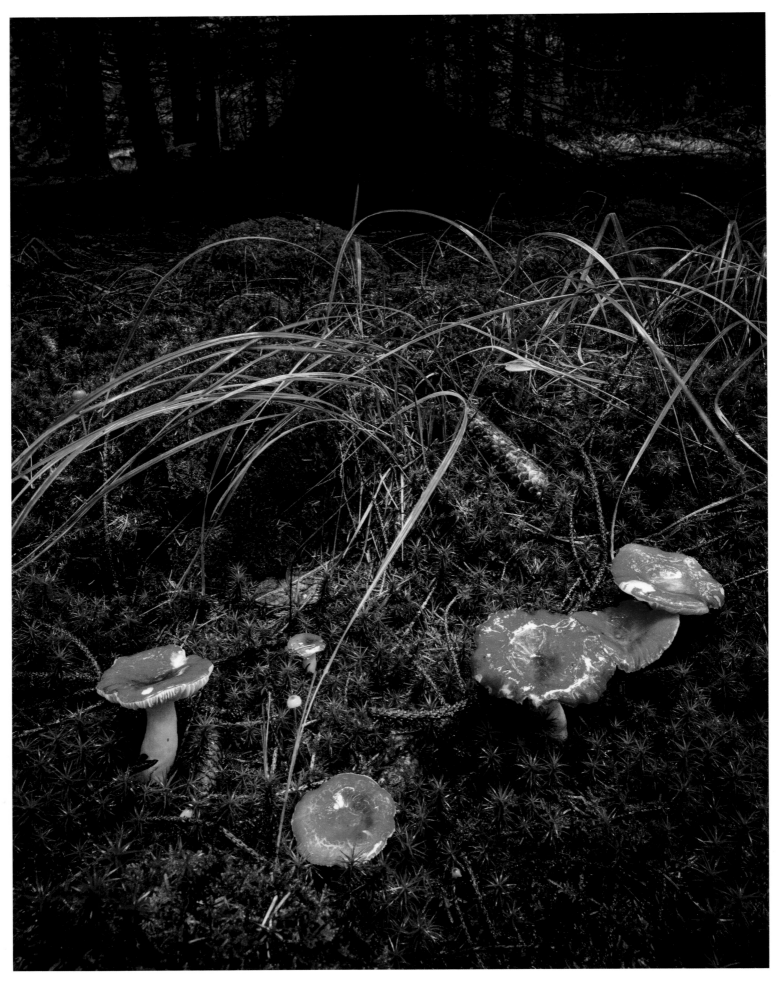

Sickener | Kirschroter Speitäubling *Russula emetica*

SYMBIOSIS
SYMBIOSE

The part of a mushroom that we notice – the section that grows above the ground – is just one small component in a highly complex system. The mushroom is the fruiting body of the underground part of the mushroom, also known as the mycelium. Given the right conditions, the spores released by the mushroom develop into a new mycelium in a different location. Although this description makes the whole endeavor sound relatively simple, a number of complex processes need to take place before a new mycelium grows.

TREES NEED FUNGI
AND IN RETURN,
FUNGI RELY ON TREES

Below the ground, the mycelium forms an infinite network of finely meshed threads, creating an enormous contact surface between the mycelium and the soil. Even the delicate root hairs that grow at the very tips of tree roots appear rather substantial compared to the super-fine threads of the mycelium. The mycelium also absorbs nutrients from the soil more effectively than a tree's root hairs, ingesting water-soluble nutrients that build up in the soil when plant and animal matter rot. The mycelium relies on the sugars that trees produce via their leaves. The fungus forms a mycorrhiza around tree roots, which enables it to pass nutrients to the tree and absorb sugars in return. Phosphorus, in particular, is much more readily absorbed by plants via the mycorrhiza. In the agricultural and horticultural sectors, this knowledge can make a real difference: with the mycorrhiza on their side, growers don't need to use as much phosphorus-based fertilizer, which is a huge benefit given that phosphorus is a finite mined resource. So, as you have probably guessed by now, trees need fungi and in return, fungi rely on trees. The mycorrhiza prevents the tree from drying out and protects it against harmful substances as well as increasing the tree's root capacity.

Der sichtbare oberirdische Teil eines Pilzes ist nur ein kleines Bruchstück eines komplexen Systems. Der Pilz ist der Fruchtkörper des unterirdischen Teils, des sogenannten Myzels. Unter den richtigen Bedingungen bilden die vom Pilz freigesetzten Sporen an einem anderen Ort ein neues Myzel. Dies ist eine sehr einfache Beschreibung – tatsächlich aber laufen komplizierte Prozesse ab, bevor sich neues Myzel entwickeln kann.

Im Boden bildet das Myzel ein endloses Netz aus feinmaschigen Fäden, wodurch ein intensiver Kontakt zwischen Myzel und Erdreich entsteht. Selbst die zarten Wurzelhaare, die an den Spitzen der Baumwurzeln wachsen, erscheinen im Vergleich zu den superfeinen Fäden des Myzels ziemlich massiv. Außerdem nimmt das Myzel Nährstoffe aus dem Boden effektiver auf als die Wurzelhaare eines Baumes, indem es wasserlösliche Nährstoffe resorbiert, die sich im Boden ansammeln, wenn pflanzliche und tierische Stoffe verrotten. Ein Baum produziert über seine Blätter Zucker, der für das Existieren des Myzels notwendig ist. Der Pilz bildet eine Mykorrhiza um die Baumwurzeln, die es ihm ermöglicht, Nährstoffe an den Baum weiterzu-

PFLANZEN BENÖTIGEN PILZE,
UND PILZE WIEDERUM
SIND AUF PFLANZEN
ANGEWIESEN

geben und im Gegenzug Zucker zu absorbieren. Vor allem Phosphate können von Pflanzen mit Hilfe der Mykorrhizapilze viel leichter aufgenommen werden als ohne sie. In der Landwirtschaft und im Gartenbau kann dieses Wissen einen echten Unterschied machen: Mykorrhizapilze können die Notwendigkeit, Phosphatdünger auszubringen, verringern. Dies ist ein großer Vorteil, denn Phosphate werden aus Mineralien gewonnen und sind damit eine endliche Ressource. Man kann also sagen, Pflanzen benötigen Pilze, und Pilze wiederum sind auf Pflanzen angewiesen. Die Mykorrhiza schützt die Pflanze oder

Mycorrhizas come in many different types, shapes, and sizes: some varieties prefer certain species of tree, like the larch bolete which – as its name suggests – only grows around larch trees. Newly forested areas are home to mycorrhizas that aren't found in ancient woodlands. Some mycorrhizas penetrate right into the tree root cells, while others grow between the cells, in the intercellular spaces between the tree roots. The tree and the mycorrhiza secrete substances that enable them to communicate. From the messages it receives from the tree, the mycorrhiza knows which "ingredients" it needs to deliver to the tree – and the tree knows whether the fungus is the right place to get what it requires.

Scientists are now increasingly able to decode the secrets of this intriguing method of communication. Research has also revealed that, if this system were ever to suffer irreparable damage, there would be disastrous consequences for our planet and for humanity. After millions of years of evolution, plants and mycorrhizas still rely on one another to survive.

den Baum beispielsweise auch vor Austrocknung und Schadstoffen und erhöht die Durchlässigkeit des Bodens. Es gibt eine große Vielfalt an Mykorrhizen. Einige Arten haben eine Vorliebe für bestimmte Bäume. So trifft man den Gold-Röhrling beispielsweise ausschließlich bei Lärchen. In neu entstandenen Wäldern wachsen andere Mykorrhizapilze als in alten Waldbeständen. Es gibt Mykorrhizen, die direkt in die Baumwurzelzellen hineinwachsen, aber auch solche, die nur in den Zellzwischenräumen der Wurzeln existieren. Der Baum und die Mykorrhizapilze kommunizieren miteinander, indem sie bestimmte Stoffe austauschen. Eine Mykorrhiza weiß also, welche „Zutaten" sie freisetzen muss, und der Baum erkennt, ob der Pilz der richtige Partner ist.

Wissenschaftler sind zunehmend in der Lage, die Geheimnisse dieser faszinierenden Kommunikationsmethode zu entschlüsseln. Dabei wird deutlich, dass ein irreparabler Bruch in diesem System katastrophale Folgen für die Erde und damit für die Menschheit haben könnte. Nach Millionen von Jahren der Evolution sind Pflanzen und Mykorrhizen weiterhin aufeinander angewiesen, um überleben zu können.

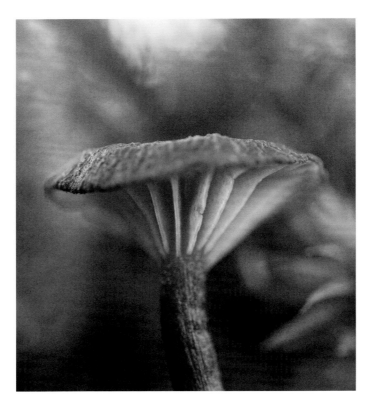

This page: **Verdigris navel** | Diese Seite: **Blaugrüner Nabeling** *Omphalina chlorocyanea*

Right page: **Sulfur knight** | Rechte Seite: **Schwefelritterling** *Tricholoma sulphureum*

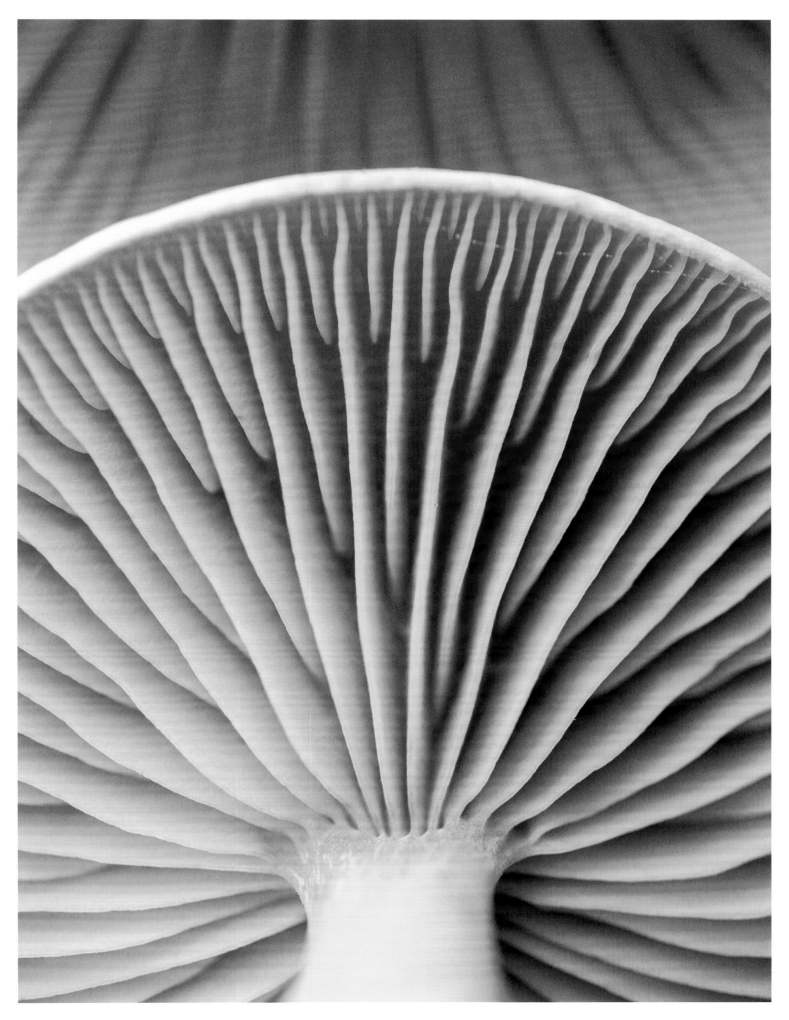

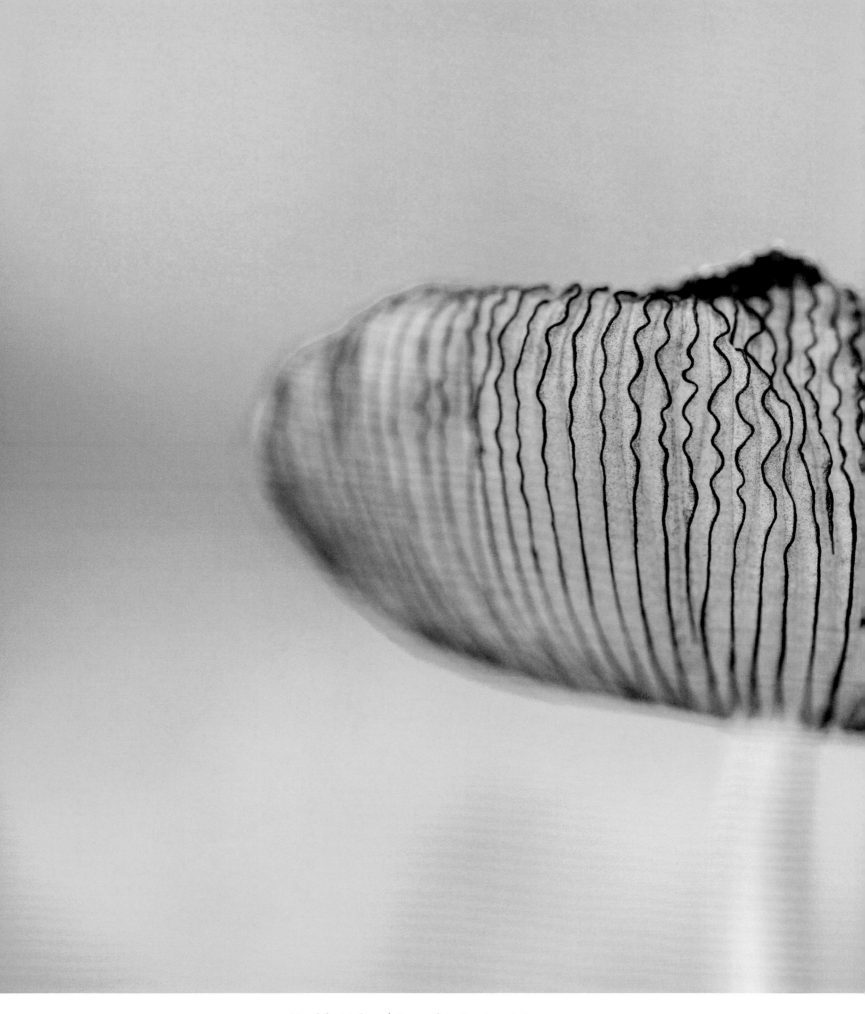

Hare'sfoot inkcap | Hasenpfote *Coprinopsis lagopus*

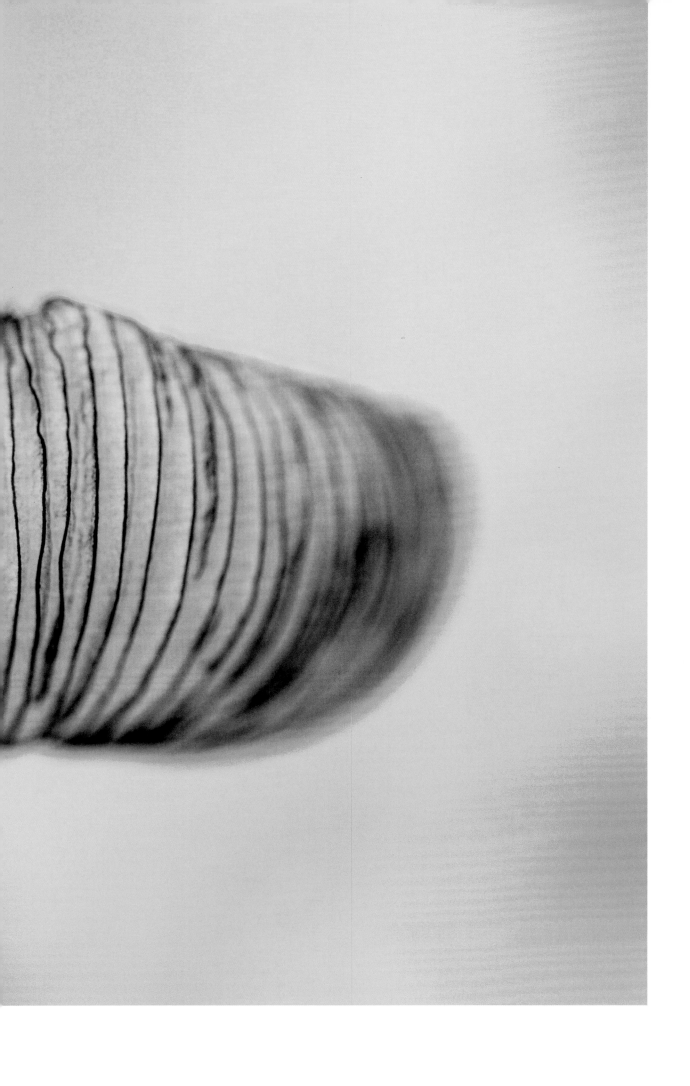

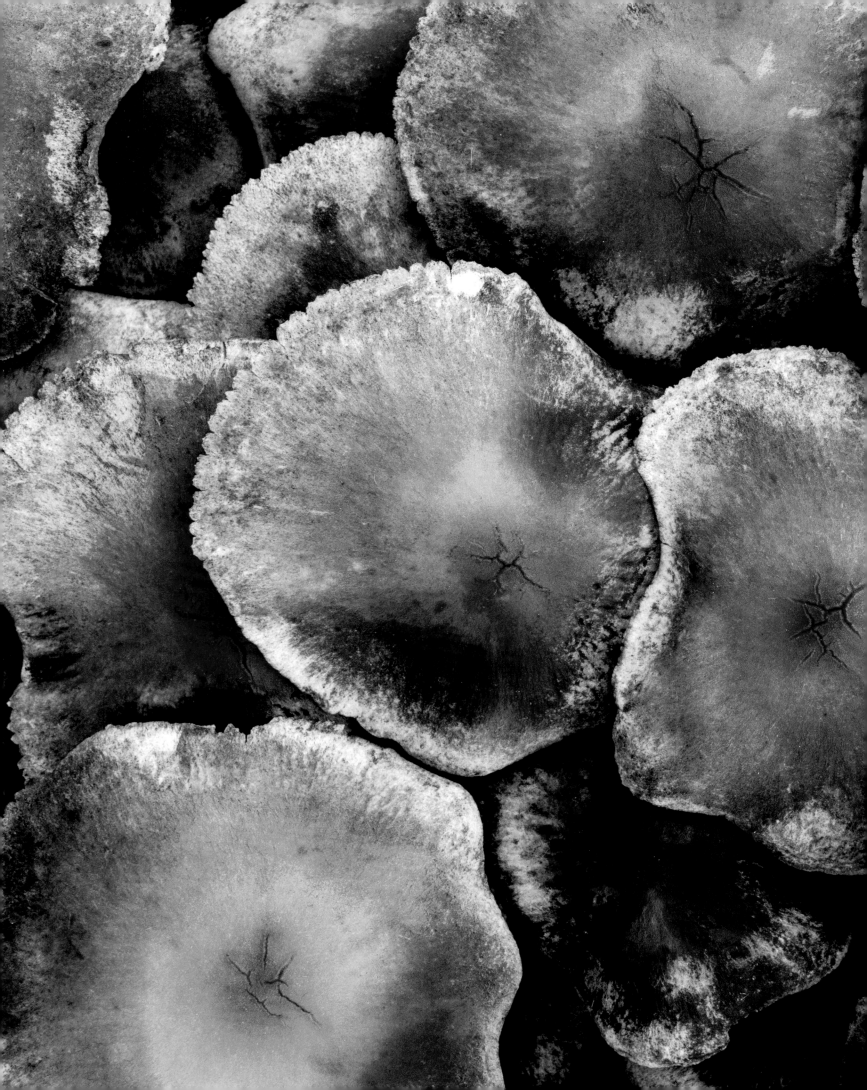

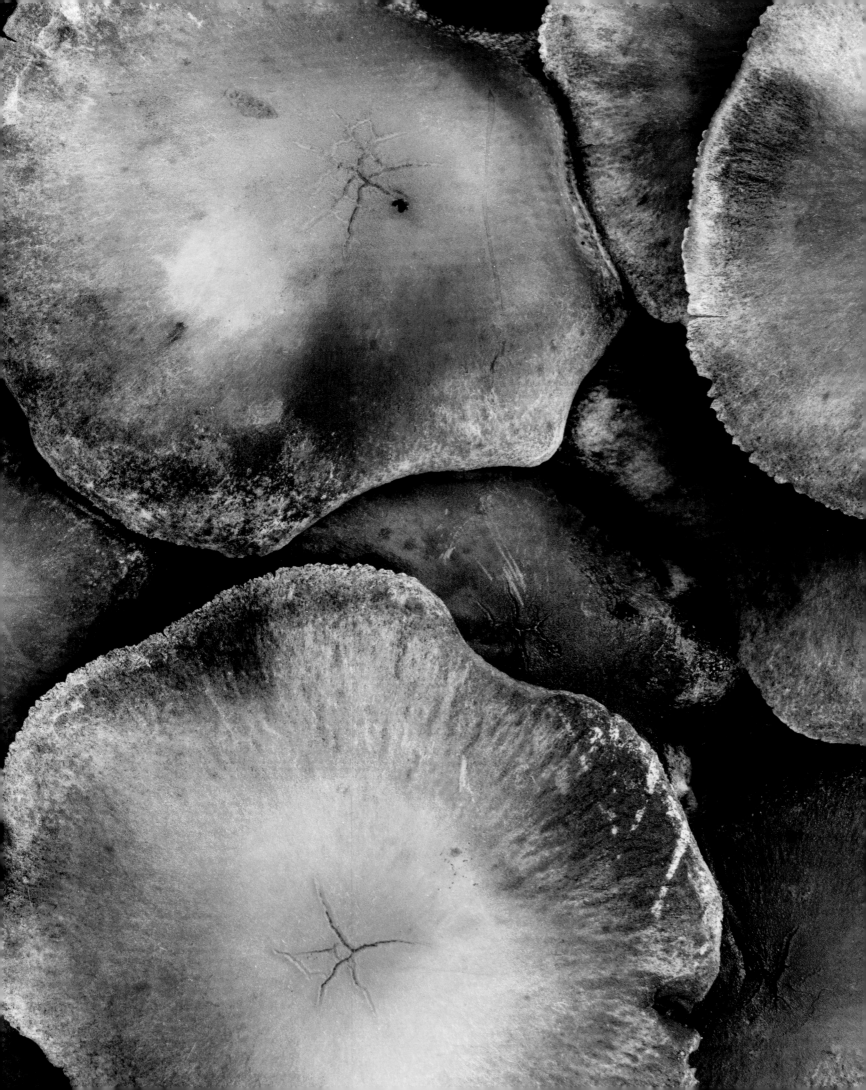

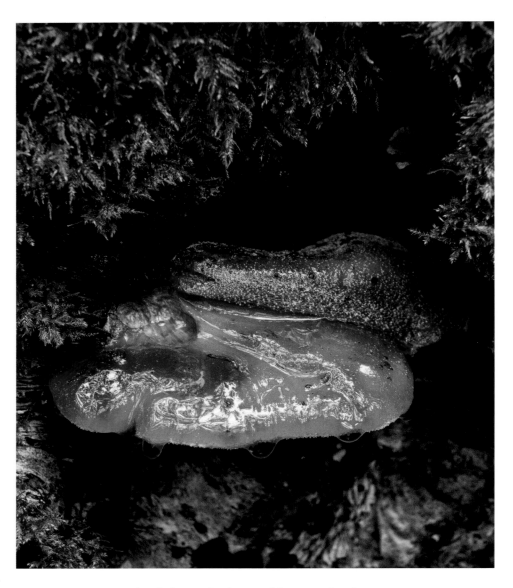

Beefsteak fungus | Leberreischling *Fistulina hepatica*

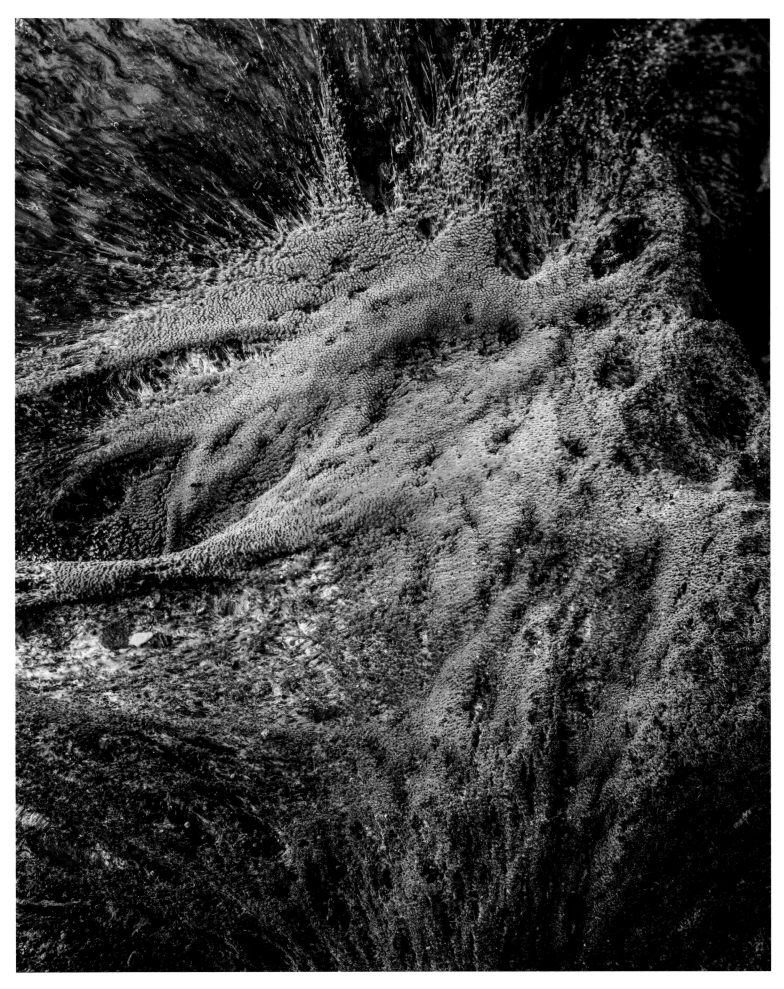

Beefsteak fungus | Leberreischling *Fistulina hepatica*

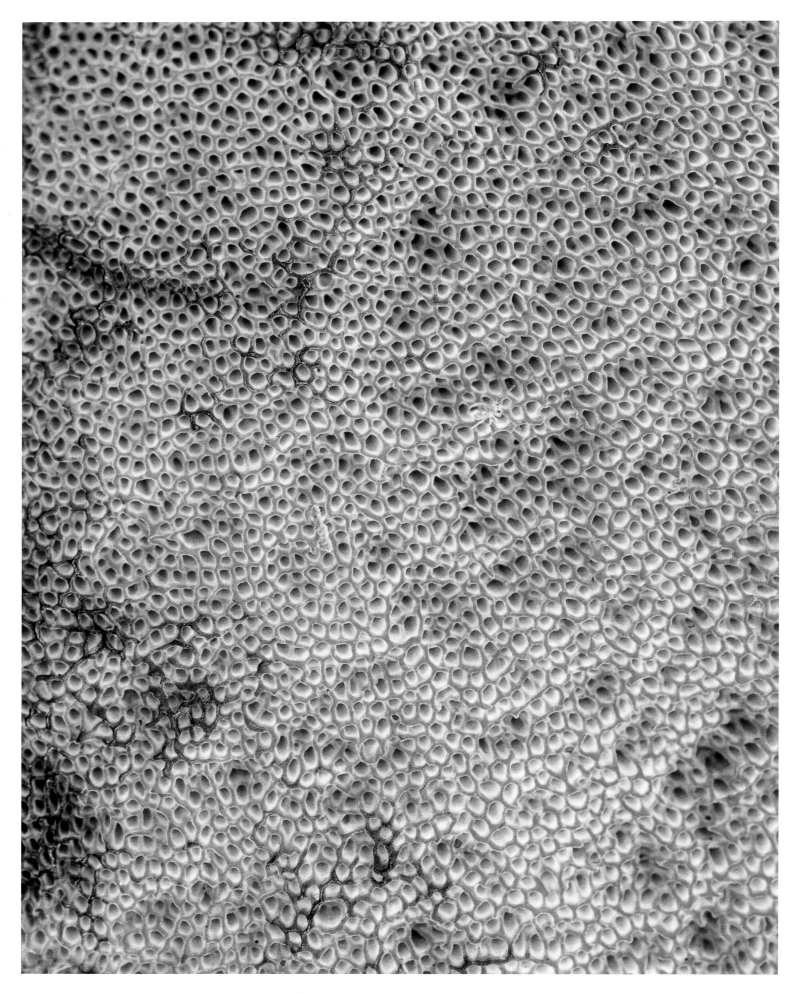

Scarletina bolete | Flockenstieliger Hexenröhrling *Neoboletus erythropus*

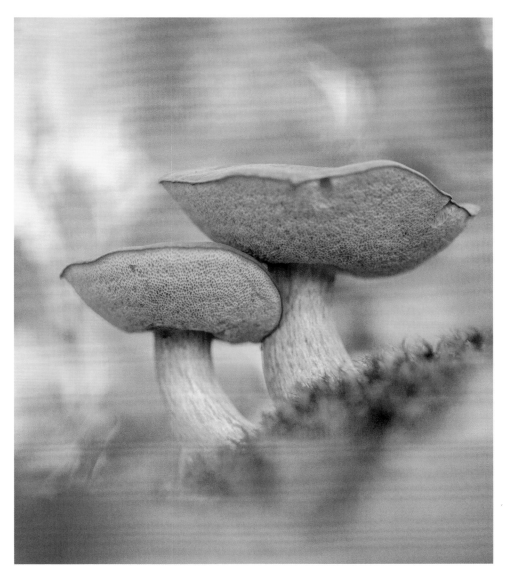

Bay bolete | Maronenröhrling *Imleria badia*

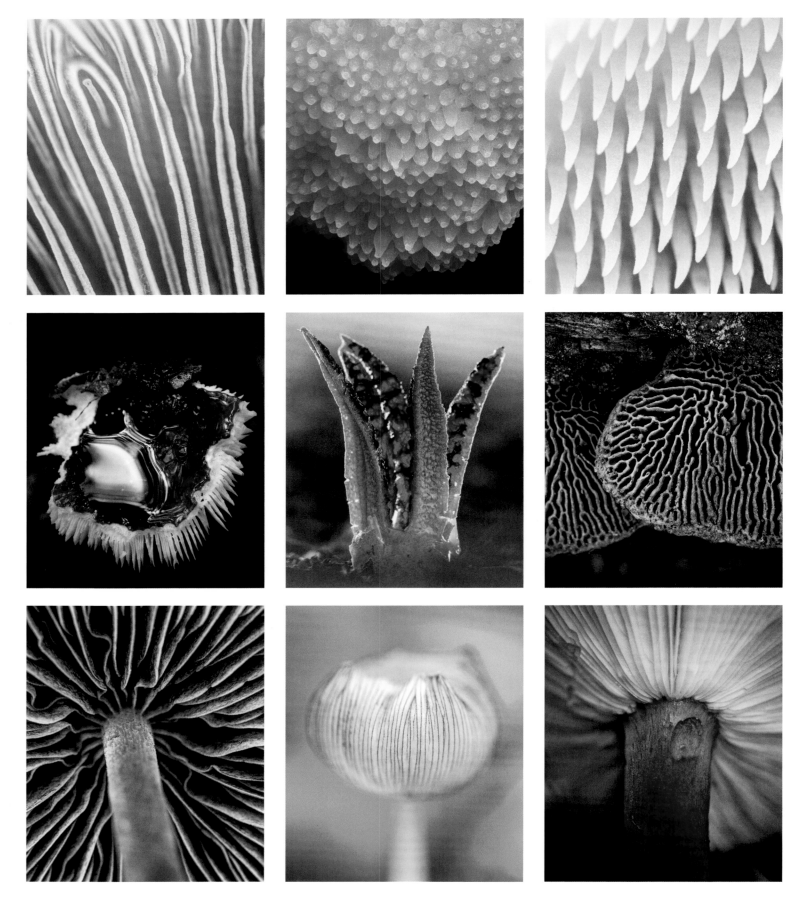

From top left to bottom right | Von links oben nach rechts unten:

Splitgill | Spaltblättling *Schizophyllum commune* / Raspberry slime mold | Lachsfarbener Schleimpilz *Tubulifera arachnoidea*

Ear-pick fungus | Ohrlöffel-Stacheling *Auriscalpium vulgare* / Russula brunneoviolacea | Violettbrauner Täubling *Russula brunneoviolacea*

Devil's fingers | Tintenfischpilz *Clathrus archeri* / Oak mazegill | Eichenwirrling *Daedalea quercina*

Wine roundhead | Riesenträuschling *Stropharia rugosoannulata*

Hare'sfoot inkcap | Hasenpfote *Coprinopsis lagopus* / Bloody brittlegill | Blut-Täubling *Russula sanguinea*

32

VARIETIES
FORMENVIELFALT

From striped, serrated and veined to round, oblong, red, yellow and blue – mushrooms come in a vast array of shapes and colors. In fact, their bright hues are often the reason why we can easily spot them in the forest, on moorland, or in open fields.

Fly agarics are known for their familiar bright-red caps dotted with distinctive white spots, which has resulted in this mushroom making frequent appearances in fairytales and fables. The fly agaric belongs to the Agaricales order of fungi, all of which have neat rows of gills lined up underneath the cap. From this cap, the wind distributes the mushroom's spores to new potential growth sites.

CLOSED UP, THE STRUCTURE RESEMBLES AN ARCHITECTURAL MASTERPIECE

There are many different varieties and sizes of gilled mushroom. The eye-catching parasol mushroom is a common sight along roadsides and pathways, with its umbrella-shaped cap resting atop a tall stem. Size-wise, mycenas are the opposite of parasol mushrooms and much harder to spot; these tiny mushrooms have delicate-looking stems that, on closer inspection, are actually much sturdier than they first appear. The porcini, or penny bun mushroom, is perhaps even better known than the fly agaric; this bolete mushroom is easily identified by the tubes or holes under the cap. Closed up, the structure resembles an architectural masterpiece, and with a little bit of imagination you may even be able to see church-organ-like pipes in the structure. The earpick fungus, on the other hand, is a miniscule and therefore much less famous specimen that grows on pine cones. The underside of the cap – which measures at most two centimeters across – is filled with tiny, neatly arranged

Von gestreift, gezahnt, geädert bis zu rund, länglich, rot, gelb und blau – Pilze gibt es in unzähligen Formen und Farbvarianten. Durch ihre leuchtenden Farben fallen sie oft auf und sind in Wäldern, auf Heideflächen oder offenen Feldern nicht schwer zu finden.

Der Fliegenpilz ist bekannt für seine leuchtend rote Kappe mit den weißen Punkten. Dieses auffällige Aussehen hat dafür gesorgt, dass er häufig in Märchen und Fabeln vorkommt. Der Fliegenpilz zählt zu den Blätterpilzen, was leicht zu erkennen ist, wenn man ihm unter den Hut schaut. Die Lamellen, auch als Blätter bezeichnet, sind ordentlich aufgereiht. Der Wind verbreitet die Sporen aus diesem Hut, weht sie zu neuen, vielversprechenden Lebensräumen.

Blätterpilze gibt es in vielen Formen und Größen. Häufig und auffallend ist der Riesenschirmling oder Parasol, der auf seinem langen Fuß an Straßenrändern steht. Schwieriger zu finden und von der Größe her das genaue Gegenteil sind die Helmlinge (Mycena). Diese kleinen Pilze zeichnen sich durch ihre zarten Stiele aus, die allerdings stabiler sind als vermutet.

BEI NÄHERER BETRACHTUNG KANN MAN EIN ARCHITEKTONISCHES MEISTERWERK ERKENNEN

Der Steinpilz ist vielleicht sogar noch bekannter als der Fliegenpilz. Er ist einfach zu erkennen an den Röhren oder Löchern unter seiner Kappe. Bei näherer Betrachtung kann man ein architektonisches Meisterwerk erkennen und mit etwas Fantasie erinnert die Struktur an eine Kirchenorgel. Der Ohrlöffel-Stacheling ist ein sehr kleiner und daher wenig bekannter Pilz, der auf den Zapfen von Nadelbäumen wächst. Die Unterseite seines Hutes – dessen Durchmesser maximal zwei Zentimeter misst – zeigt auffallende, regelmäßig angeordnete Stacheln. Klein, aber fein ist dieser Pilz und ein kunstvolles Wunder von

teeth. This small-but-perfectly-formed mushroom is an aesthetically pleasing natural wonder. The seemingly endless variety of mushroom shapes and sizes increases even further if we expand our horizons to look at species that grow on wood. Oyster mushrooms often have veins on the bottom, while oak mazegills have a labyrinth-like structure that resembles a network of tunnels on their underside.

The natural diversity in the world of fungi and mushrooms is a never-ending source of fascination and amazement.

Mutter Natur. Die geradezu unendliche Formenvielfalt nimmt noch zu, wenn man die Arten betrachtet, die auf Holz wachsen. Muschelseitlinge haben oft eine geäderte Unterseite, der Eichenwirrling hingegen zeigt ein Gangsystem, das wie ein Labyrinth wirkt.

Die natürliche Vielfalt in der Welt der Pilze ist eine unerschöpfliche Quelle der Faszination und des Staunens.

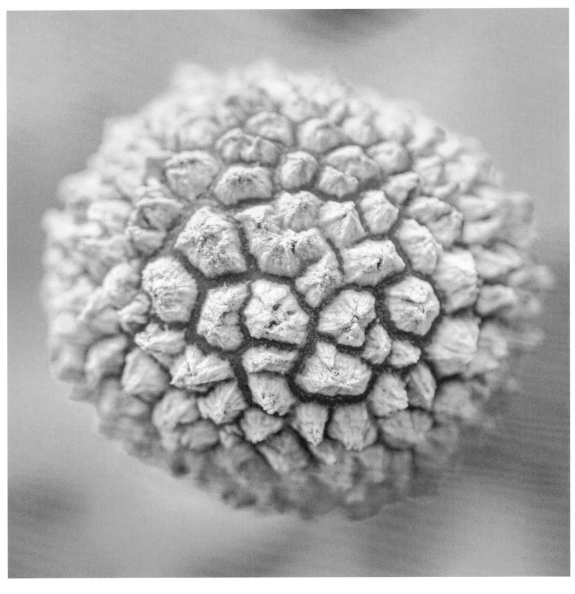

This page: **Fly agaric** | Diese Seite: **Fliegenpilz** *Amanita muscaria*

Right page: **Amethyst deceiver** | Rechte Seite: **Violetter Lacktrichterling** *Laccaria amethystina*

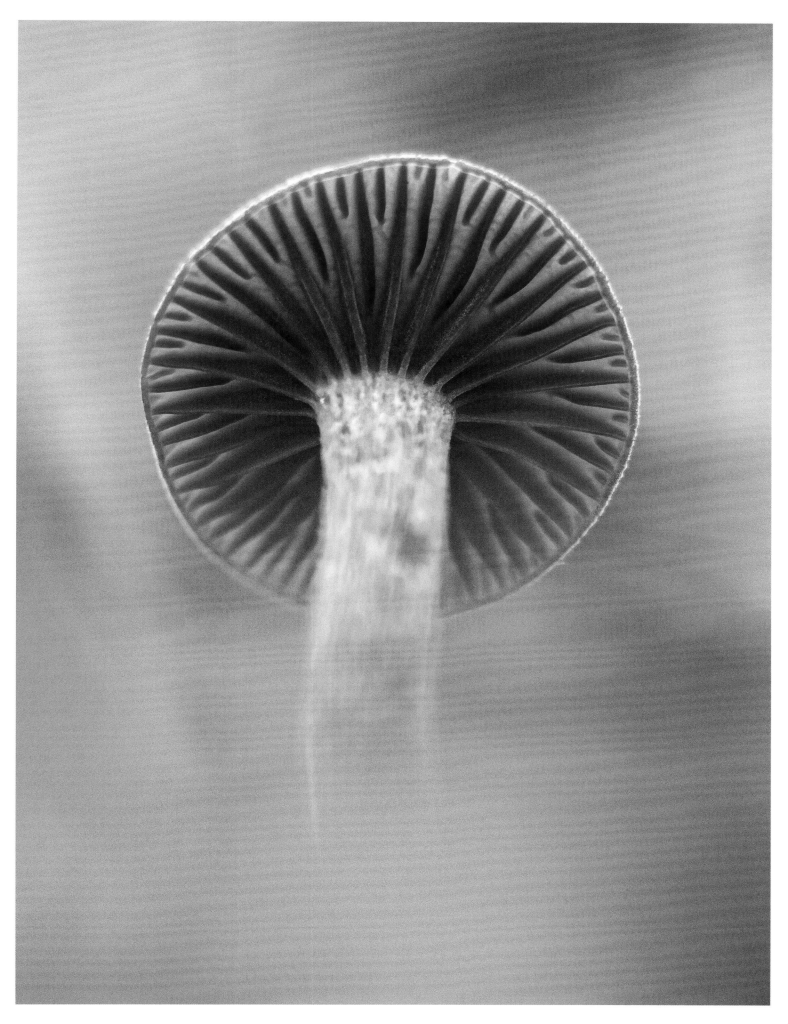

Fly agaric | Fliegenpilz *Amanita muscaria*

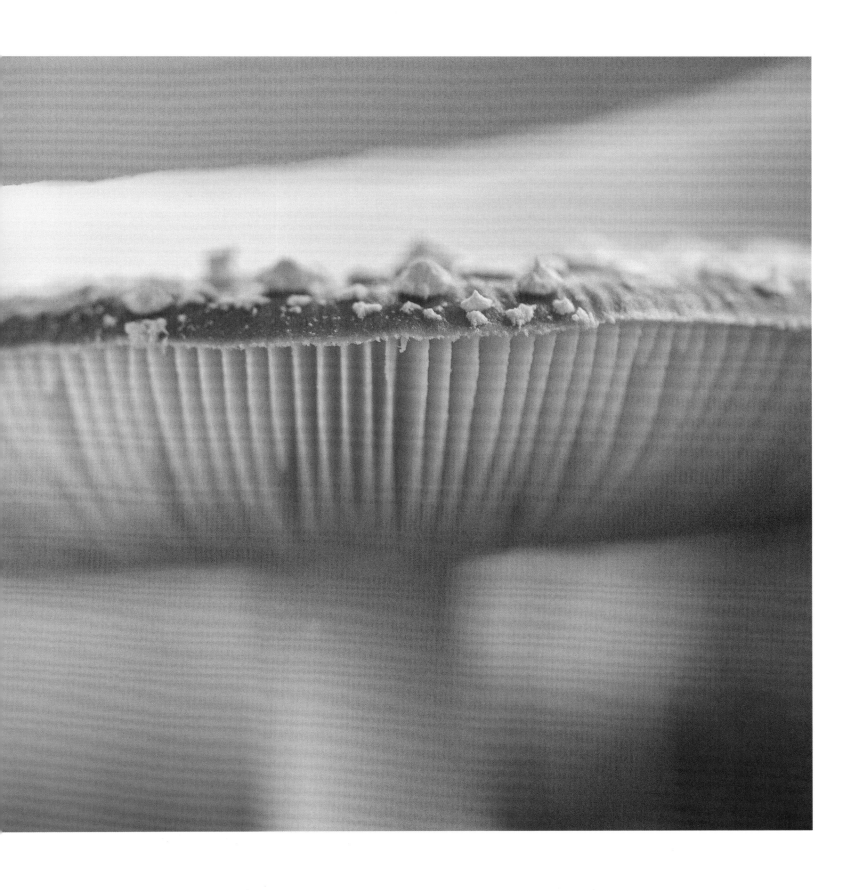

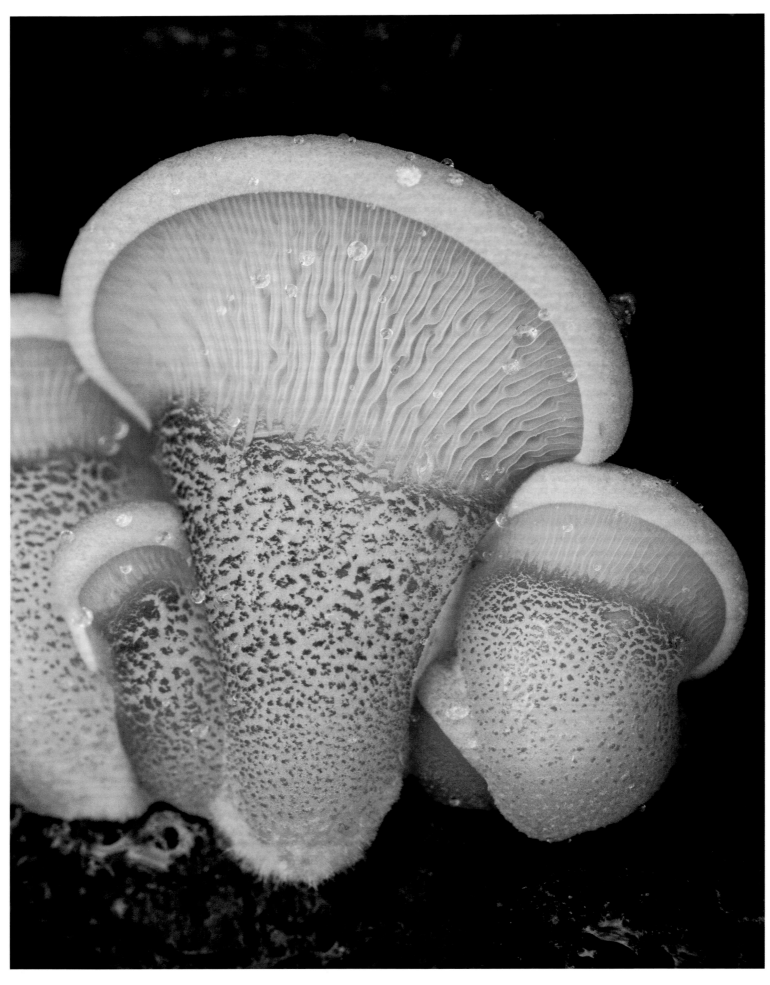

Olive oysterling | Gelbstieliger Muschelseitling *Sarcomyxa serotina*

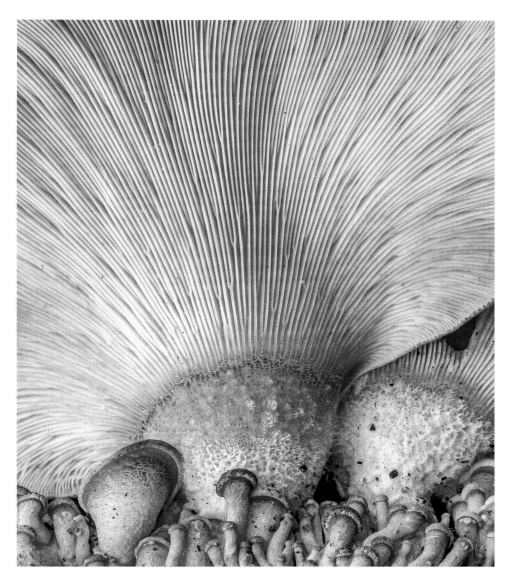

Olive oysterling | Gelbstieliger Muschelseitling *Sarcomyxa serotina*

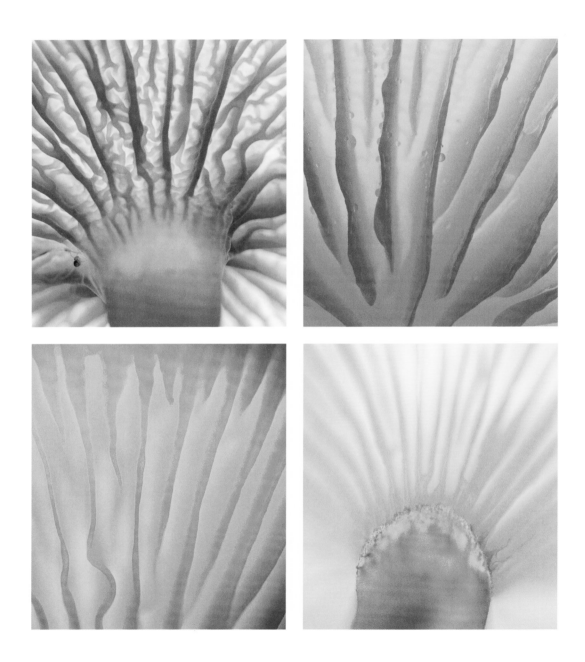

From top left to bottom right / Von links oben nach rechts unten:
Trumpet chanterelle | Trompeten-Pfifferling *Cantharellus tubaeformis* / Porcelain fungus | Beringter Schleimrübling *Oudemansiella mucida*
White domecap | Weißer Rasling *Clitocybe connata* / White domecap | Weißer Rasling *Clitocybe connata*

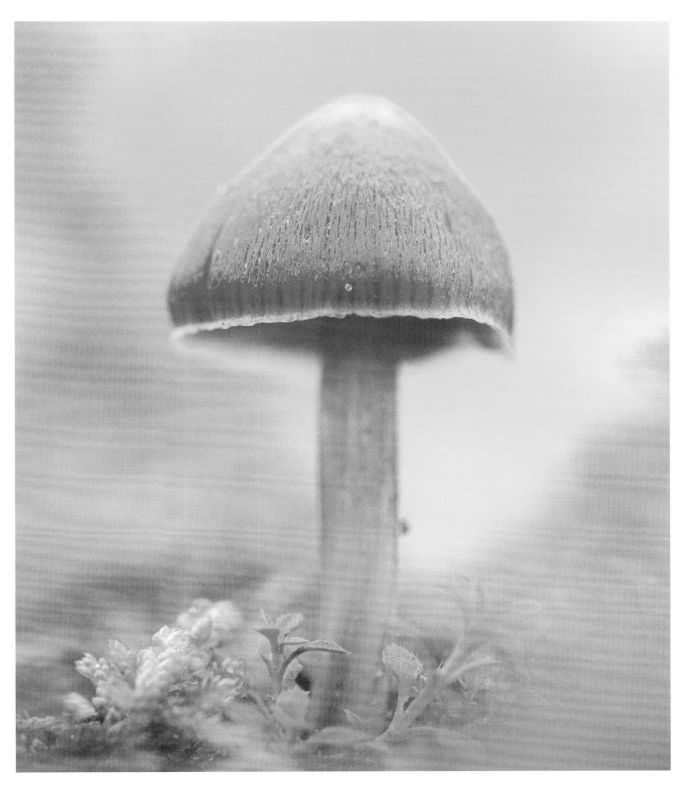

Blackening waxcap | Kegeliger Saftling *Hygrocybe conica*

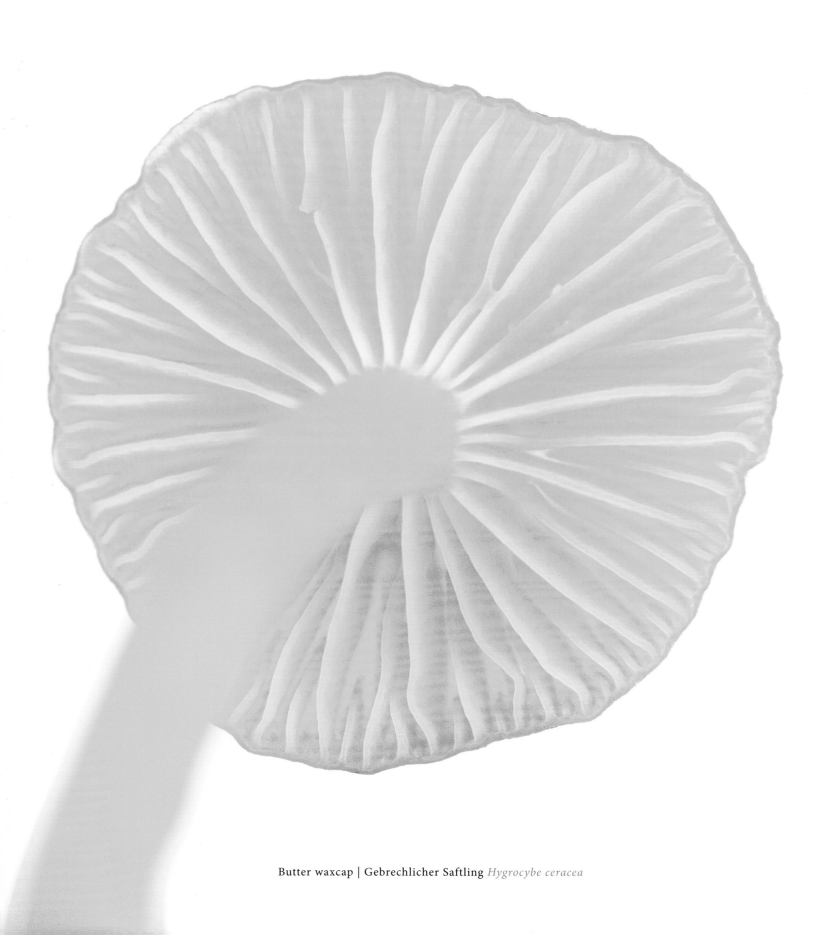

Butter waxcap | Gebrechlicher Saftling *Hygrocybe ceracea*

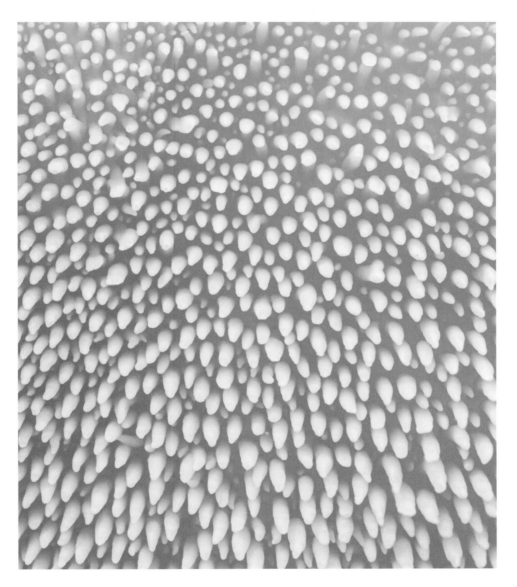

Wood hedgehog | Semmel-Stoppelpilz *Hydnum repandum*

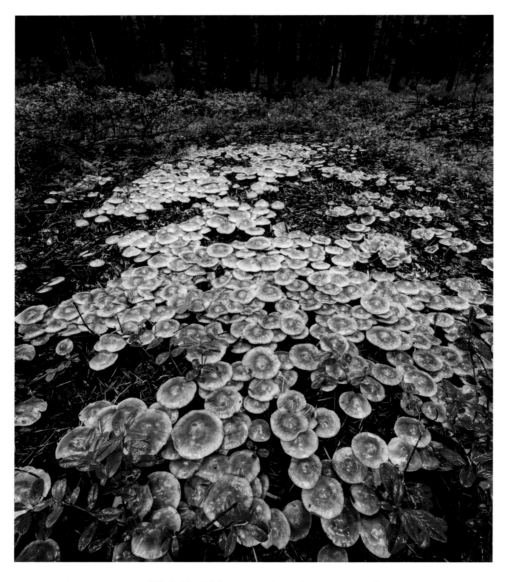

Common rustgill | Geflecktblättriger Flämmling *Gymnopilus penetrans*

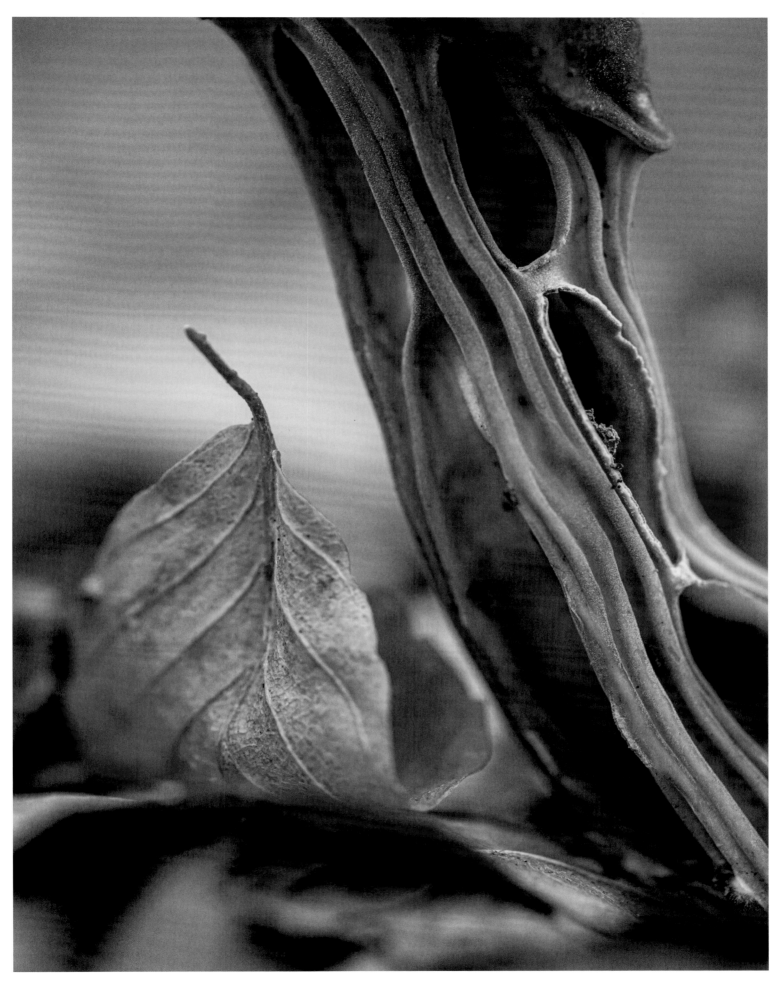

Elfin saddle | Gruben-Lorchel *Helvella lacunosa*

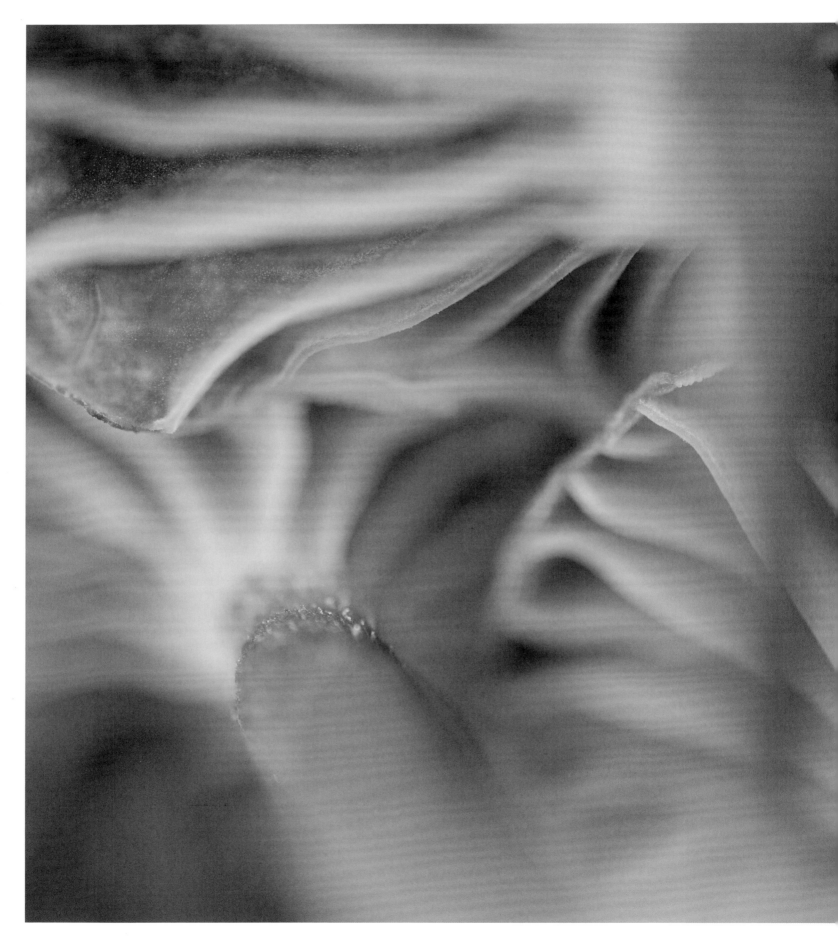

Verdigris navel | Blaugrüner Nabeling *Omphalina chlorocyanea*

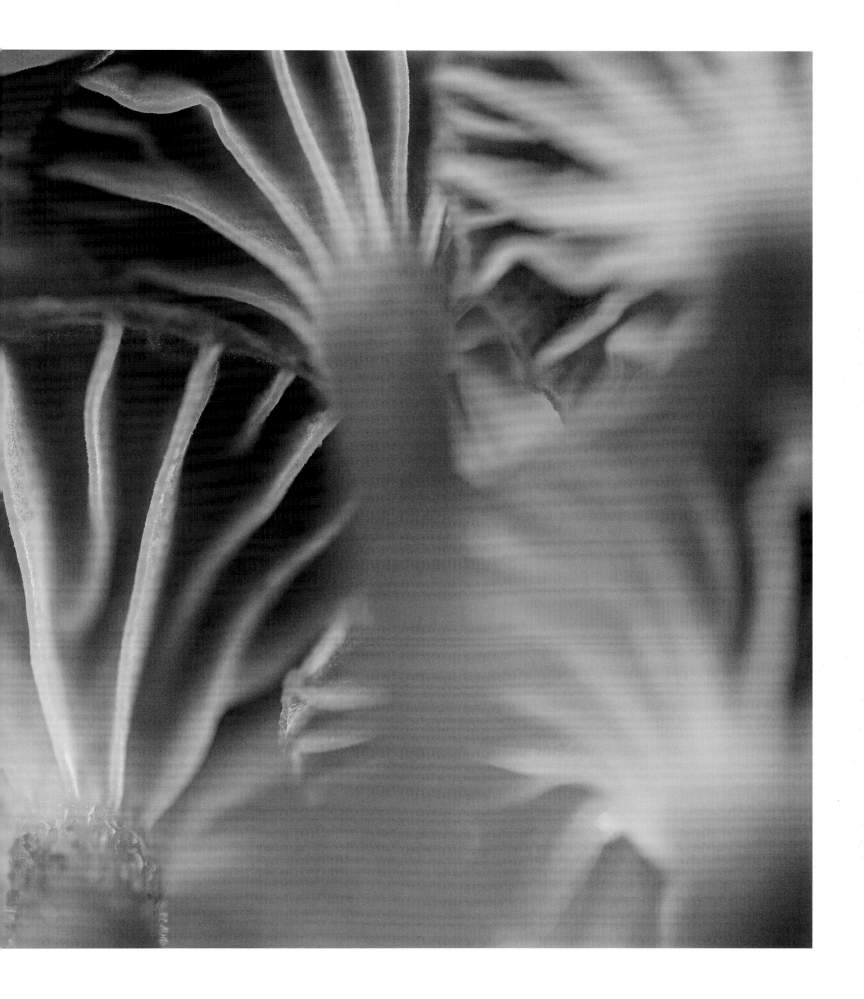

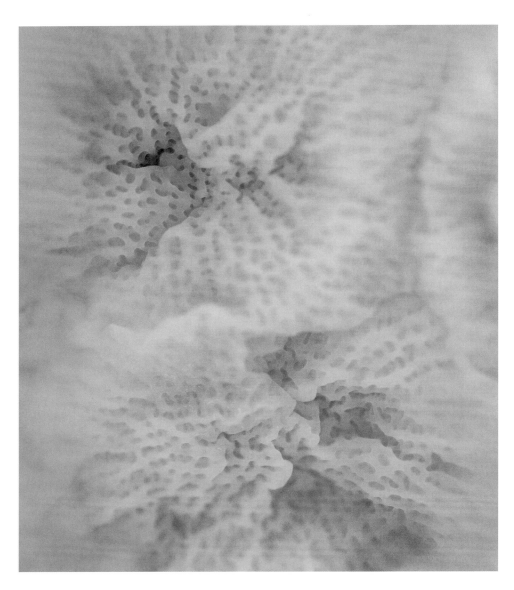

Jelly rot | Gallertfleischiger Fältling *Phlebia tremellosa*

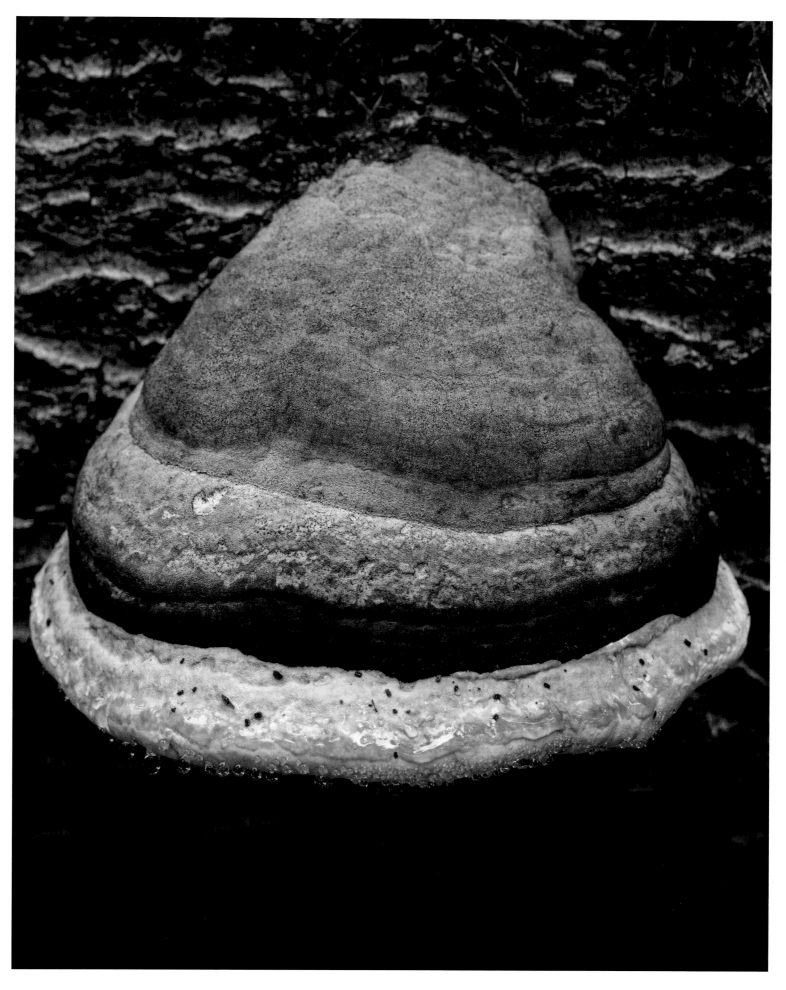

Tinder bracket | Zunderschwamm *Fomes fomentarius*

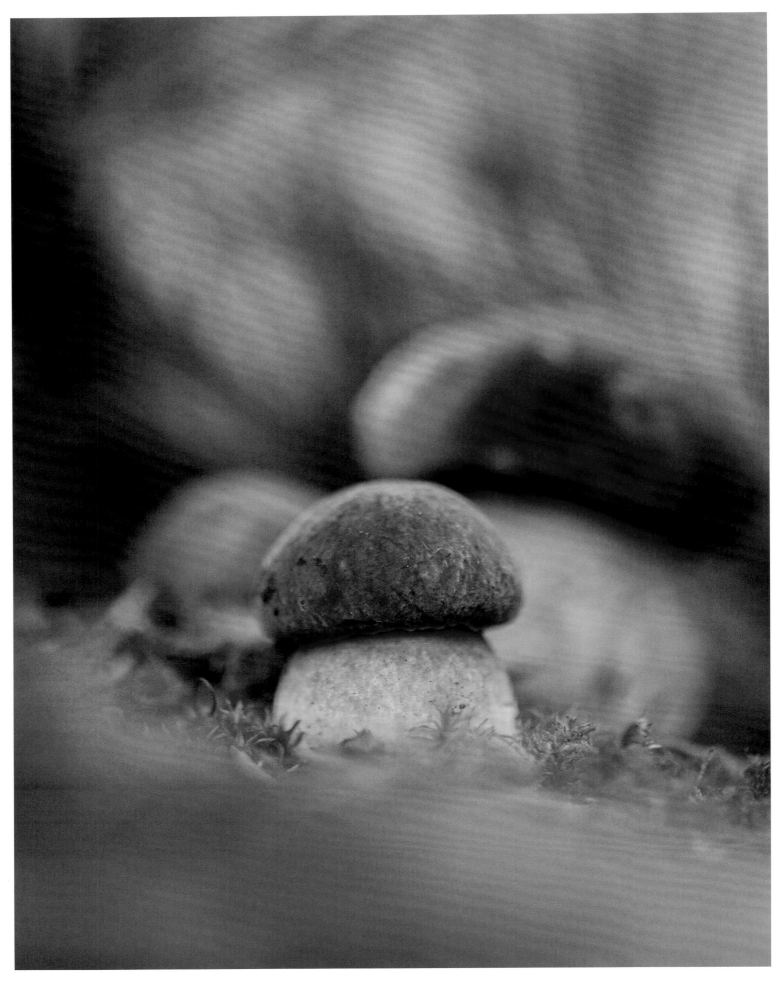

Scarletina bolete | Flockenstieliger Hexenröhrling *Neoboletus erythropus*

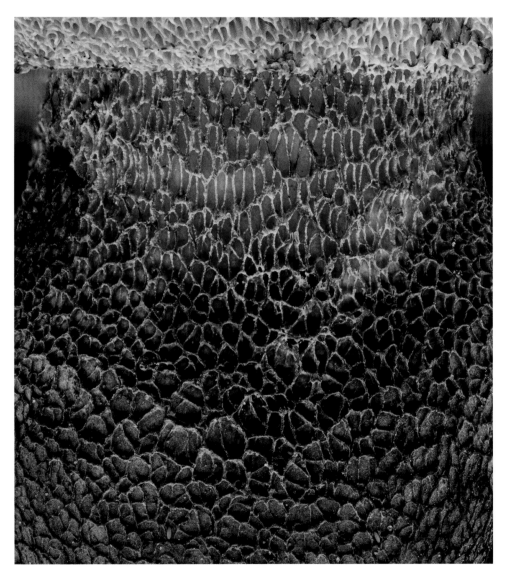

Bitter beech bolete | Schönfuss-Röhrling *Caloboletus calopus*

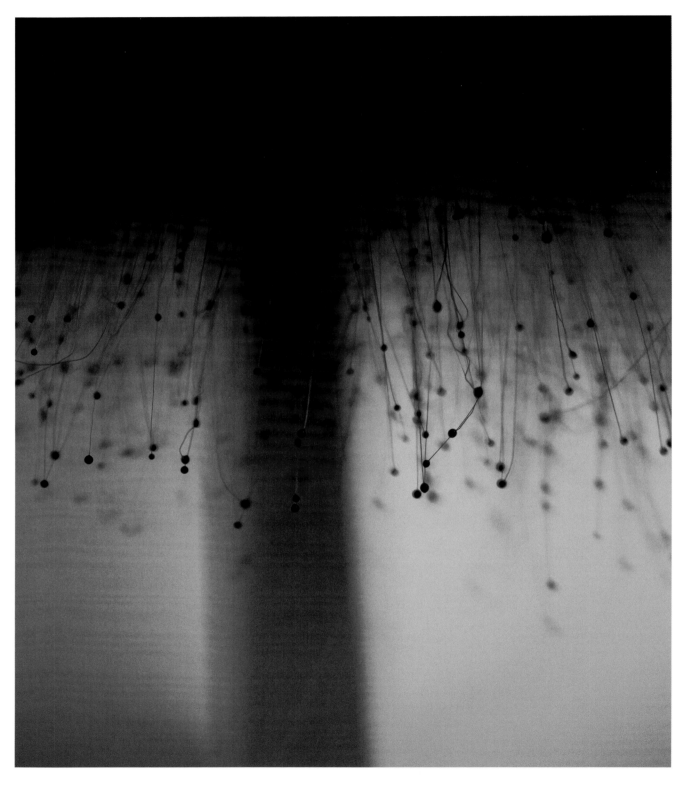

Rosy bonnet with bonnet mold | Rosa Rettich-Helmling mit Helmlingsschimmel *Mycena rosea*

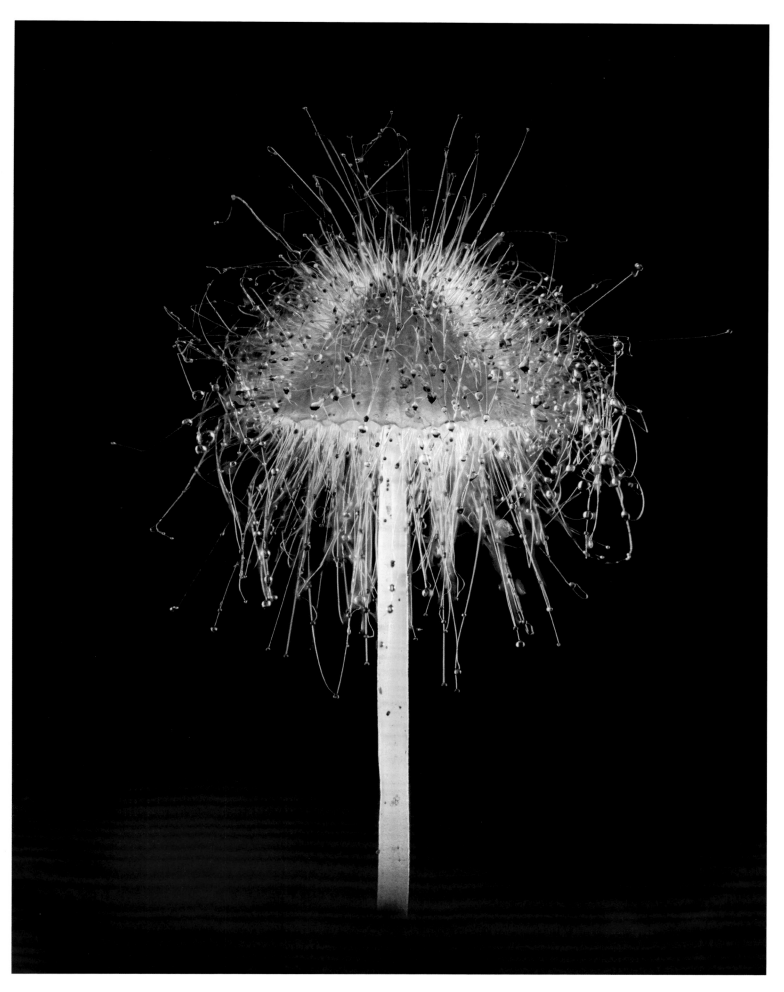

Yellow leg bonnet with bonnet mold | Dehnbarer Helmling mit Helmlingsschimmel *Mycena epipterigya*

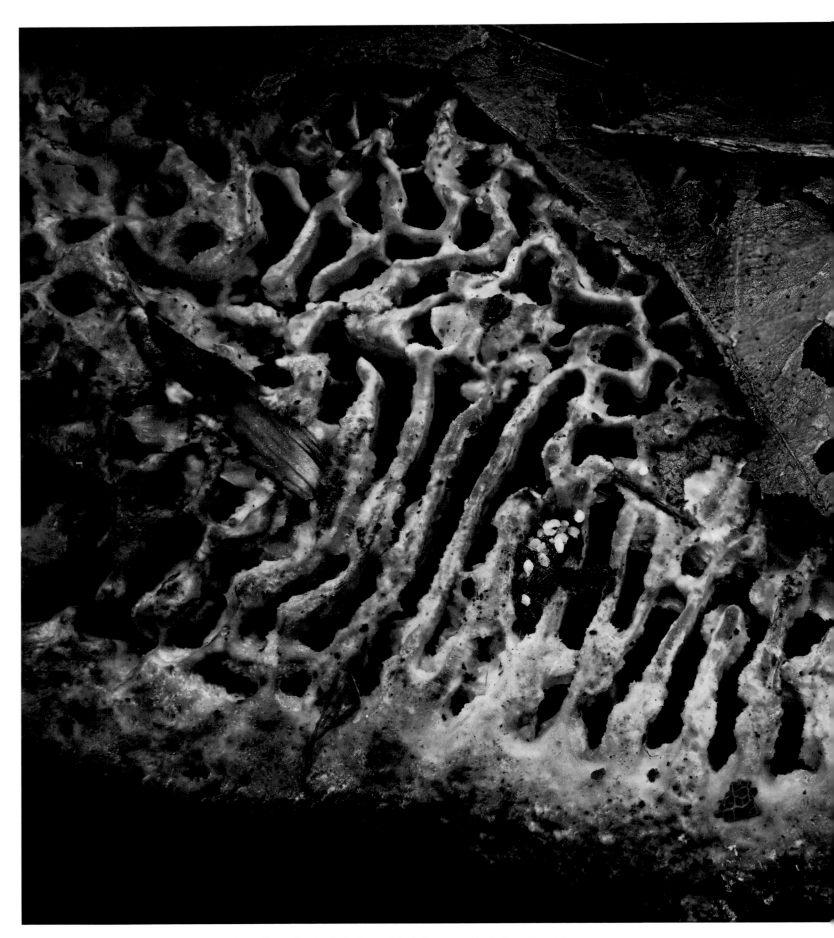

Tulasnella violea | Lilafarbener Wachskrustenpilz *Tulasnella violea*
growing on **oak mazegill** | gewachsen auf **Eichenwirrling** *Daedalea quercina*

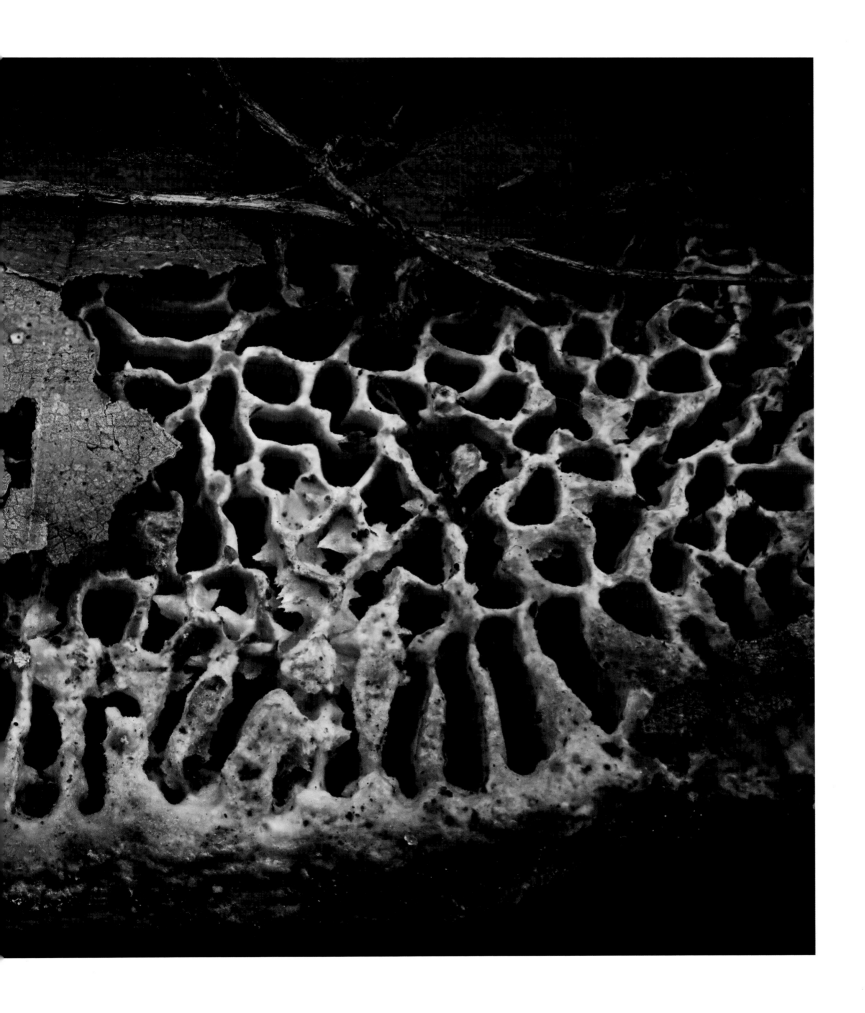

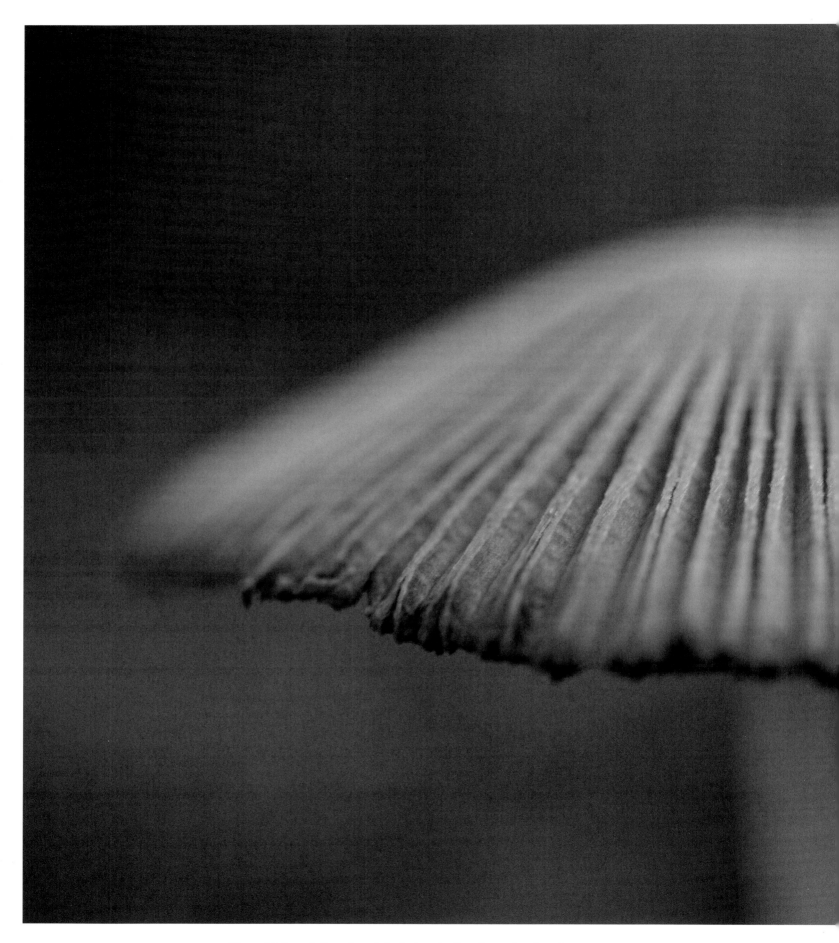

Pleated inkcap | Gemeiner Scheibchentintling *Parasola plicatilis*

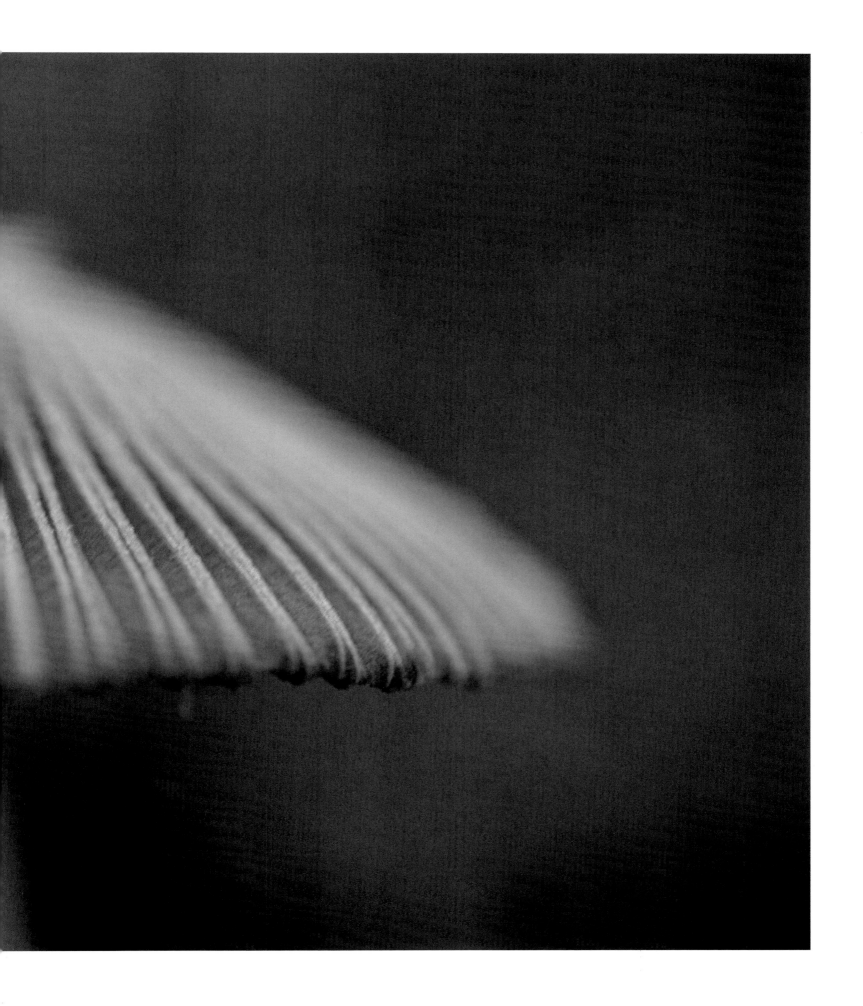

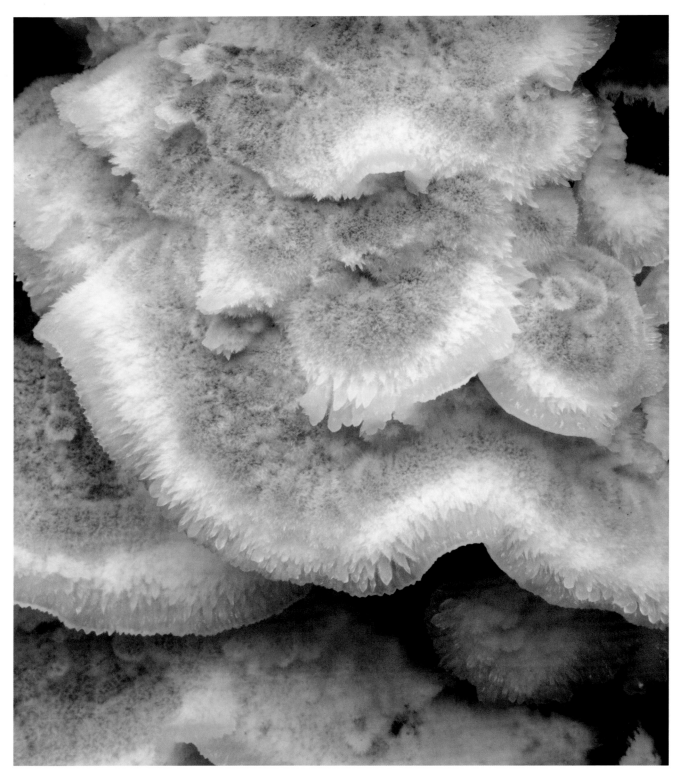

Silverleaf fungus | Violetter Knorpelschichtpilz *Chondrostereum purpureum*

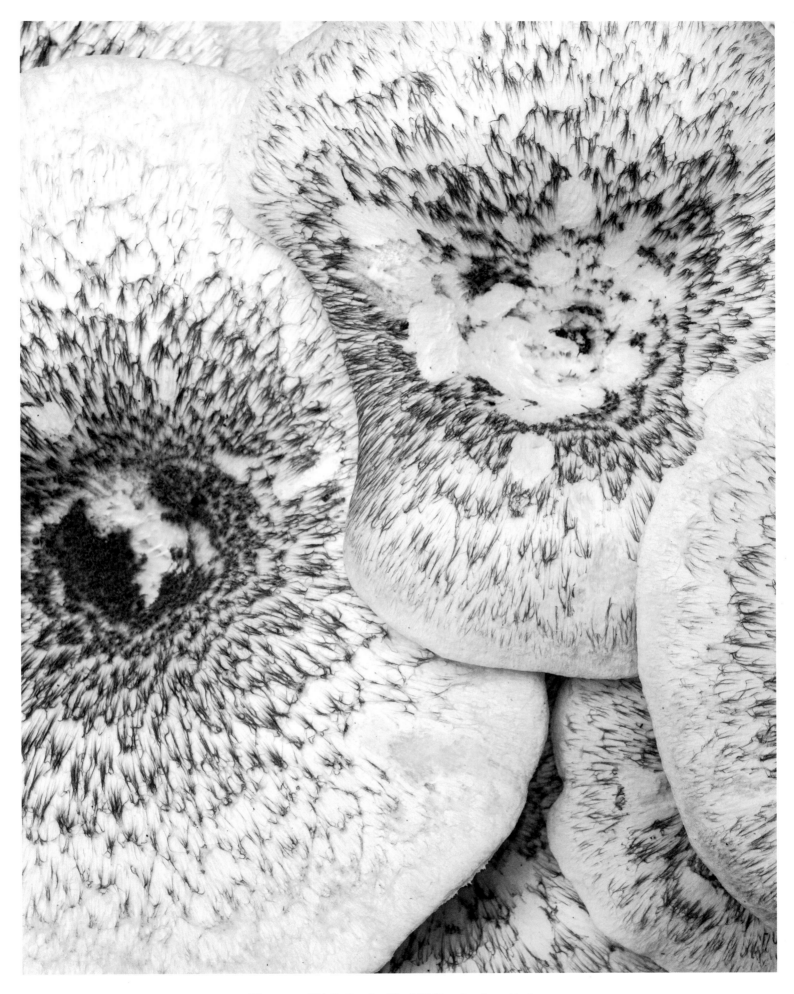

Tiger sawgill | Getigerter Sägeblättling *Lentinus tigrinus*

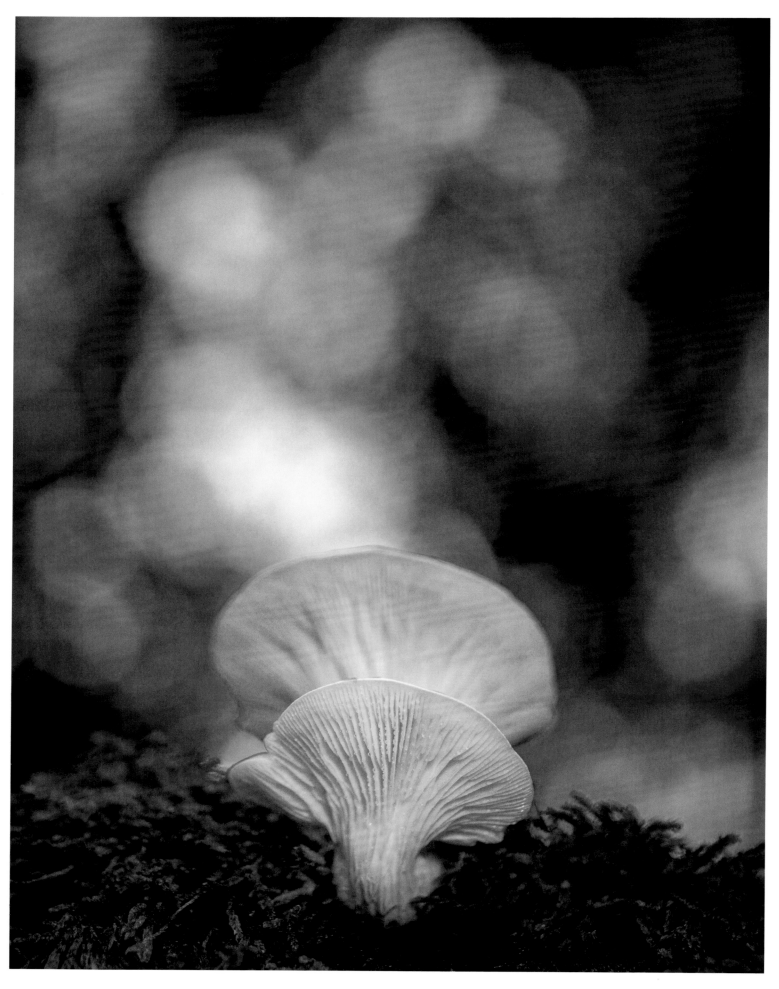

Pale oyster | Lungen-Seitling *Pleurotus pulmonarius*

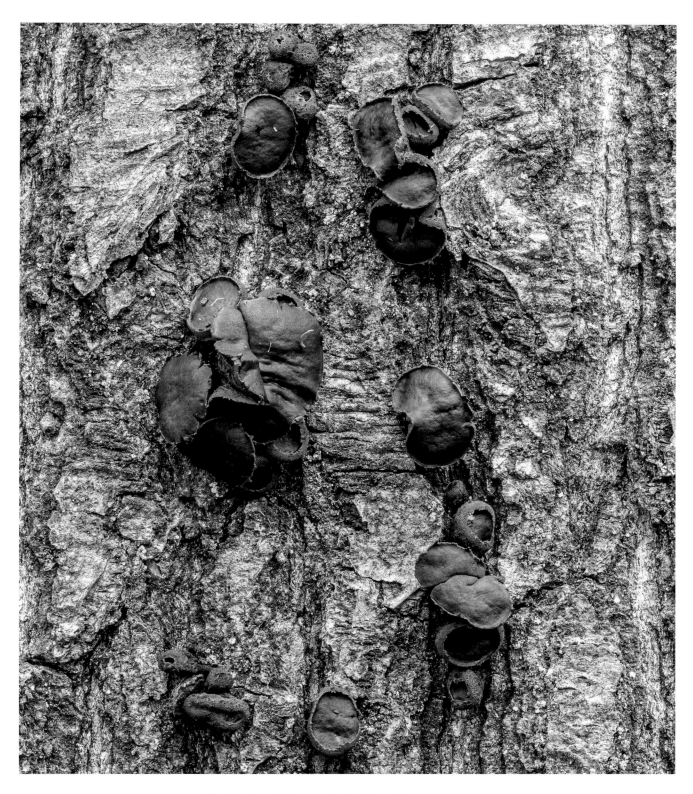

Black bulgar | Schmutzbecherling *Bulgaria inquinans*

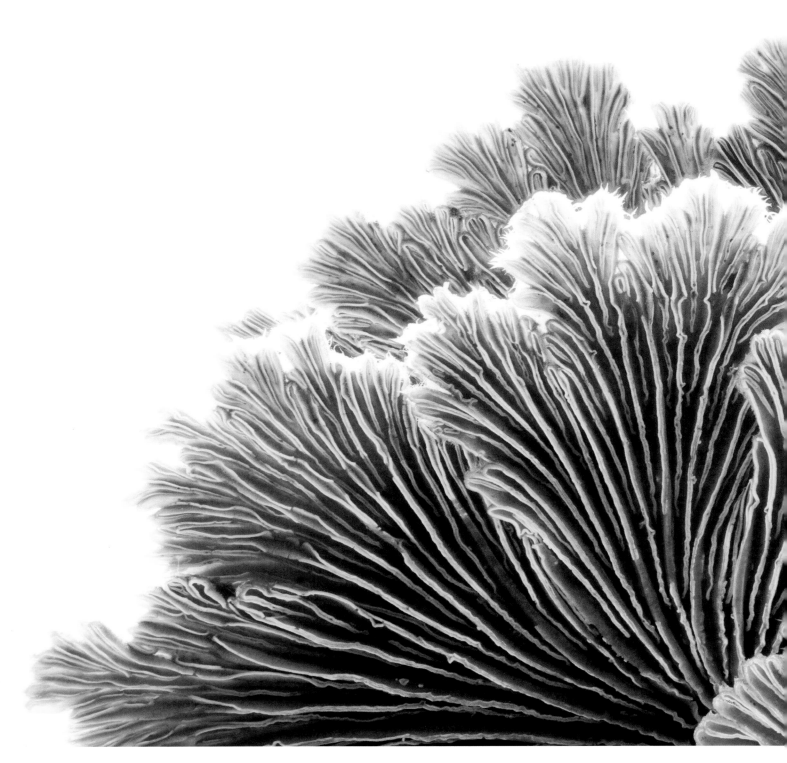

Splitgill | Spaltblättling *Schizophyllum commune*

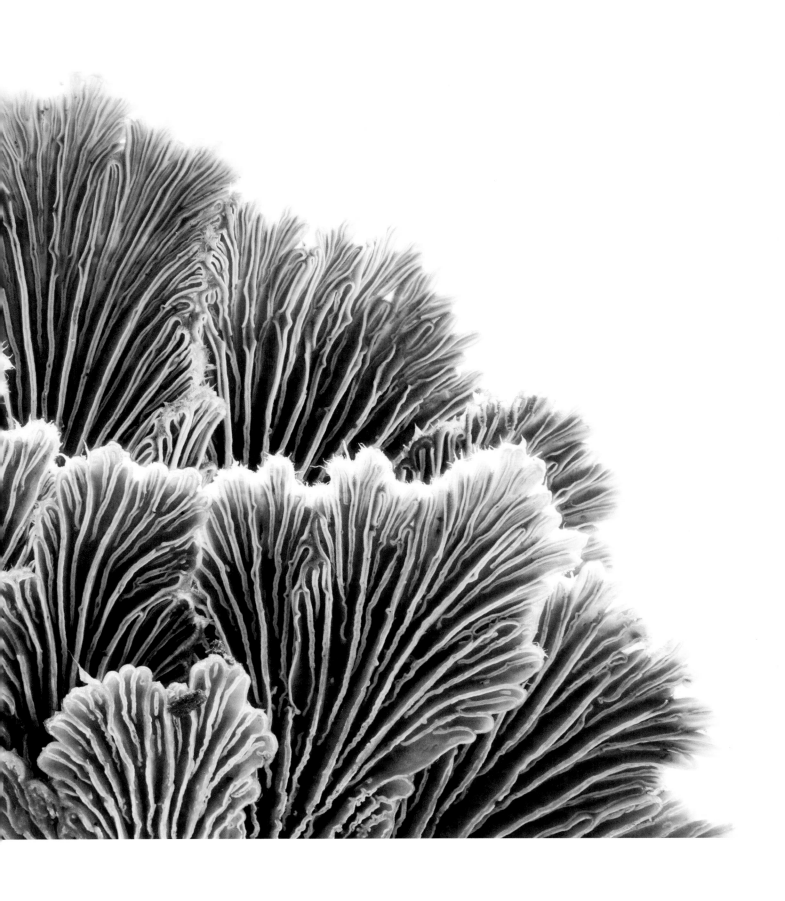

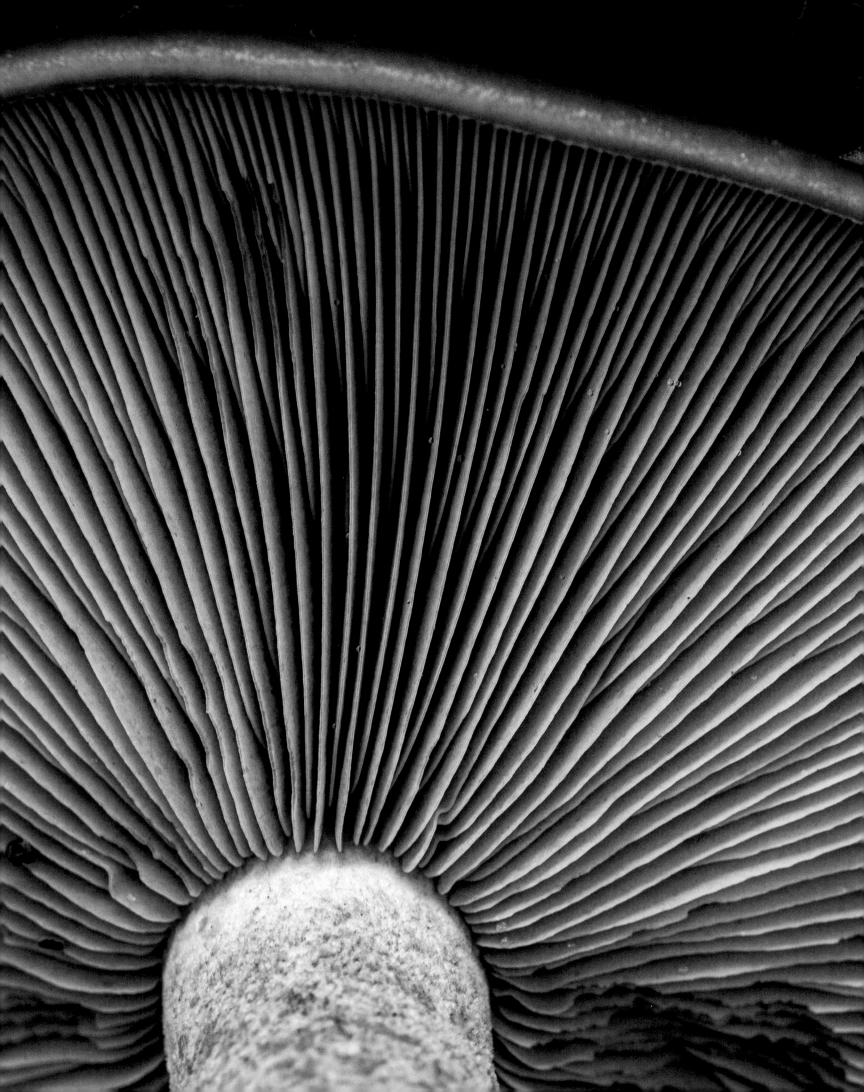

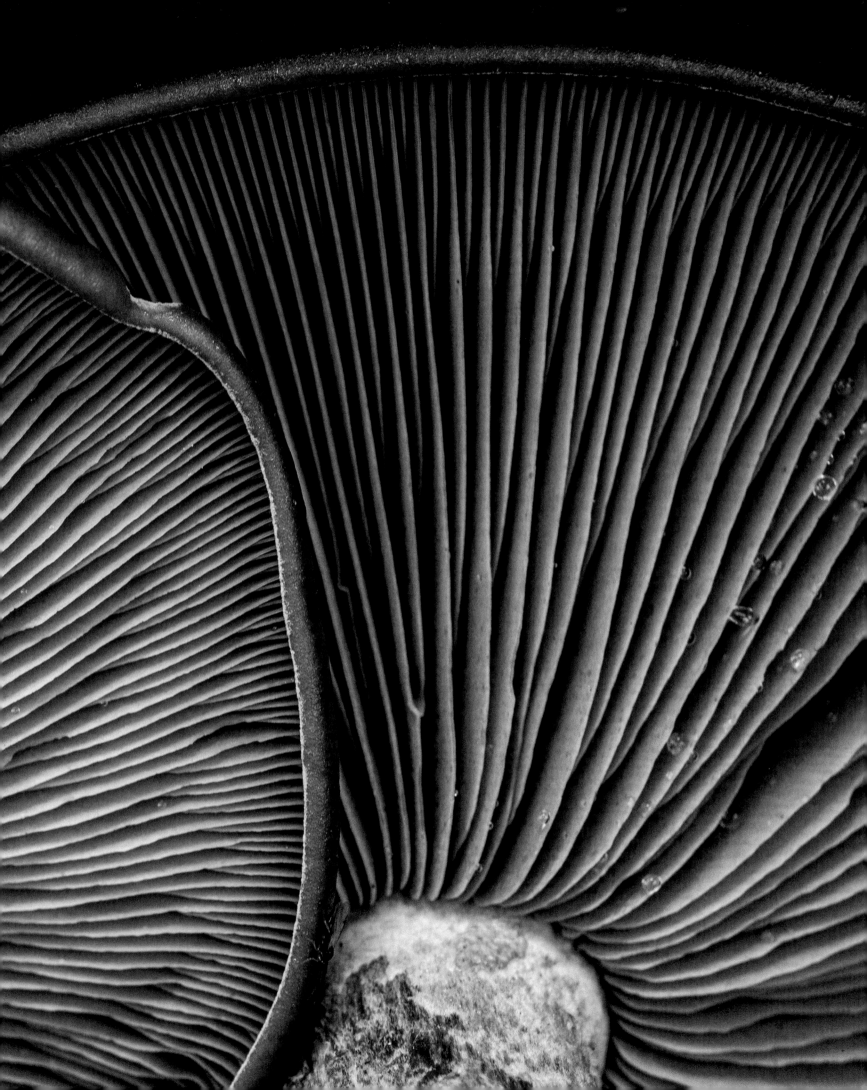

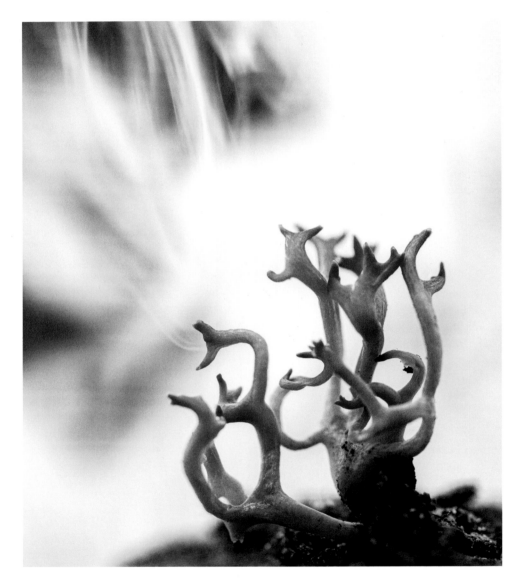

Lilac coral | Violette Zwergkoralle *Ramariopsis pulchella*

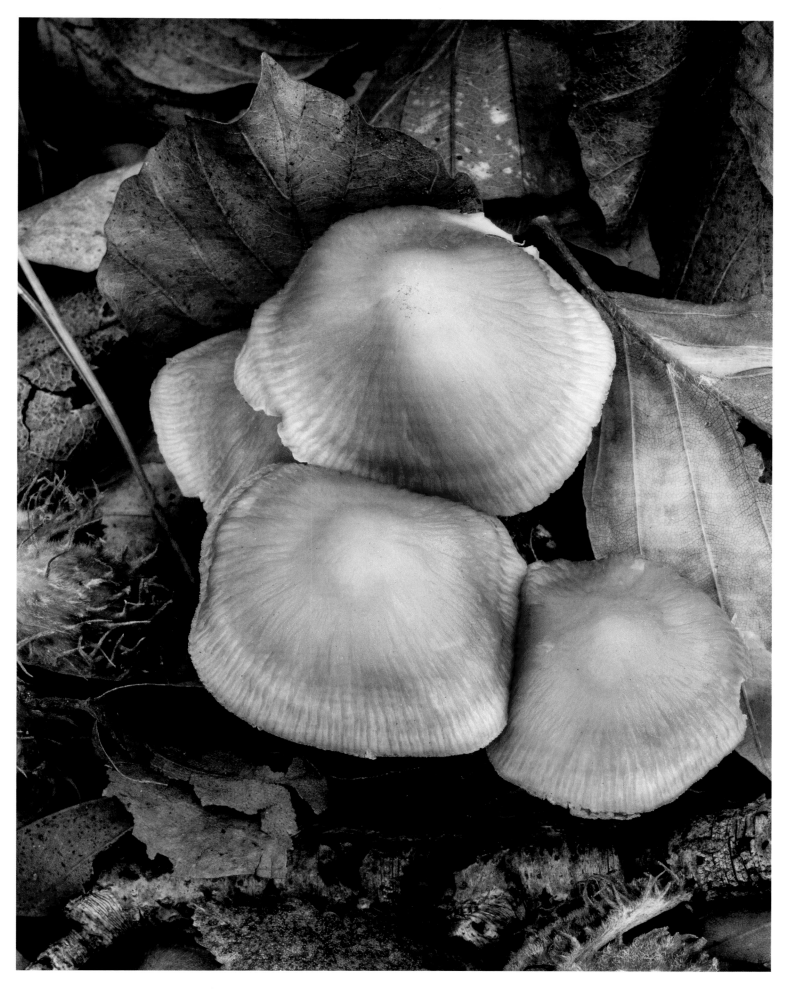

Rosy bonnet | Rosa Rettich-Helmling *Mycena rosea*

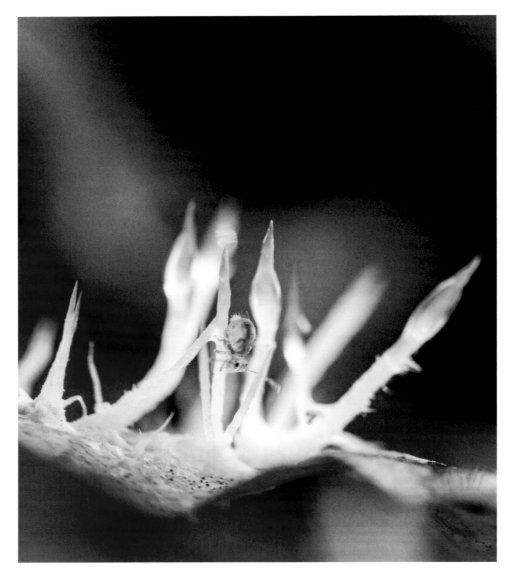

Mycelium threads with springtail | Myzel-Fäden mit Springschwanz

MEDICINAL
HEILKRAFT

The antibiotic penicillin is undoubtedly one of the most well-known medicines in the world and the most important scientific discovery of the twentieth century. Penicillin was discovered by chance on September 3rd, 1928 by British physician and scientist Alexander Fleming.

ALL OF A SUDDEN, MEDICAL PROFESSIONALS WERE ABLE TO PROPERLY TREAT INFECTIONS THAT HAD PREVIOUSLY BEEN UNTREATABLE

A few weeks prior to his major medical break-through, Fleming had started to culture bacteria in petri dishes in his laboratory. To his surprise, he found out that bacterial growth was significantly reduced in one of his glass dishes – and that dish had also grown a layer of mold, which prevented the bacteria from multiplying as intended. He repeated the experiment a number of times, with the same result on each occasion. He presented these groundbreaking results to a fungus specialist, and the mycologist quickly identified that the fungus in the petri dishes belonged to the genus Penicillium.

Years later, this discovery finally culminated in the launch of the antibiotic medicine we know today. When it became available for public use at the end of the Second World War, penicillin was hailed as a "wonder drug" and prevented an enormous amount of suffering; all of a sudden, medical professionals were able to properly treat infections that had previously been untreatable. Their patients' prospects of survival increased significantly – and it was all thanks to a simple mold. Conservative estimates suggest that penicillin and related antibiotics have saved more than two-hundred million lives. Interest in

Eines der bekanntesten Medikamente und die wichtigste Entdeckung des 20. Jahrhunderts ist zweifellos das Antibiotikum Penicillin. Es wurde am 3. September 1928 durch Zufall vom britischen Arzt und Forscher Alexander Fleming entdeckt.

Einige Wochen vor seinem großen medizinischen Durchbruch hatte Fleming in seinem Labor begonnen, Bakterien in Petrischalen zu züchten. Zu seiner Überraschung stellte er fest, dass das Bakterienwachstum in einer seiner Glasschalen deutlich reduziert war – und in dieser Schale hatte sich zudem eine Schimmelschicht gebildet, die die Bakterien daran hinderte, sich wie vorgesehen zu vermehren. Er wiederholte das Experiment mehrere Male mit demselben Ergebnis. Diese bahnbrechende Entdeckung legte er einem Mykologen vor und der Pilzexperte konnte schnell feststellen, dass der Pilz in der besagten Laborschale zur Gattung Penicillium gehörte. Jahre später gipfelte diese Entdeckung schließlich in der

PLÖTZLICH WAREN DIE MEDIZINER IN DER LAGE, INFEKTIONEN, DIE ZUVOR UNBEHANDELBAR WAREN, ZU BEKÄMPFEN

Einführung der heute bekannten antibiotischen Medizin. Als es am Ende des Zweiten Weltkriegs der Öffentlichkeit zur Verfügung stand, wurde Penicillin als „Wundermittel" gepriesen und verhinderte enormes Leid; plötzlich waren die Mediziner in der Lage, Infektionen, die zuvor unbehandelbar waren, zu bekämpfen. Die Überlebenschancen von Patienten stiegen deutlich – dank eines einfachen kleinen Pilzes. Penicillin und verwandte Antibiotika haben nach vorsichtigen Schätzungen inzwischen mehr als zweihundert Millionen Menschenleben gerettet! Aus diesem Grund stehen Pilze weiterhin im Fokus der medizinischen Forschung. Auch in der westlichen Welt nimmt das

mushrooms and fungus in the medical world remains high, and Western medicine is slowly recognizing the benefits of mushrooms in medicinal applications. Scientists are increasingly conducting high-level research into the effects of the active substances found in mushrooms. In Asia, this process has been ongoing for centuries – perhaps because Asian cultures are more closely connected to nature.

Scientists are hopeful that substances found in the common butter waxcap could inhibit the growth of some cancer cells, while substances extracted from Phellinus mushrooms could help to combat breast cancer. Around the world, scientists are on a quest to find new applications for mushrooms – applications that may be just as groundbreaking as the discovery of penicillin almost a century ago.

Interesse an der medizinischen Anwendung langsam zu. Immer mehr Wissenschaftler befassen sich intensiv mit den Wirkmechanismen der in Pilzen enthaltenen Stoffe. In Asien werden die Kräfte der Pilze schon seit vielen Jahrhunderten genutzt, möglicherweise da man dort grundsätzlich ein engeres Verhältnis zur Natur pflegt.

Hoffnungsvoll stimmt die Entdeckung, dass Substanzen aus der Schmetterlings-Tramete das Wachstum bestimmter Krebszellen vermindern können. Außerdem können Stoffe aus dem Gemeinen Feuerschwamm möglicherweise gegen Brustkrebs eingesetzt werden. Wissenschaftler auf der ganzen Welt sind auf der Suche nach Anwendungsmöglichkeiten für Pilze –Anwendungen, die ebenso bahnbrechend sein könnten wie die Entdeckung des Penicillins vor fast einem Jahrhundert.

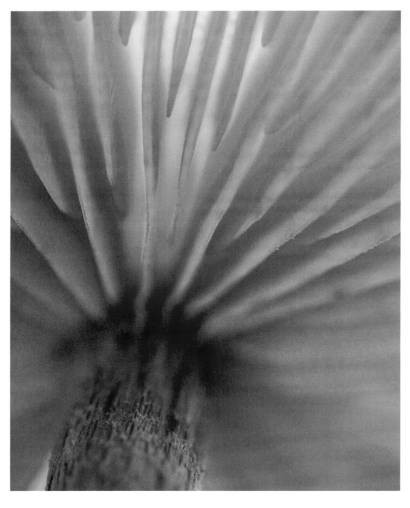

This page: **Deceiver** | Diese Seite: **Rötlicher Lacktrichterling** *Laccaria laccata*
Right page: **Saffrondrop bonnet** | Rechte Seite: **Orangemilchender Helmling** *Mycena crocata*

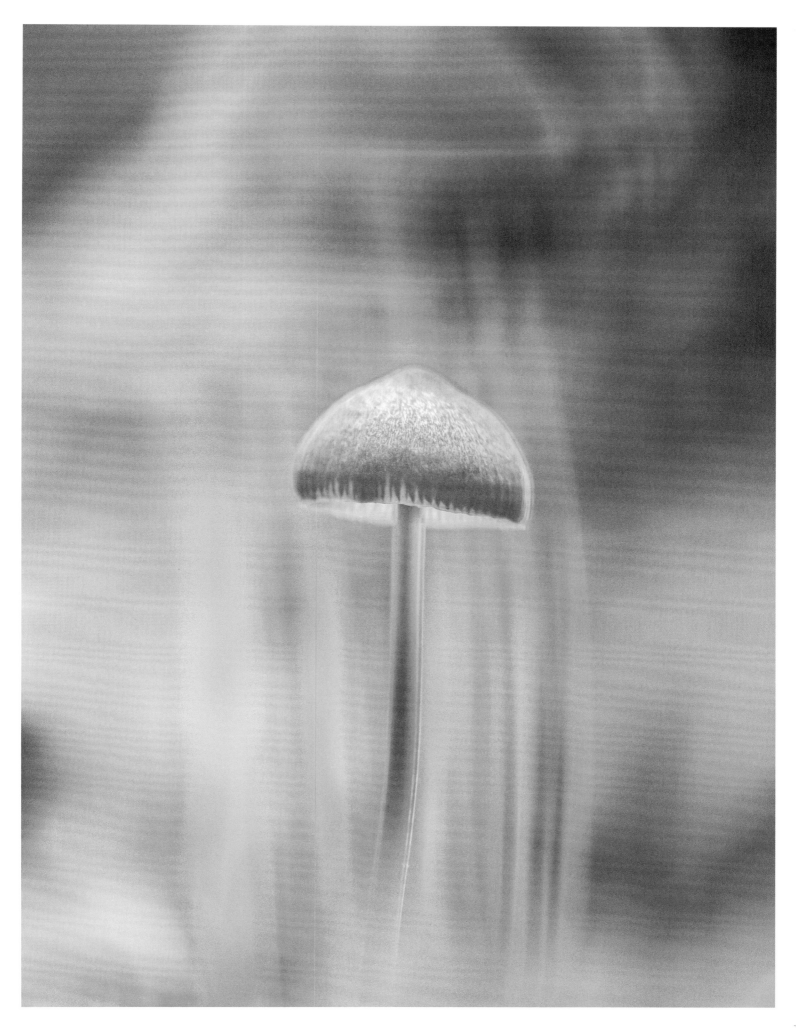

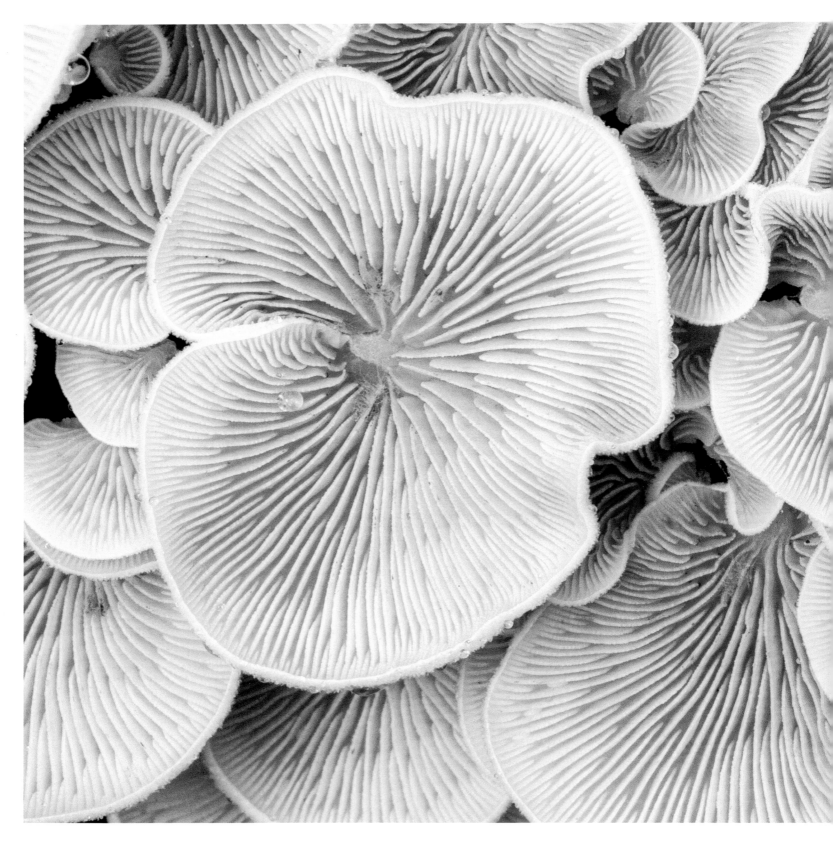

Variable oysterling | Gemeines Stummelfüsschen *Crepidotus variabilis*

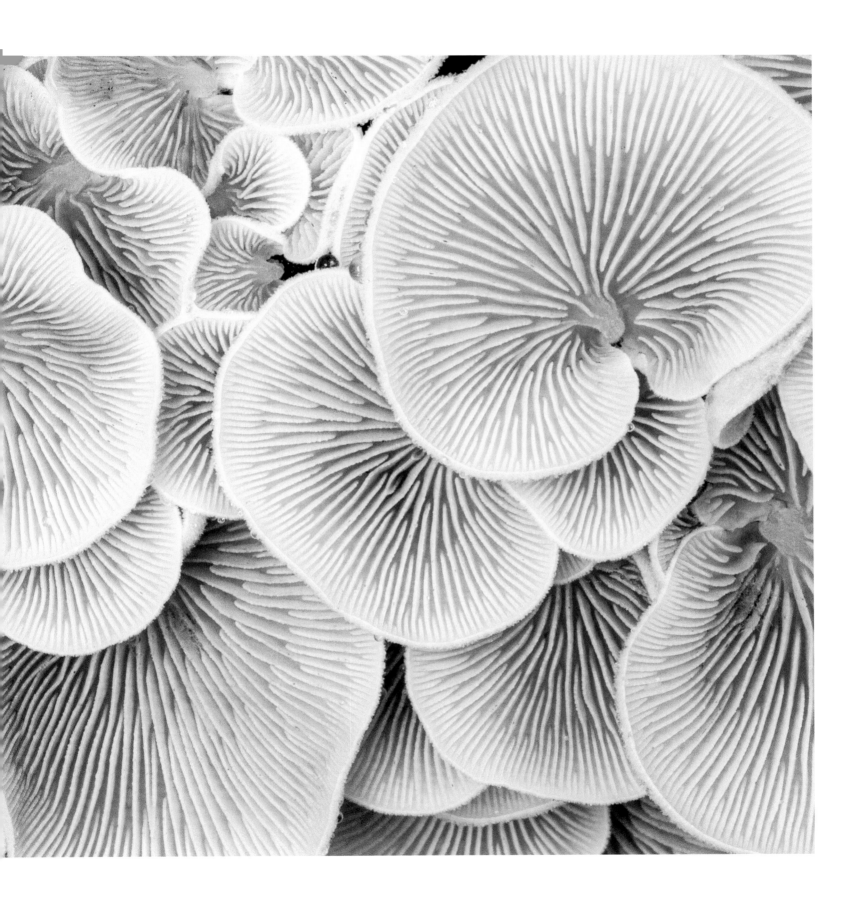

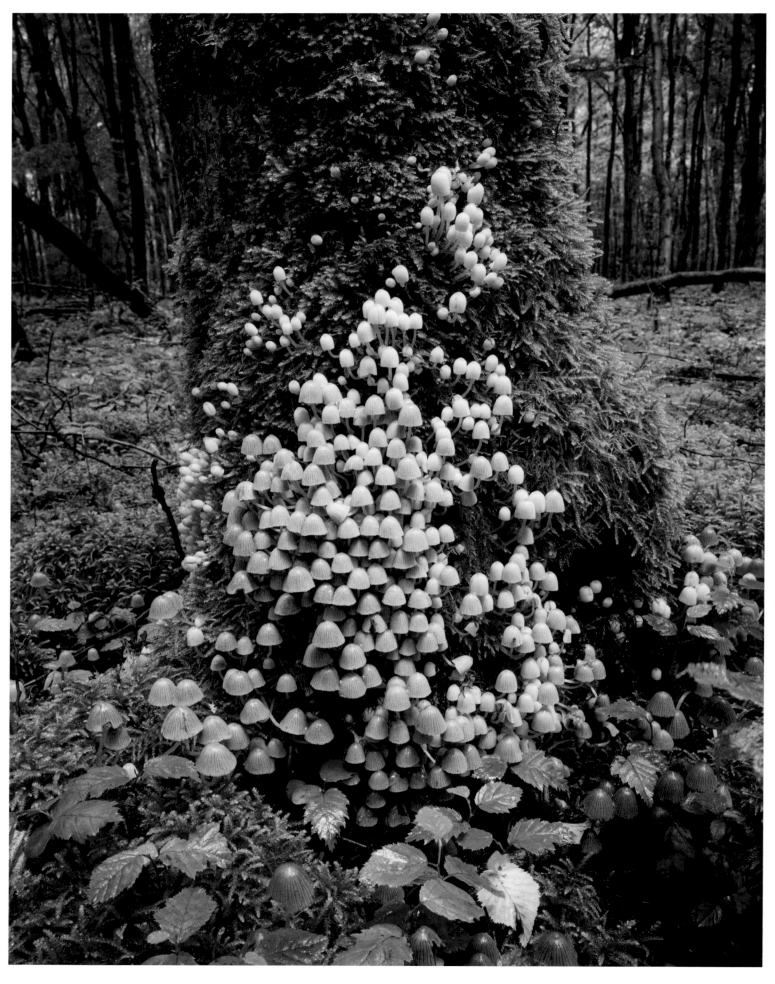

Fairy inkcap | Gesäter Tintling *Coprinellus disseminatus*

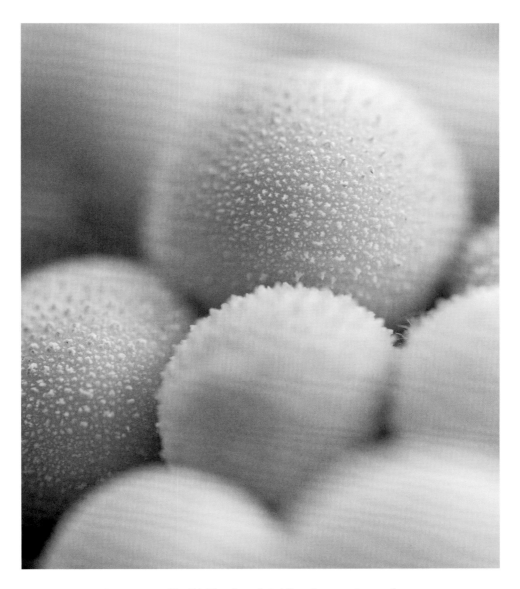

Common puffball | Flaschen-Stäubling *Lycoperdon perlatum*

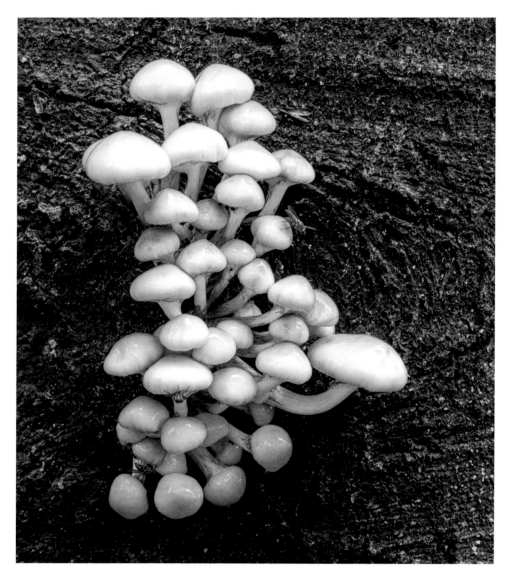

Porcelain fungus | Beringter Schleimrübling *Oudemansiella mucida*

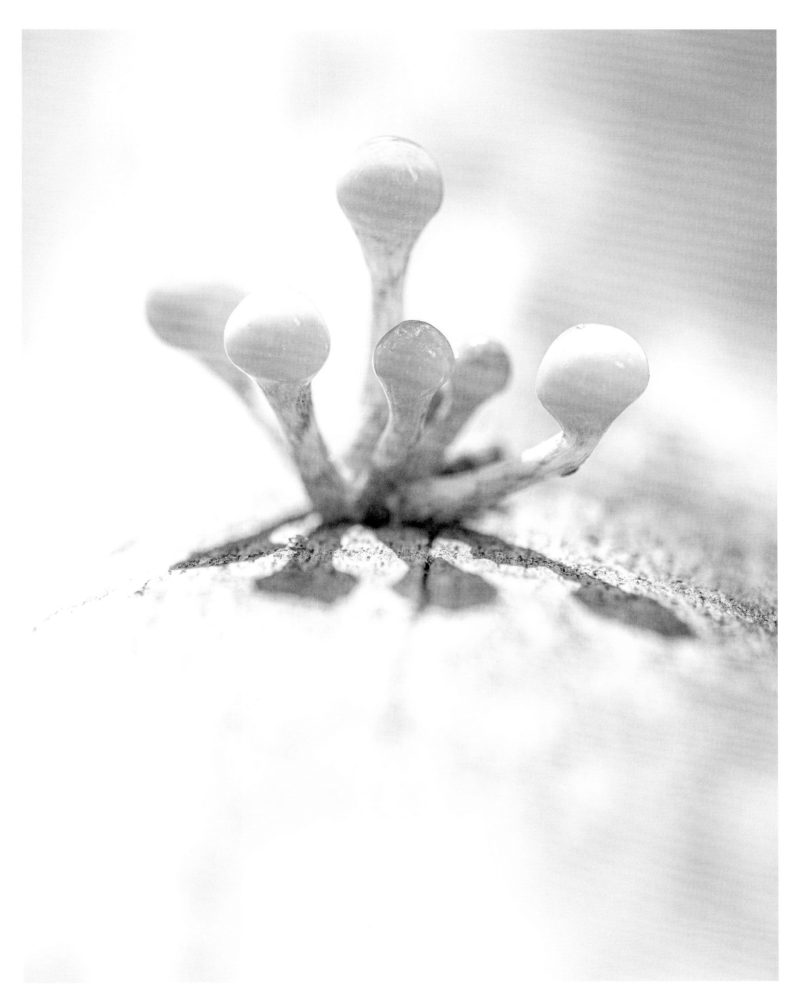

Porcelain fungus | Beringter Schleimrübling *Oudemansiella mucida*

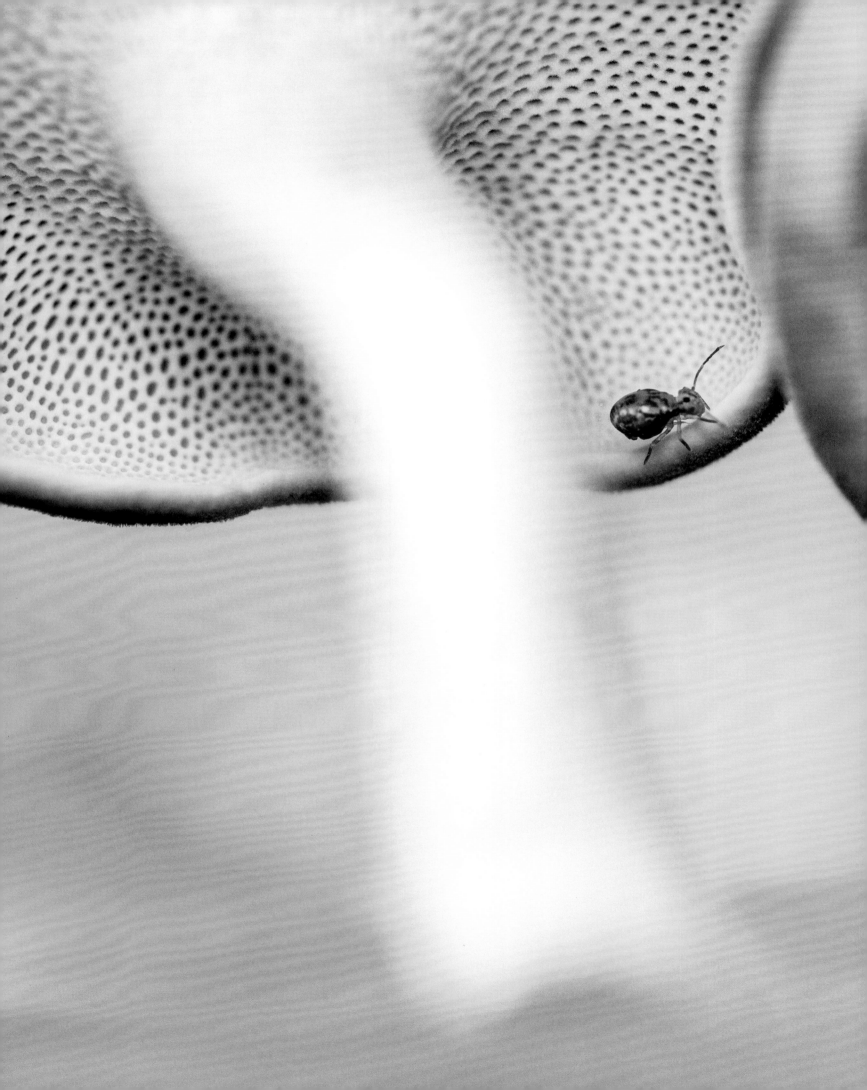

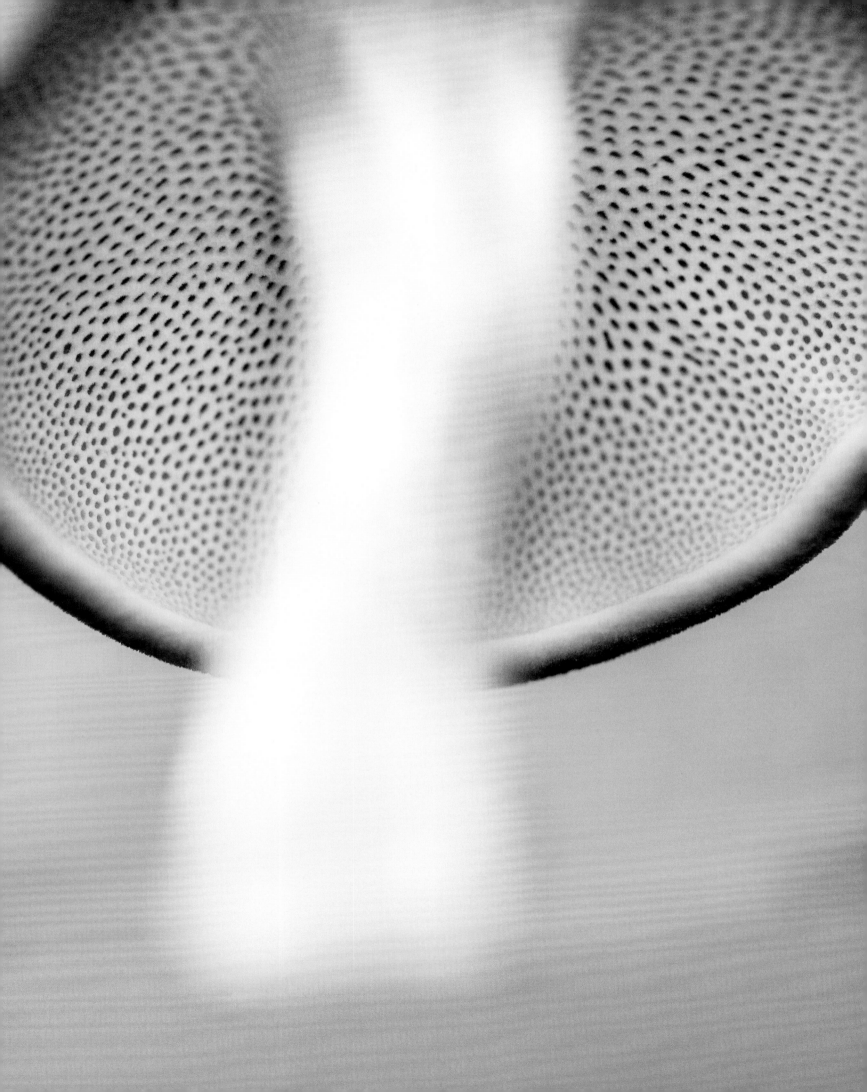

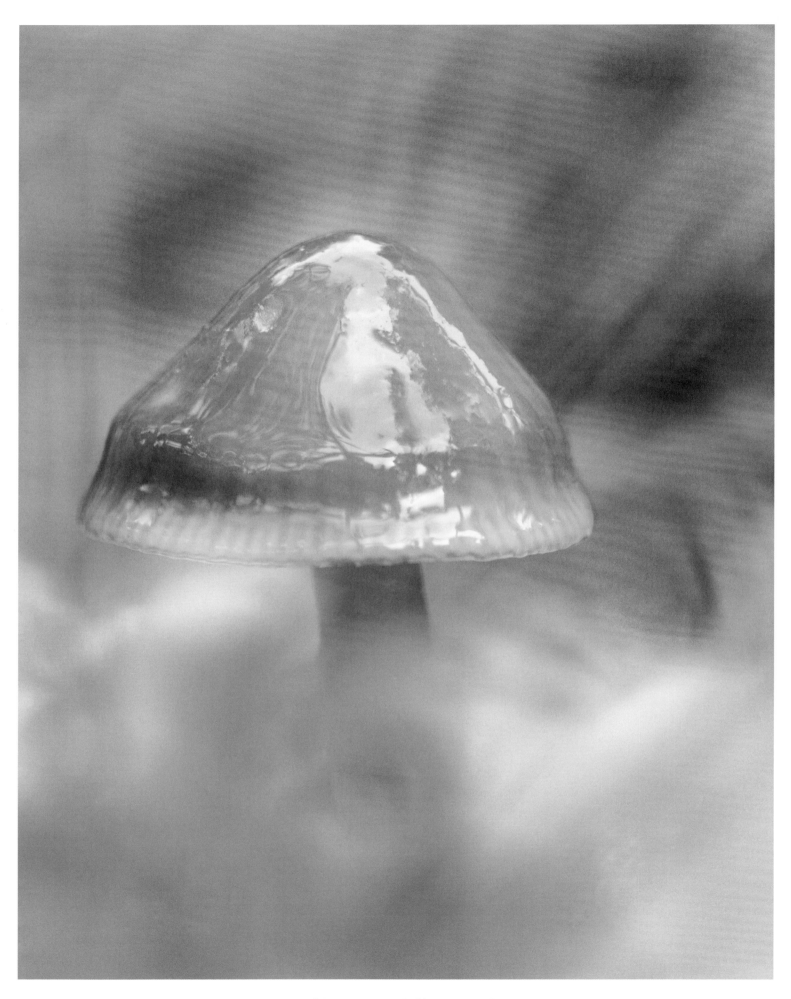

Parrot waxcap | Papageigrüner Saftling *Hygrocybe psittacina*

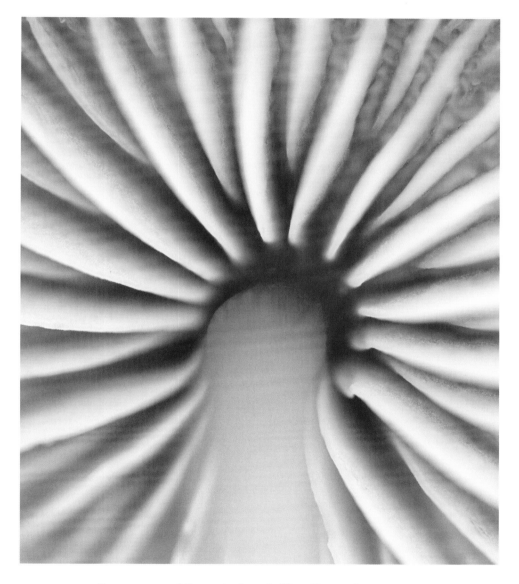

Parrot waxcap | Papageigrüner Saftling *Hygrocybe psittacina*

Previous page: **Springtail and winter polypore** | Vorherige Seite: **Winterporling mit Springschwanz** *Polyporus brumalis*

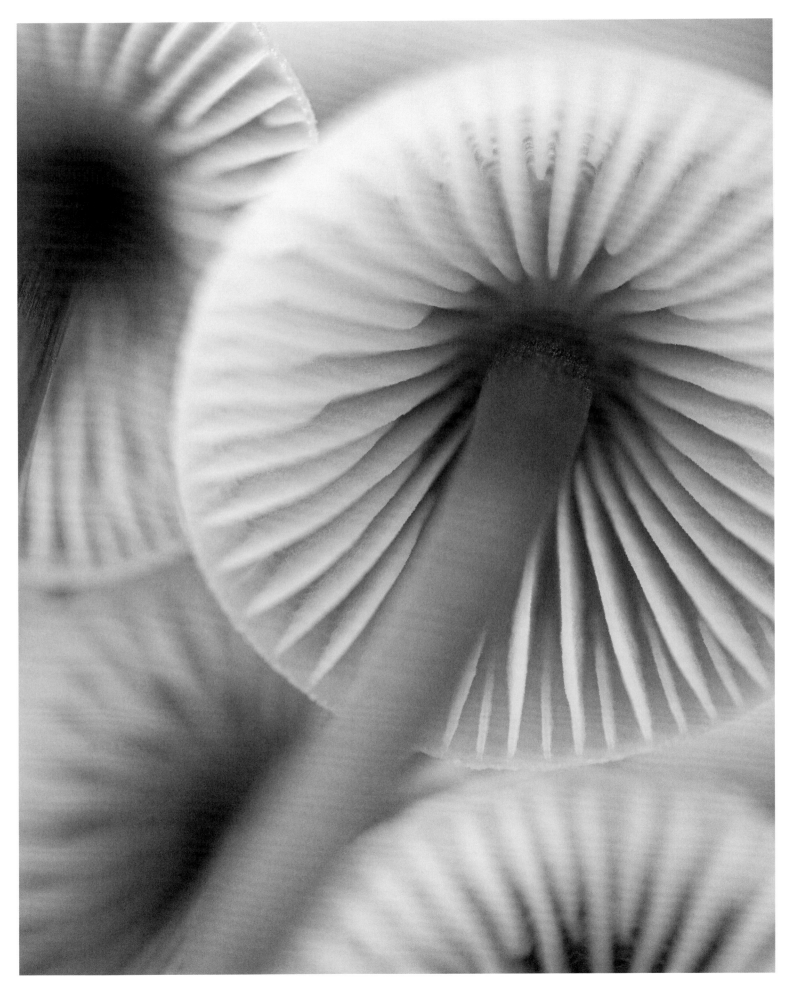

Angel's bonnet | Olivgrauer Helmling *Mycena arcangeliana*

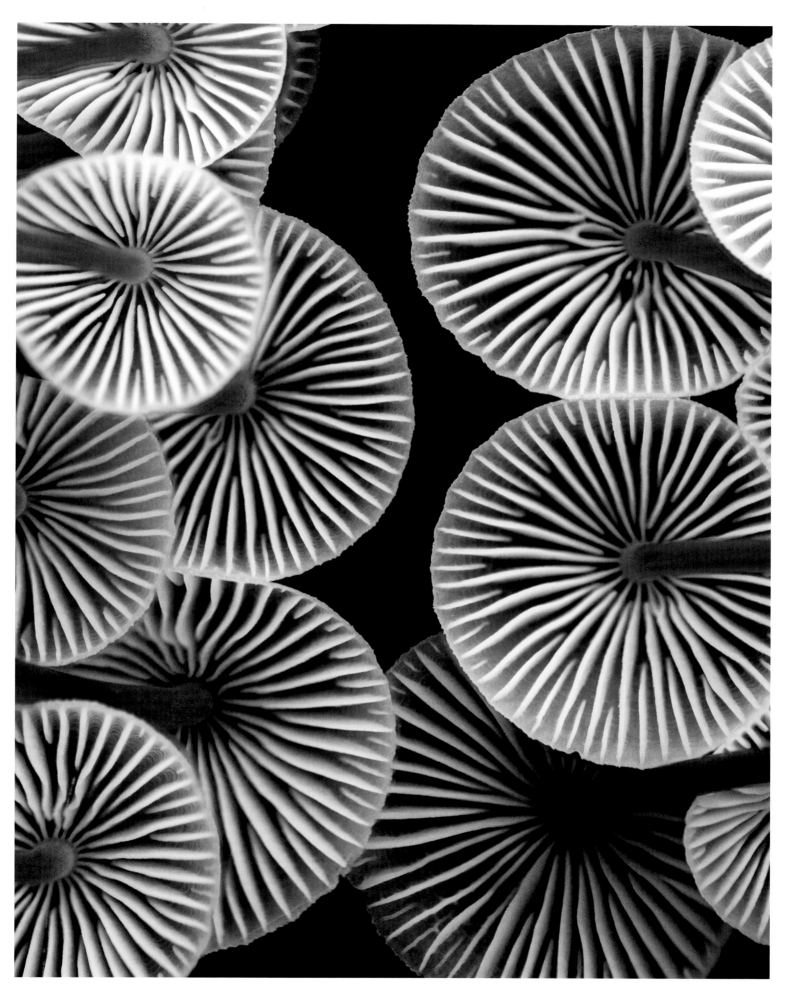

Angel's bonnet | Olivgrauer Helmling *Mycena arcangeliana*

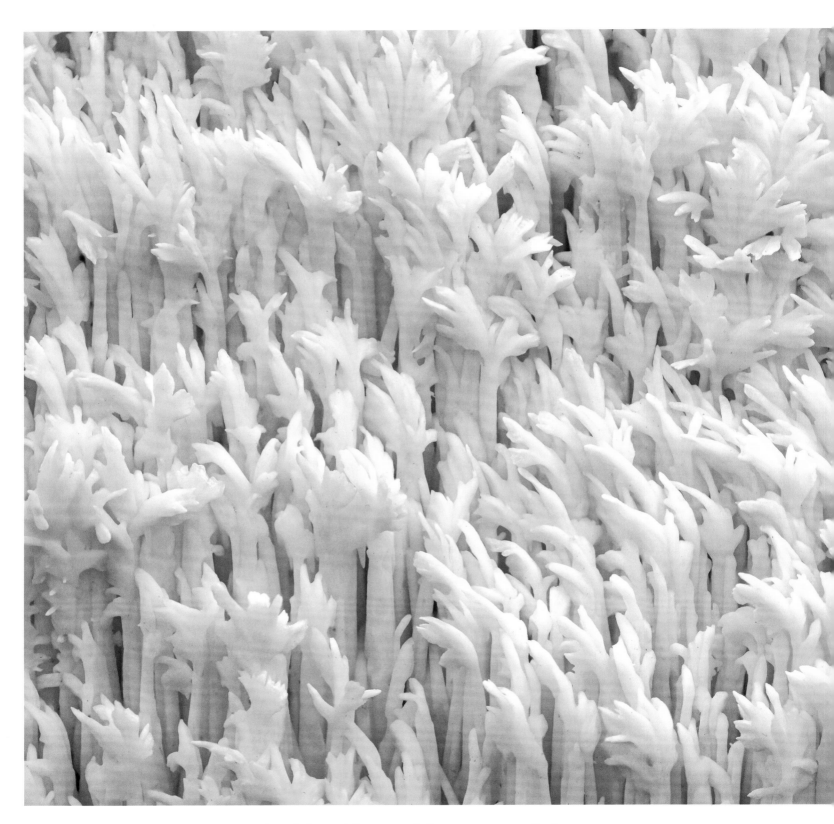

Coral tooth fungus | Ästiger Stachelbart *Hericium coralloides*

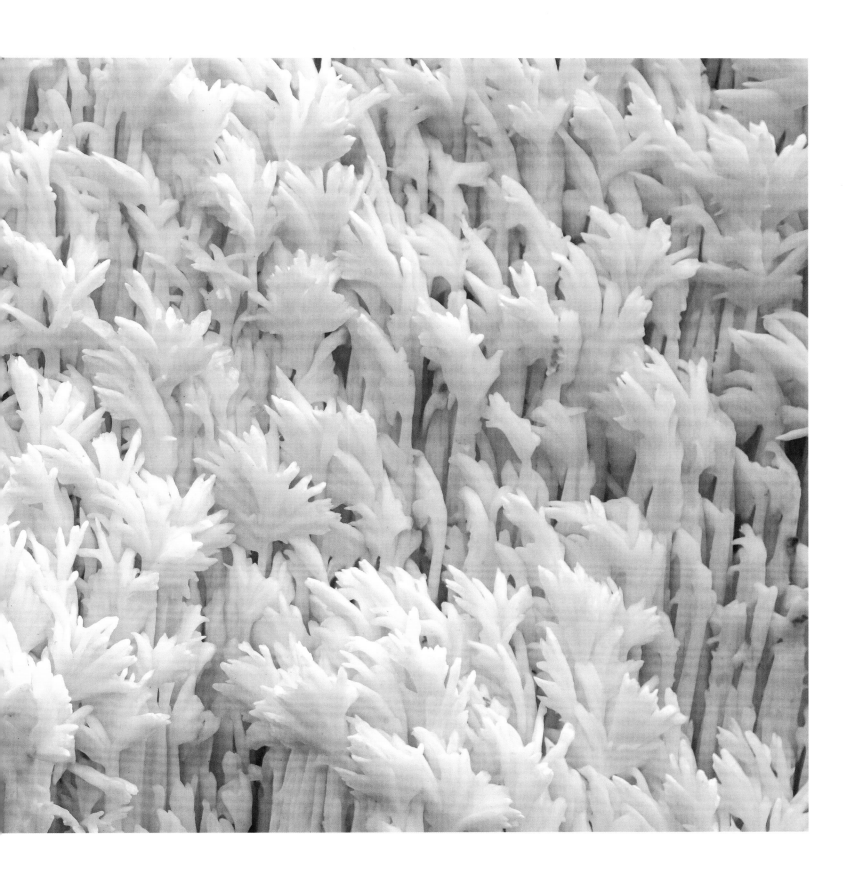

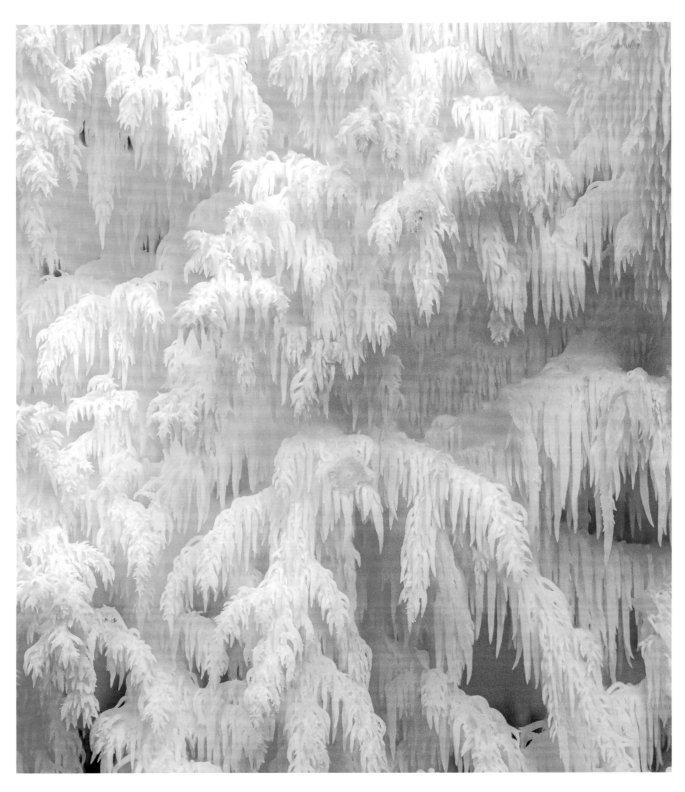

Coral tooth fungus | Ästiger Stachelbart *Hericium coralloides*

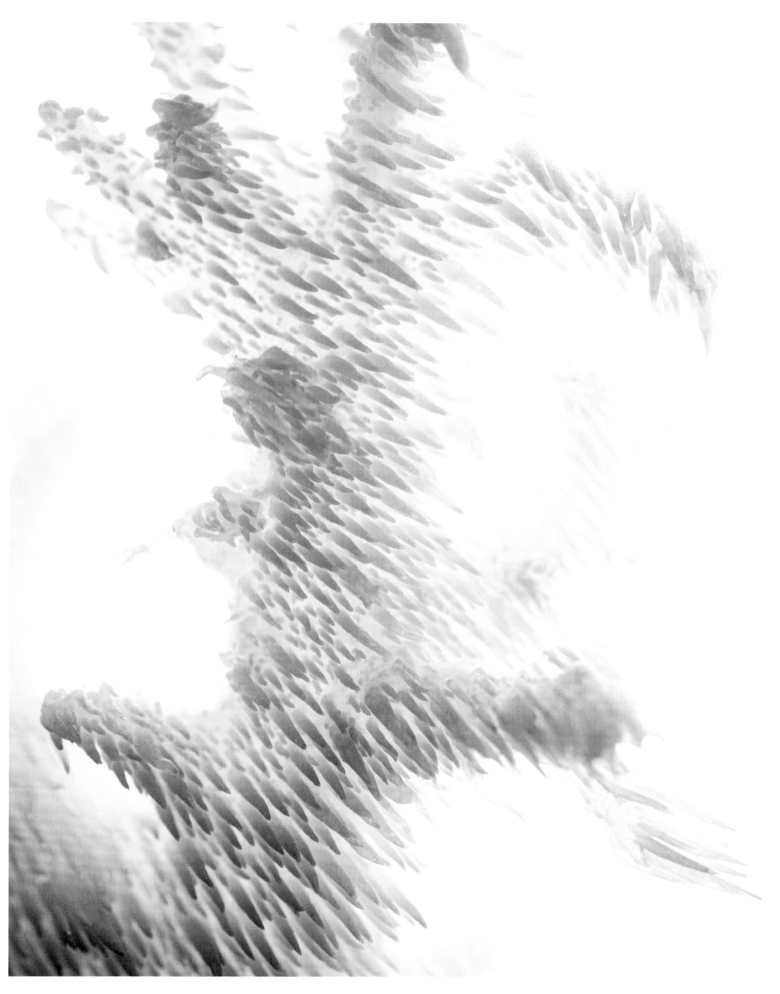

Coral tooth fungus | Ästiger Stachelbart *Hericium coralloides*

Ceratiomyxa porioides | Weißes Netzpolster *Ceratiomyxa porioides*

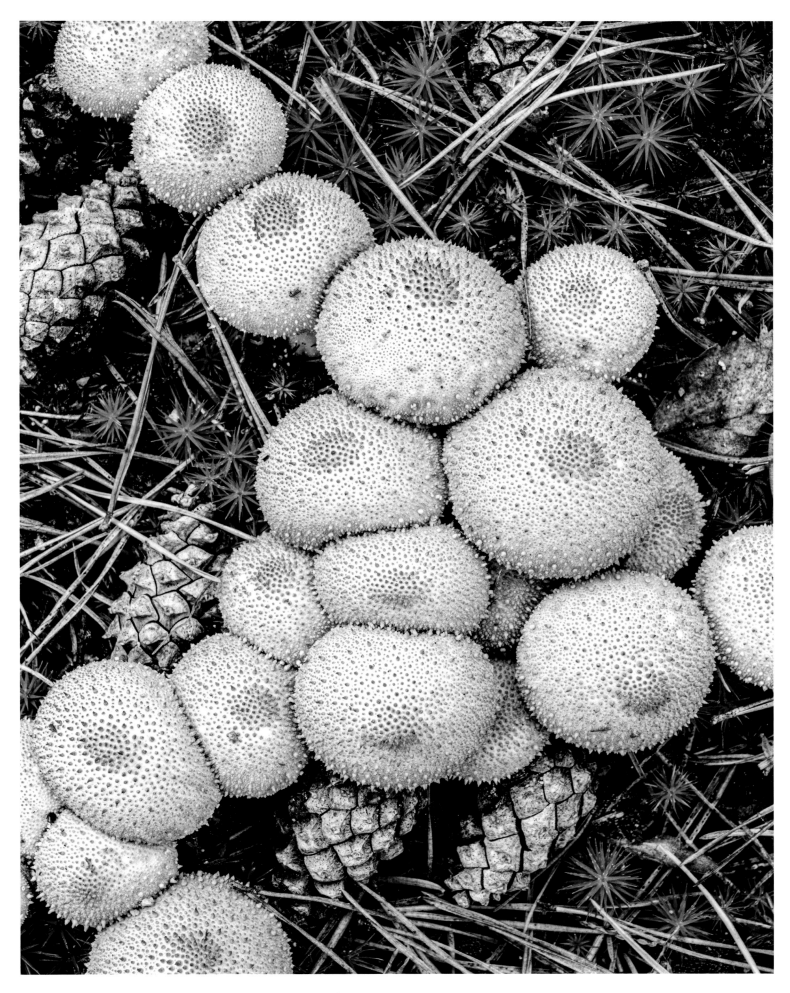

Common puffball | Flaschen-Stäubling *Lycoperdon perlatum*

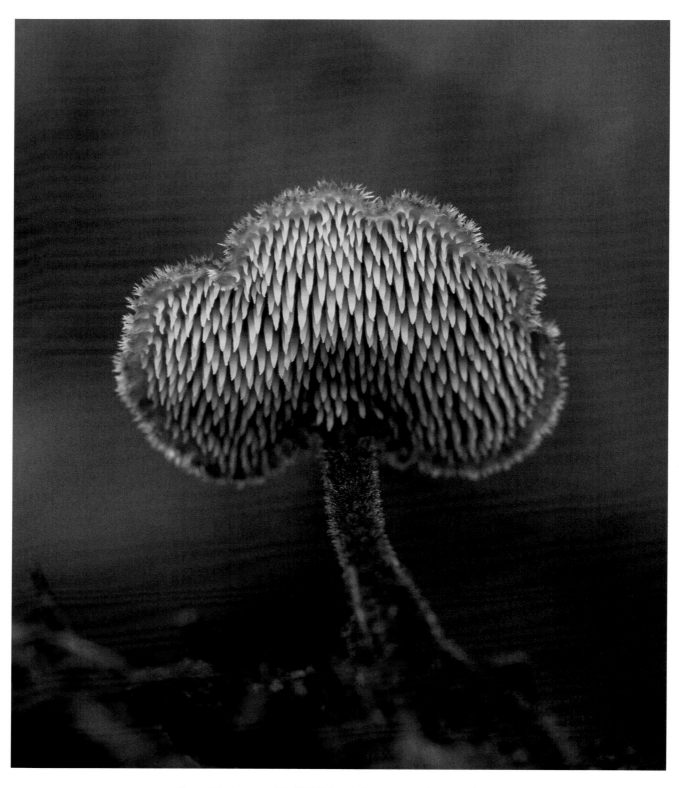

Ear-pick fungus | Ohrlöffel-Stacheling *Auriscalpium vulgare*

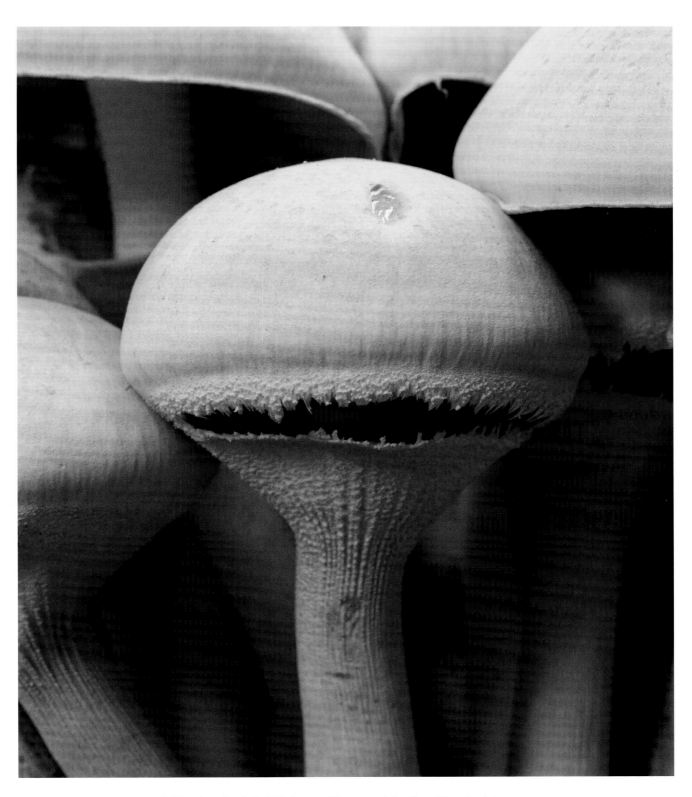

Golden bootleg | Goldfarbener Glimmerschüppling *Phaeolepiota aurea*

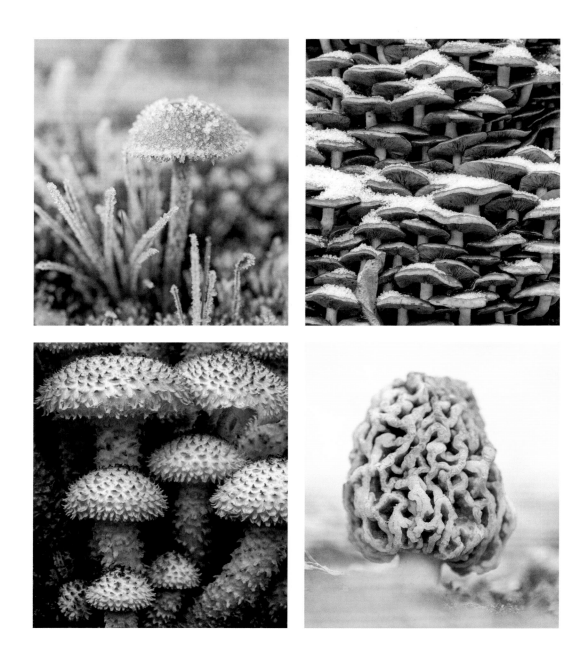

From top left to bottom right | Von links oben nach rechts unten:

Deceiver | Rötlicher Lacktrichterling *Laccaria laccata* / Sulfur tuft | Grünblättriger Schwefelkopf *Hypholoma fasciculare*
Shaggy scalycap | Sparriger Schüppling *Pholiota squarrosa* / Common morel | Gemeine Morchel *Morchella vulgaris*

KNOWLEDGE
ARTENKENNTNIS

As I dived deeper into the world of mushrooms, I expanded my knowledge by studying books and online resources dedicated to this fascinating topic. I was determined to find out why mushrooms are so important and how the individual varieties differ.

As a photographer, I also had the challenge of tracking down specific types of mushroom. Locating mushrooms isn't always difficult: arming yourself with just a little knowledge of different types of soil will help enormously. Morels, for

THE NETHERLANDS ARE HOME OF MORE THAN 6,000 IDENTIFIED SPECIES OF MUSHROOMS

example, grow in sandy dunes; you'd be unlikely to find them in the woodland around my home in Hoenderloo. Sometimes, the name of a mushroom – like Psathyrella typhae, whose common name in Dutch is the "lisdoddefranjehoed" – tells you everything you need to know about its habitat; in this case, the mushroom grows on "lisdodde", or bulrushes. But names can also be misleading: the common earthball, known in Dutch as an "aardappelbovist" ("aardappel" means "potato"), is so called not because of its location, but because it resembles a potato.

The shell-covered paths sometimes found in the Netherlands provide the perfect conditions for a whole other set of varieties: lime-rich soil is an outstanding source of nutrition for calcicolous mushrooms, so you could easily come across a mushroom that normally grows in lime-rich sand dunes alongside a disused shell-covered cycle track in Drenthe or the Veluwe region. Even though shell paths have now virtually disappeared from the landscape, the residues of the shells remain in the ecosystem – just like the mushrooms that feed off them.

Als ich tiefer in die Welt der Pilze eintauchte, erweiterte ich mein Wissen durch das Studium von Büchern und Online-Quellen zu diesem faszinierenden Thema. Ich wollte unbedingt herausfinden, warum Pilze so wichtig sind und wie sich die einzelnen Sorten unterscheiden.

Für mich als Fotografen stellte sich vor allem die Frage, wie und wo ich eine bestimmte Art finden kann. Das Auffinden von Pilzen ist tatsächlich nicht immer schwierig: Ein wenig Wissen über die verschiedenen Bodentypen hilft ungemein. Morcheln wachsen beispielsweise in Sanddünen, die man in den Wäldern um meine Heimatstadt Hoenderloo nicht so leicht findet. Manchmal verrät schon der Name, wo der Pilz wächst, zum Beispiel beim Schilfmürbling. Der Kartoffelbovist hingegen kommt nicht auf einem Kartoffelacker vor, sondern wird so genannt, weil er wie eine Kartoffel aussieht.

IN DEN NIEDERLANDEN GIBT ES MEHR ALS 6.000 IDENTIFIZIERTE PILZARTEN

Die in den Niederlanden manchmal vorkommenden Muschelpfade bieten perfekte Bedingungen für eine ganz andere Art von Pilzen: Kalkhaltige Böden sind eine hervorragende Nahrungsquelle für kalkliebende Pilze. So kann man in Drenthe oder in der Veluwe-Region an einem stillgelegten Muschelradweg leicht auf einen Pilz stoßen, der normalerweise in kalkhaltigen Sanddünen wächst. Auch wenn die Muschelwege inzwischen fast aus der Landschaft verschwunden sind, bleiben die Reste der Muscheln im Ökosystem erhalten – genau wie die Pilze, die sich von ihnen ernähren.

Steinpilze findet man oft auf alten Landgütern und auf Friedhöfen, wo der Boden weitgehend ungestört ist. Durch das

Bolete mushrooms can often be found on old country estates and in cemeteries where the ground is largely left undisturbed. The process of turning over the soil disrupts the growth of the mycelium, which is why you won't stumble across many mushrooms in farmed pastures and fields. However, pastures that have been left to nature offer much better chances for mushroom spotters. Rotting wood is another good place to look for many different species; branches, old tree trunks, and even thin twigs often play host to a number of different types of mushroom at once. Mushrooms don't just grow on plant substrates either; surprisingly, animal material can also play host to fungi. Cordyceps militaris, known in Dutch as the "rupsendoder" or "caterpillar killer", is just one example. This parasitic mushroom obtains nutrients from caterpillars and butterfly pupae, enabling it to form its 5- to 7-centimeter orange, slightly twisty and club-shaped fruiting bodies in grasslands.

The Netherlands are home of more than six thousand identified species of mushrooms. It's impossible to locate them all; doing so would require you to dedicate your entire life to the pursuit. But by expanding your knowledge and developing a real passion for the topic, you will soon be able to track down more mushrooms and get more enjoyment from this fascinating hobby.

Umgraben des Bodens wird das Wachstum des Myzels gestört, weshalb man auf bewirtschafteten Wiesen und Feldern nicht viele Pilze antrifft. Auf Weiden, die der Natur überlassen wurden, sind die Chancen für Pilzsucher dagegen viel besser. Viele Arten wachsen auch gerne auf verrottendem Holz. Auf Baumstümpfen, Stämmen und sogar dünnen Zweigen kann man oft mehrere Pilzarten gleichzeitig entdecken. Pilze wachsen nicht nur auf Pflanzennährböden, sondern auf wundersame Weise auch auf Material tierischen Ursprungs. Ein gutes Beispiel hierfür ist die Puppen-Kernkeule. Sie ist ein parasitärer Pilz, der sich von Schmetterlingsraupen und -puppen ernährt. Dieser orangefarbene, stäbchenförmige, etwas in sich gewundene Pilz, der etwa fünf bis sieben Zentimeter lang wird, kommt auf Wiesen vor.

In den Niederlanden gibt es mehr als sechstausend identifizierte Pilzarten. Es ist unmöglich, sie alle zu finden, denn dazu müsste man sein ganzes Leben der Suche widmen. Aber wenn Sie Ihr Wissen erweitern und eine echte Leidenschaft für das Thema entwickeln, werden Sie bald mehr Pilze aufspüren können und mehr Freude an diesem faszinierenden Hobby haben.

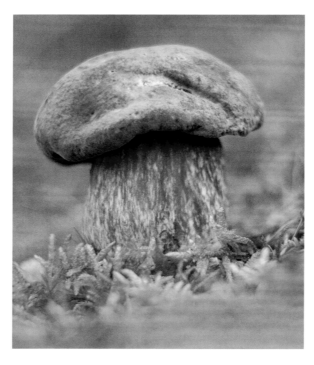

This page: **Scarletina bolete** | Diese Seite: **Flockenstieliger Hexenröhrling** *Neoboletus erythropus*

Right page: **Verdigris roundhead** | Rechte Seite: **Grünspanträuschling** *Stropharia aeruginosa*

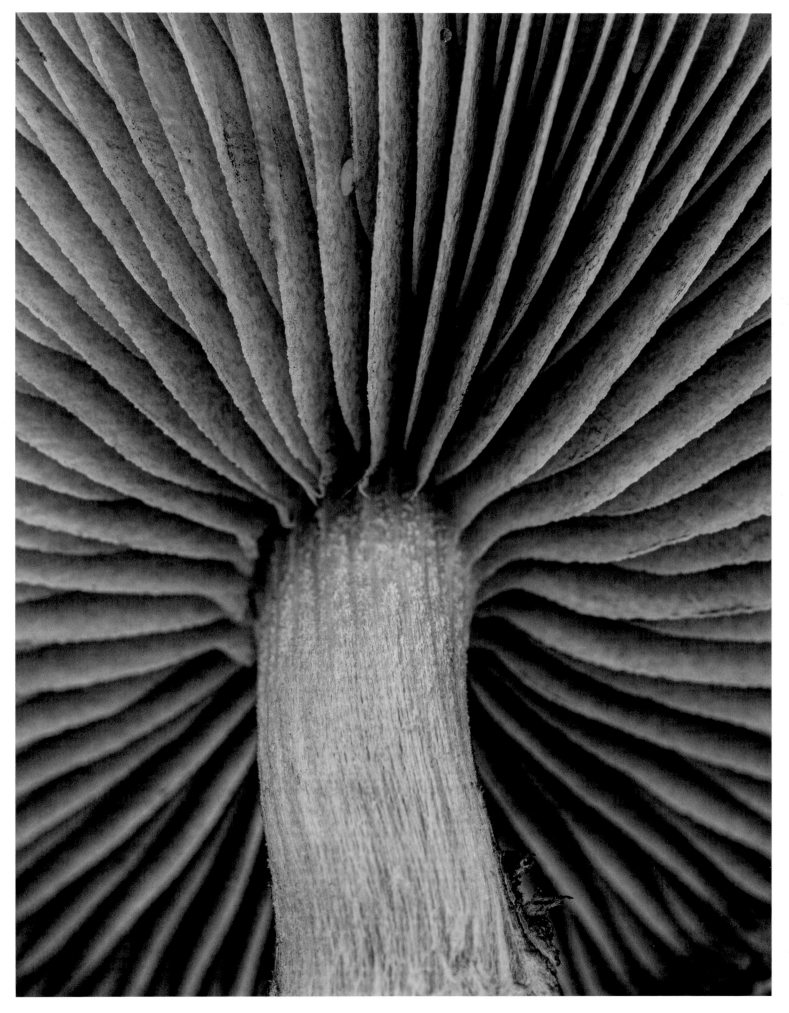

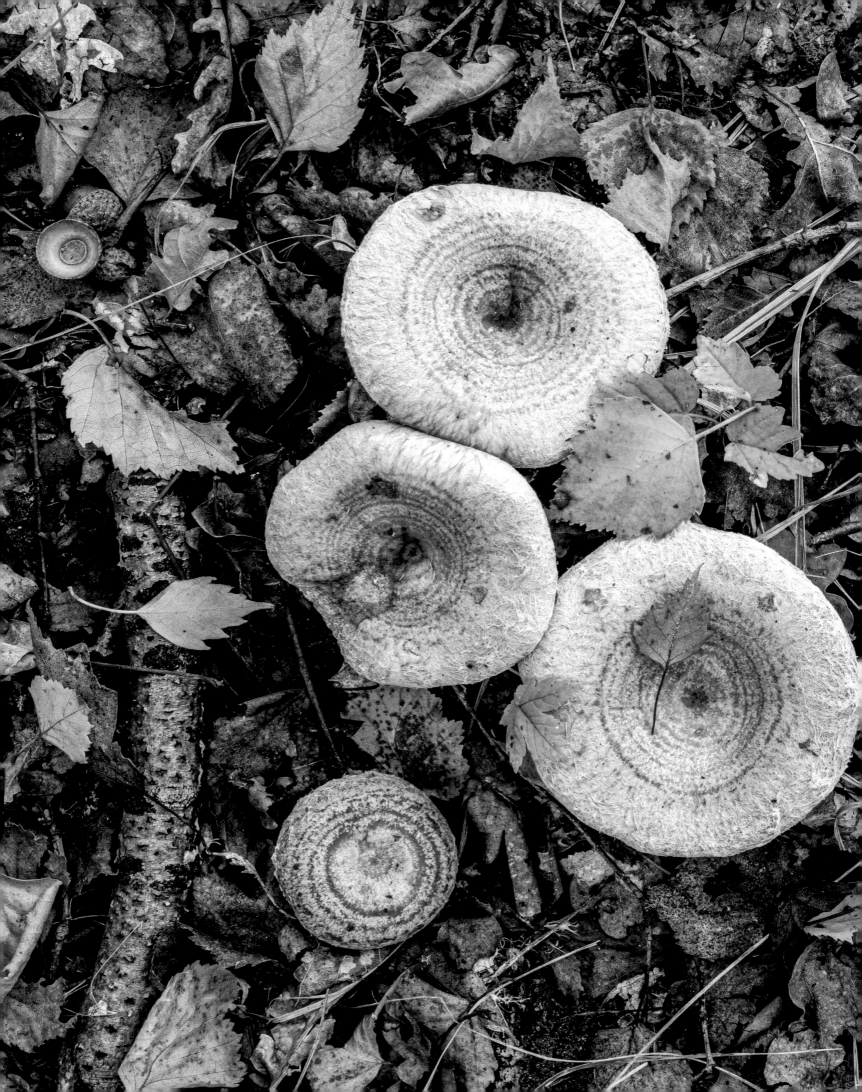

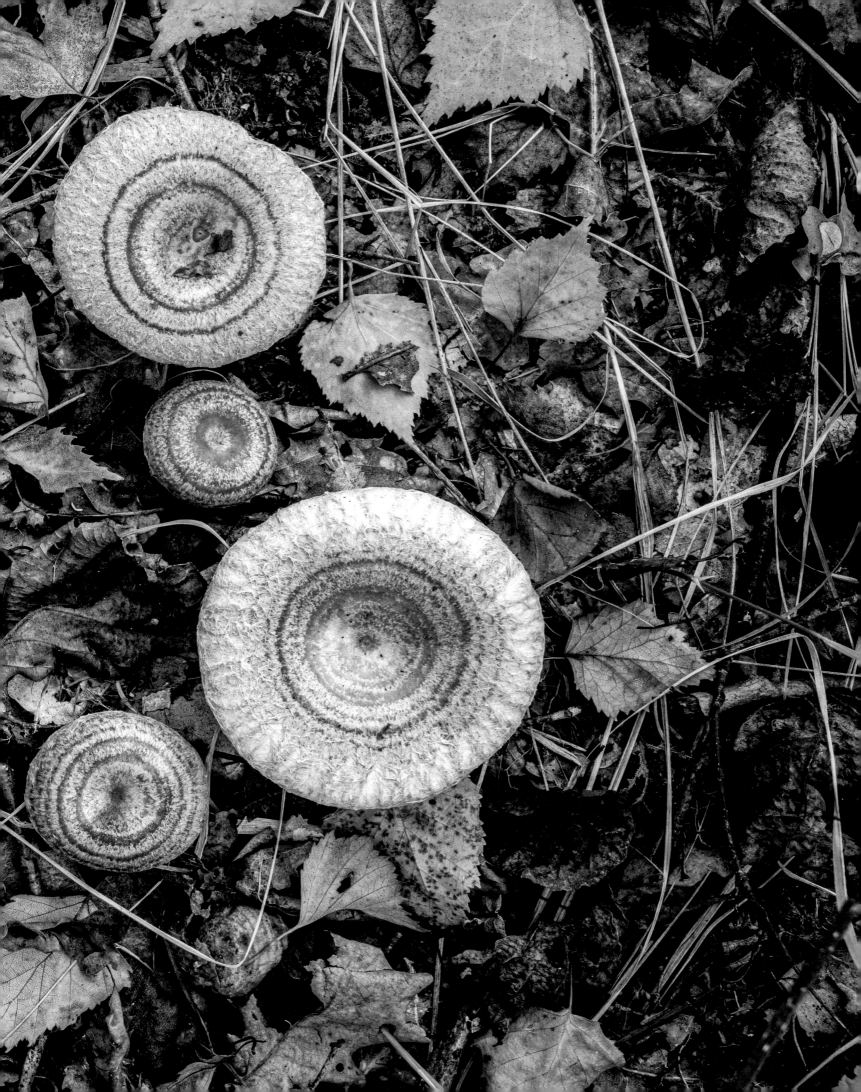

Common earthball | **Dickschaliger Kartoffelbovist** *Scleroderma citrinum*

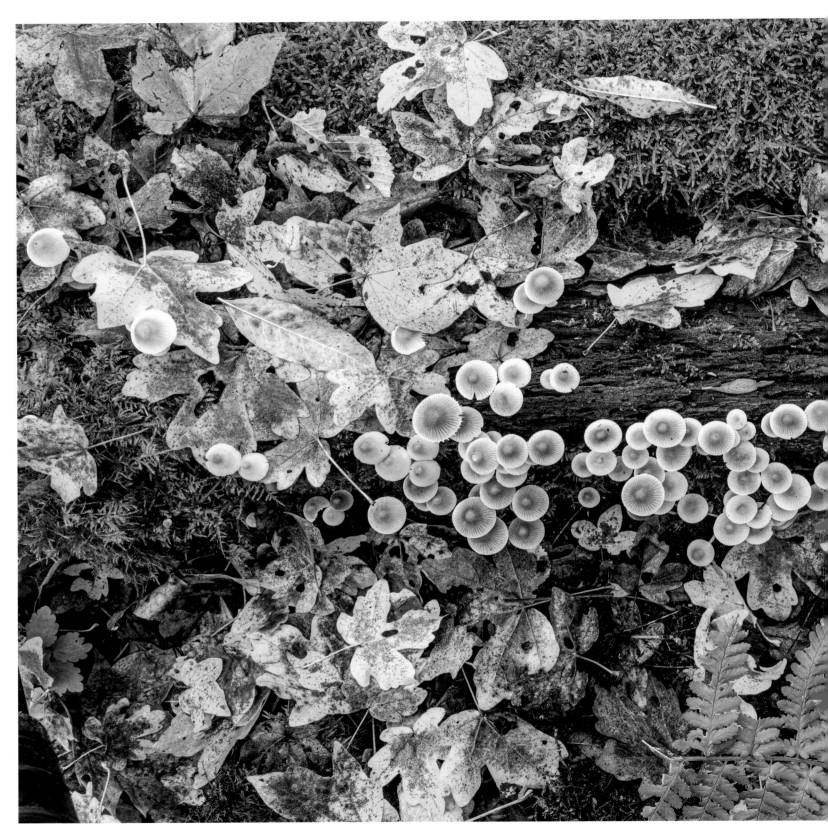

Angel's bonnet | Olivgrauer Helmling *Mycena arcangeliana*

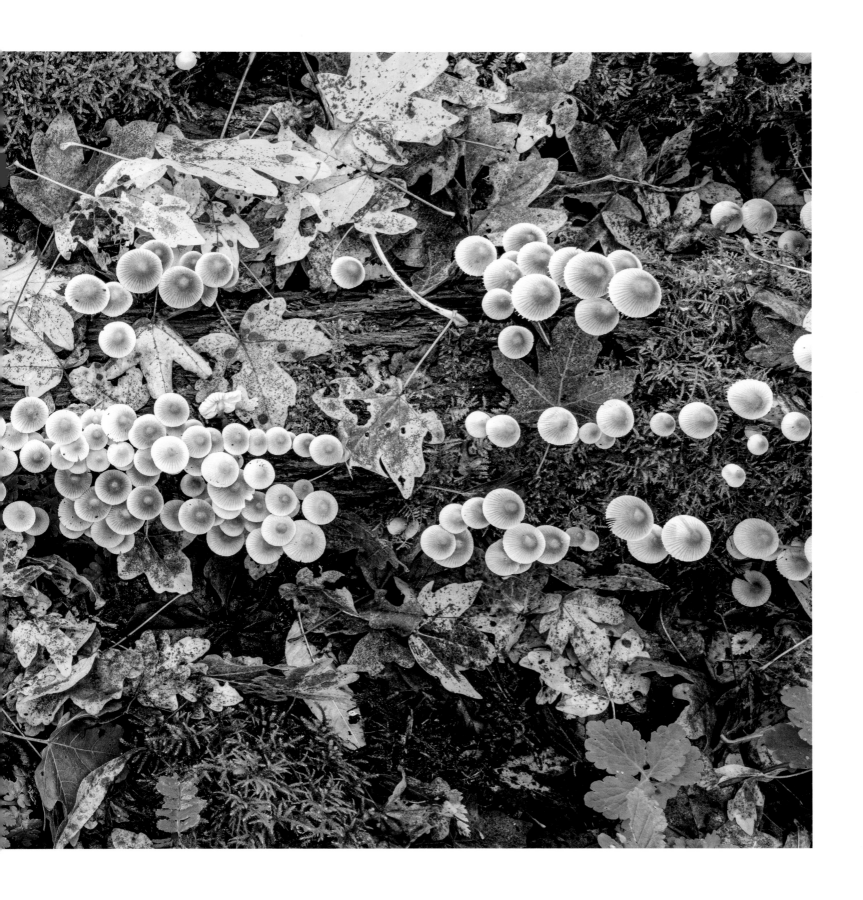

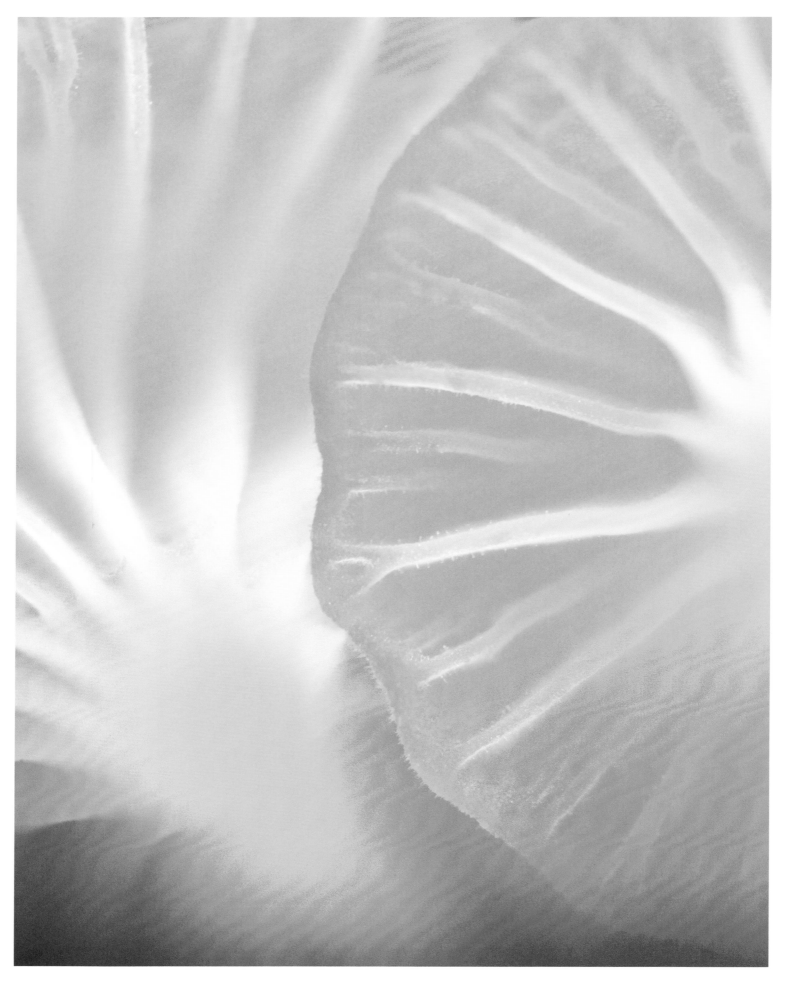

Orange mosscap | Gemeiner Heftelnabeling *Rickenella fibula*

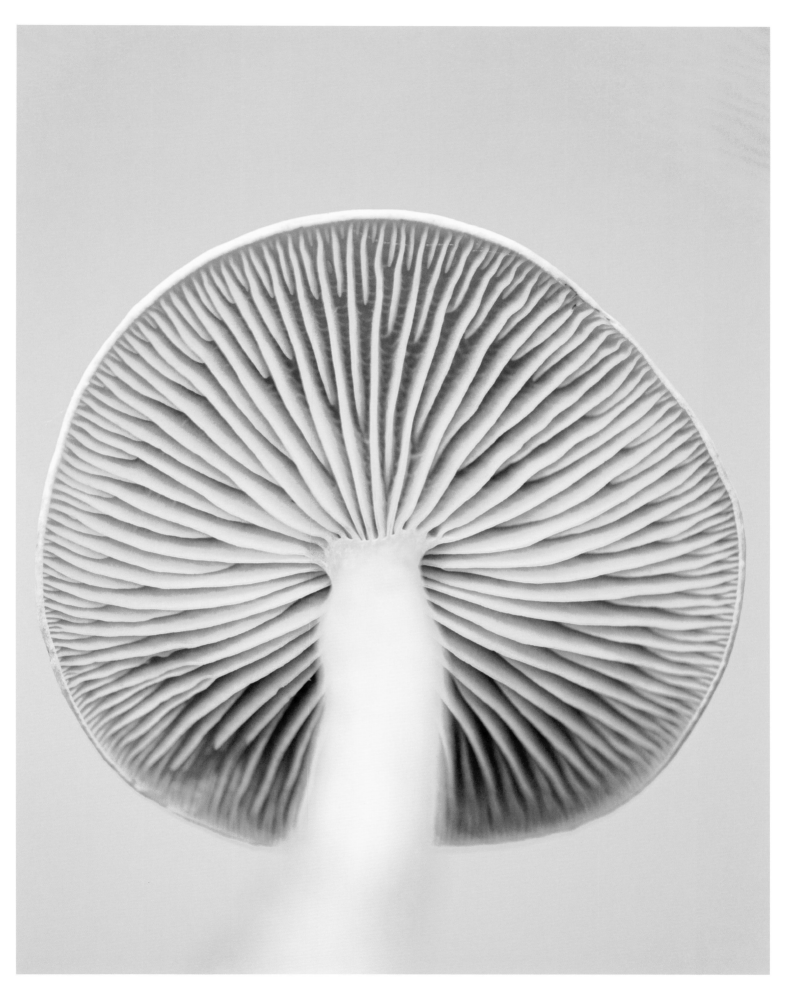

Sulfur knight | Schwefelritterling *Tricholoma sulphureum*

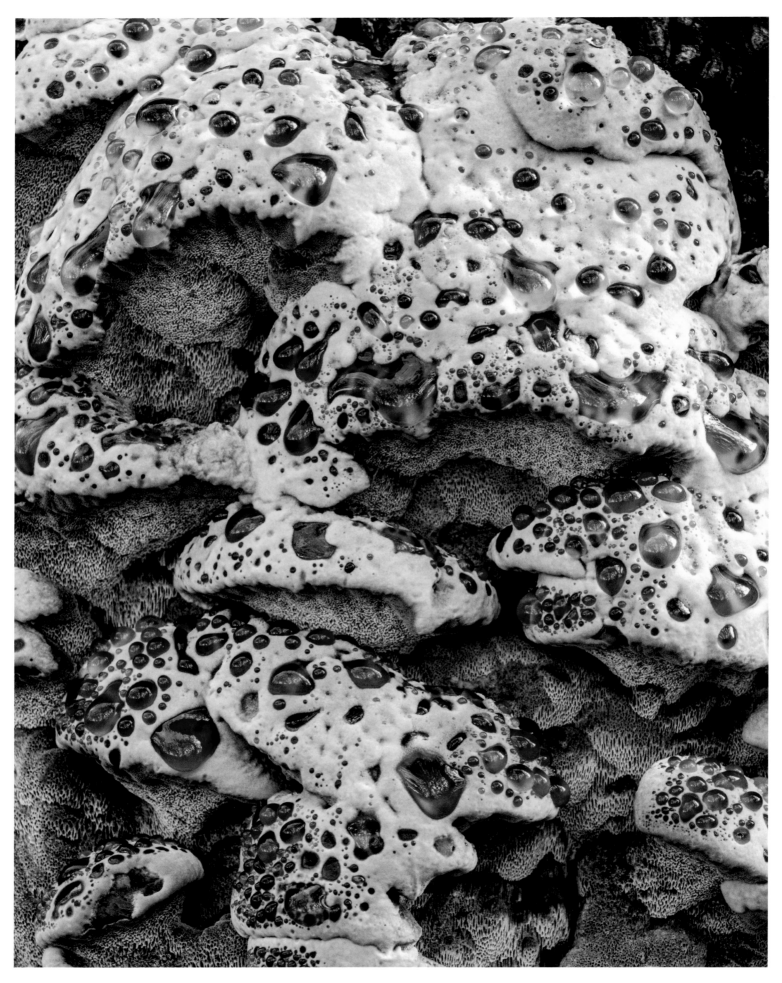

Alder bracket | Erlen-Schillerporling *Mensularia radiata*

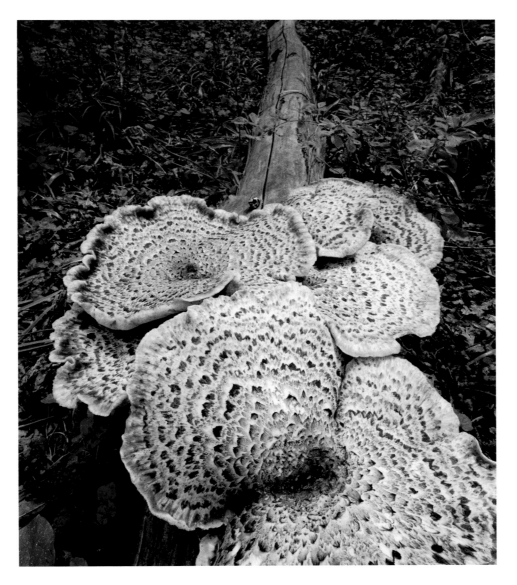

Dryad's saddle | Schuppiger Stiel-Porling *Polyporus squamosus*

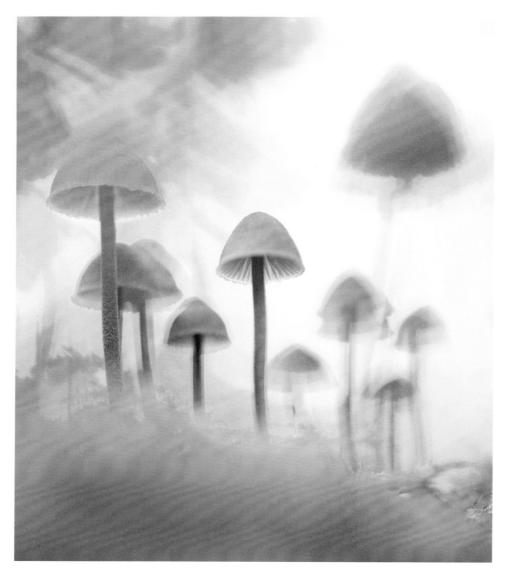

Bleeding fairy helmet | Blut-Helmling *Mycena haematopus*

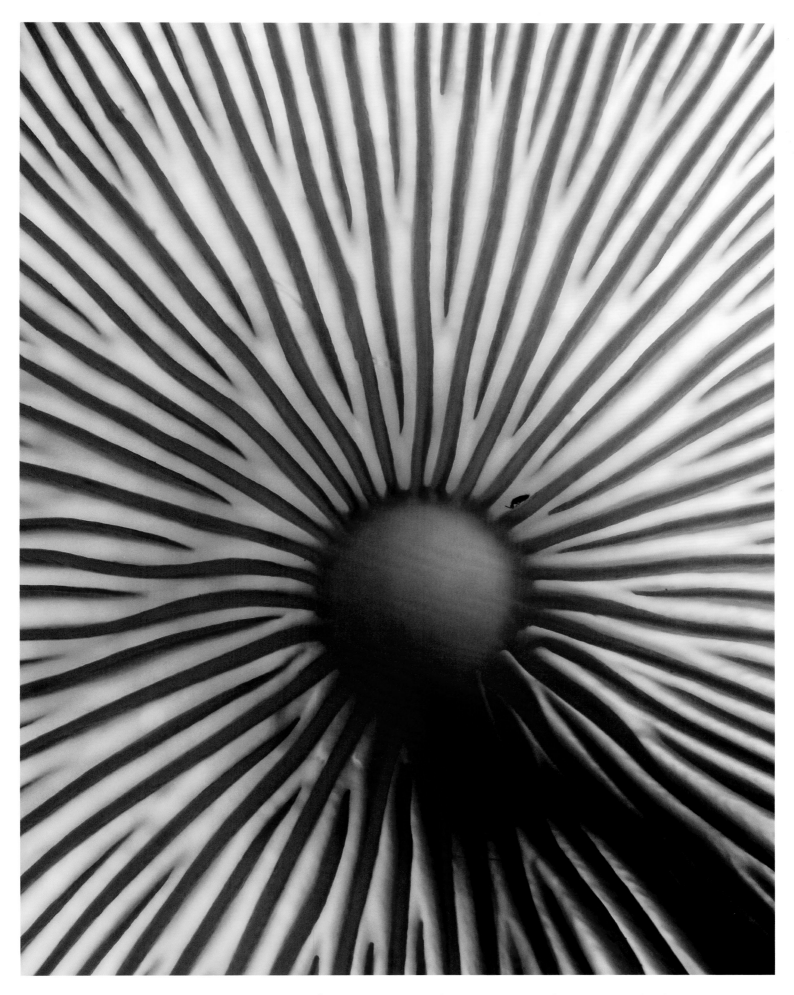

Springtail and dual-colored deceiver | Zweifarbiger Lacktrichterling mit Springschwanz *Laccaria bicolor*

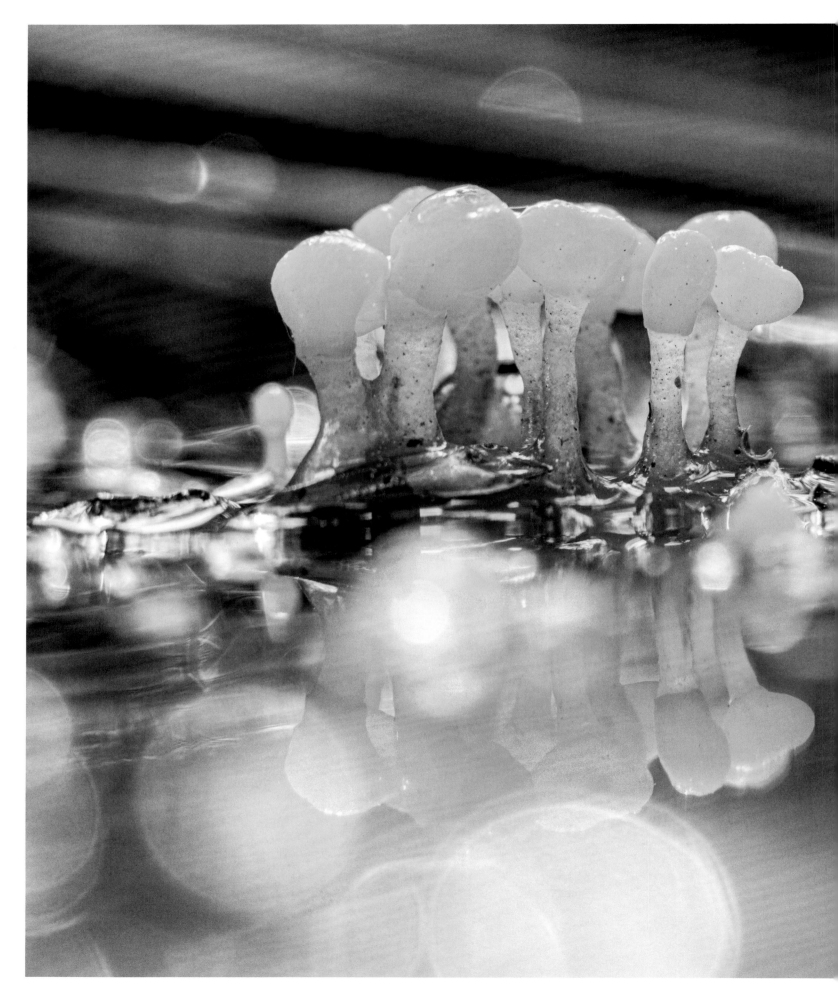

Bog beacon | Sumpf-Haubenpilz *Mitrula paludosa*

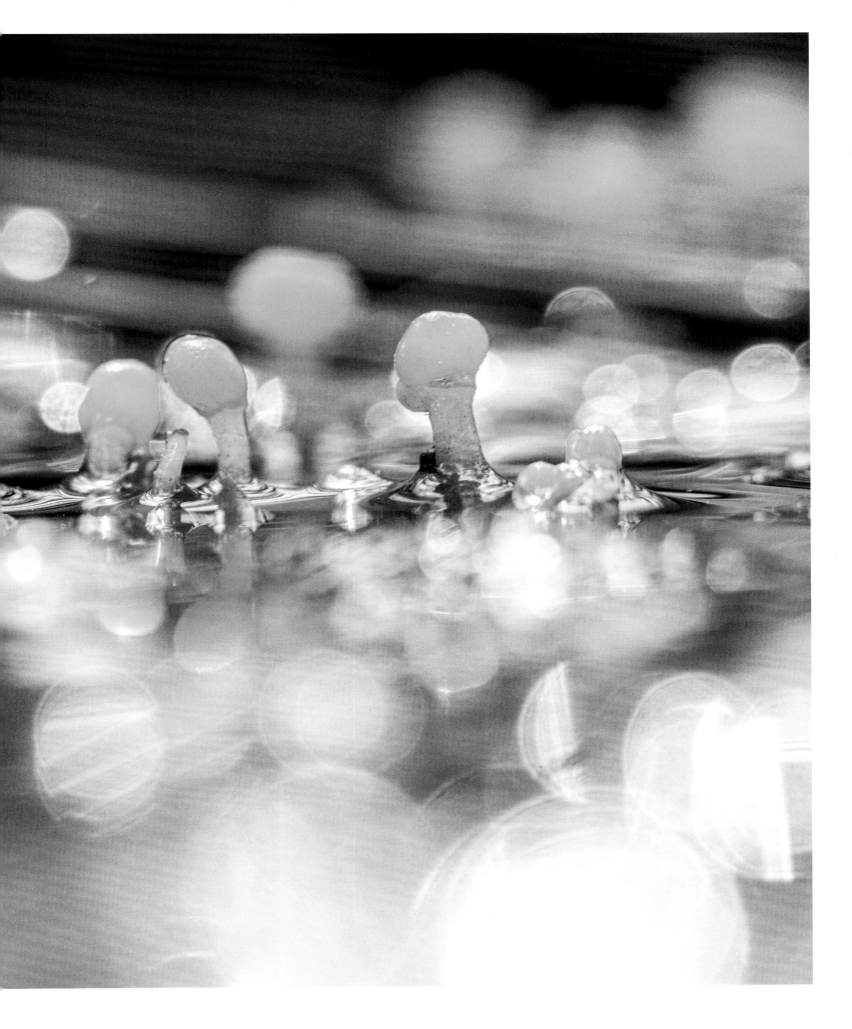

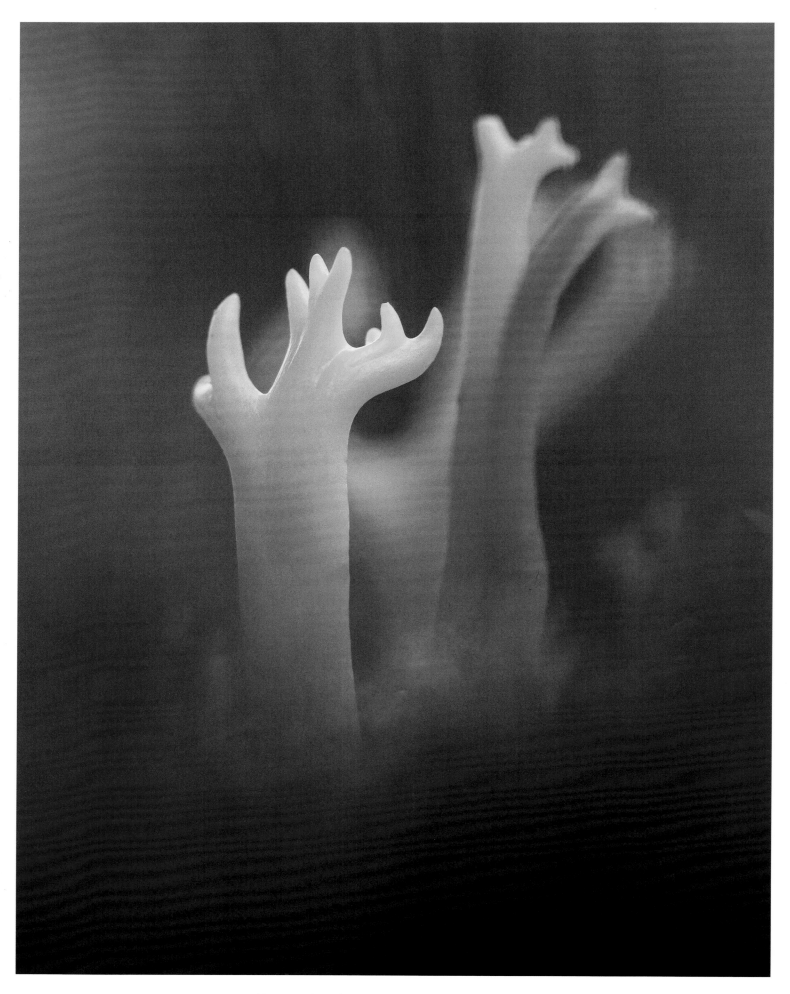

Yellow stagshorn | Klebriger Hörnling *Calocera viscosa*

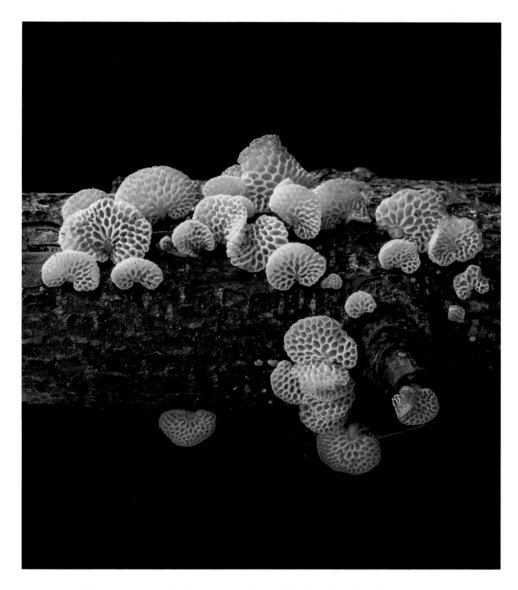

Orange porecap | Orangeroter Porenhelmling *Favolaschia calocera*

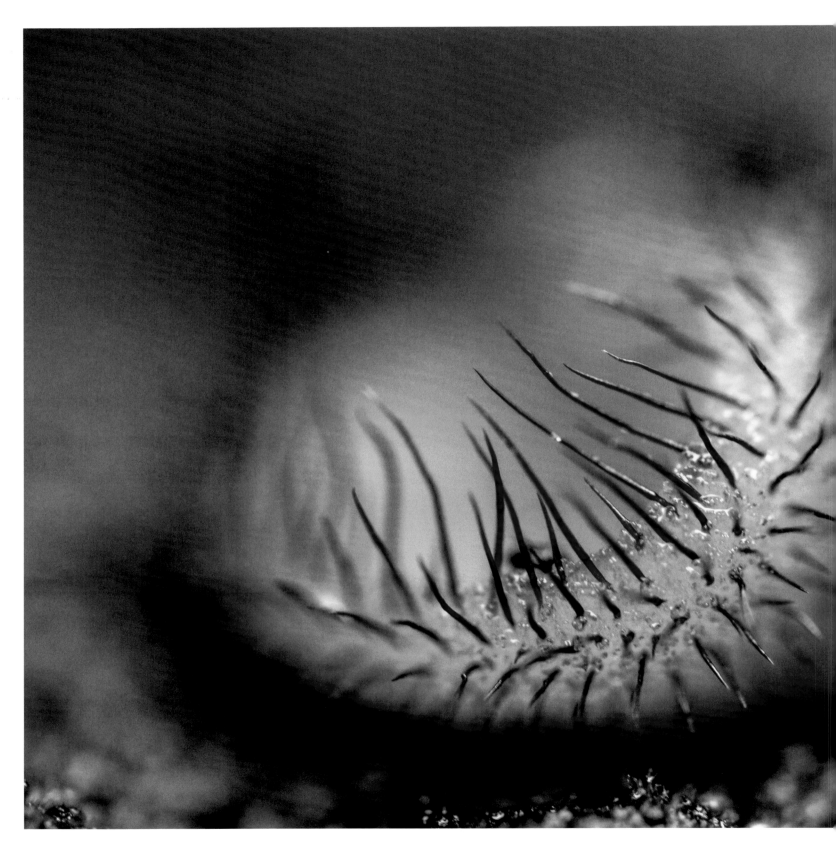

Common eyelash | Gemeiner Schildborstling *Scutellinia scutellata*

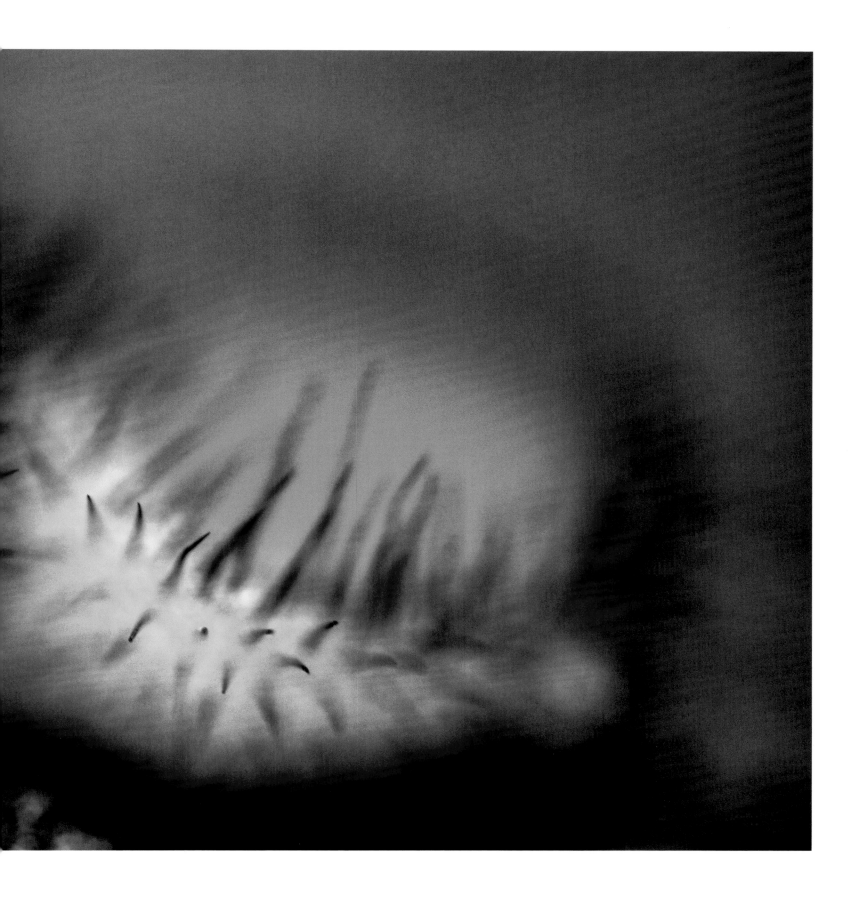

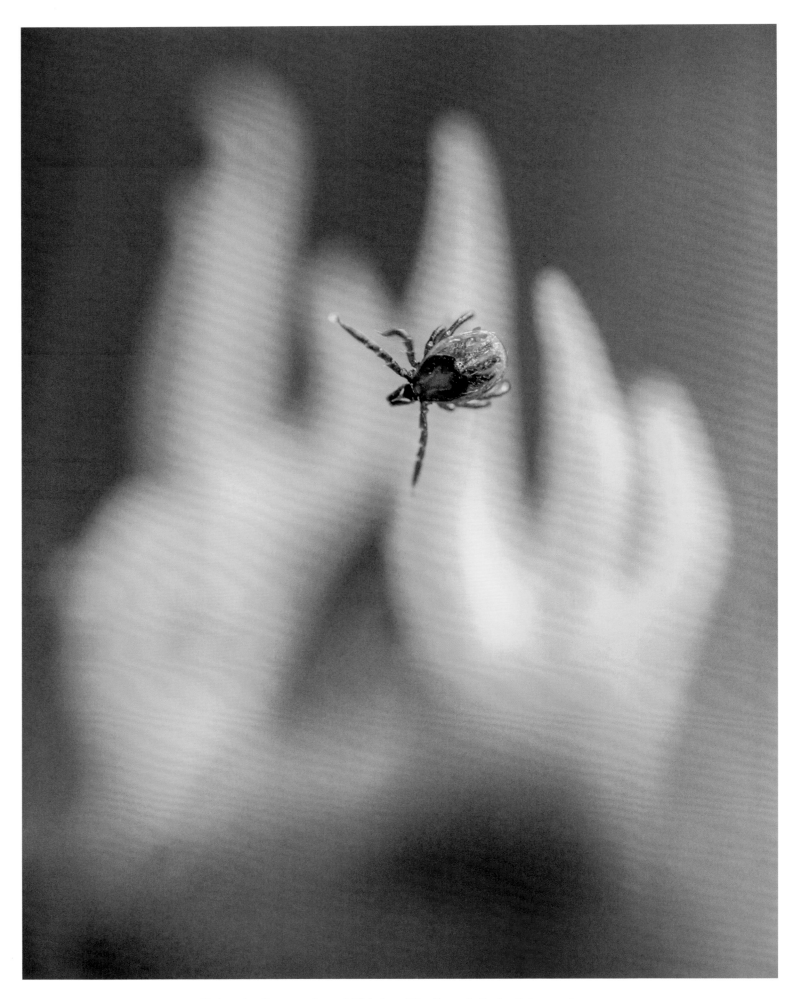

Tick and yellow stagshorn | Klebriger Hörnling mit Zecke *Calocera viscosa*

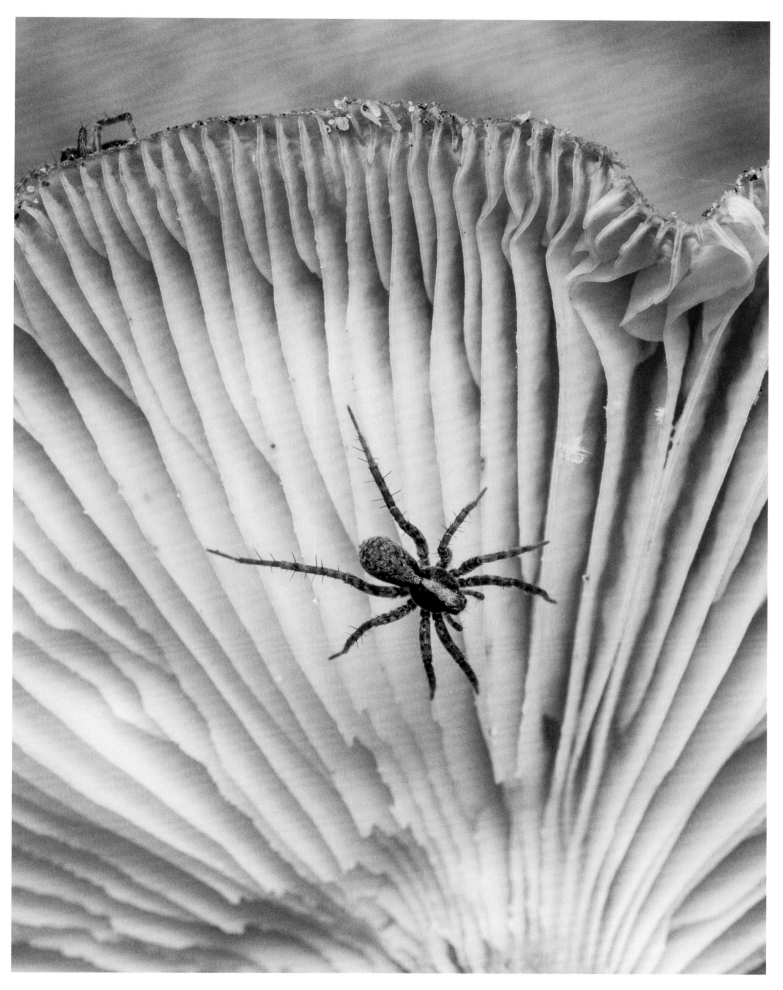

Wolf spider and deceiver | Rötlicher Lacktrichterling mit Riesenwolfspinne *Laccaria laccata*

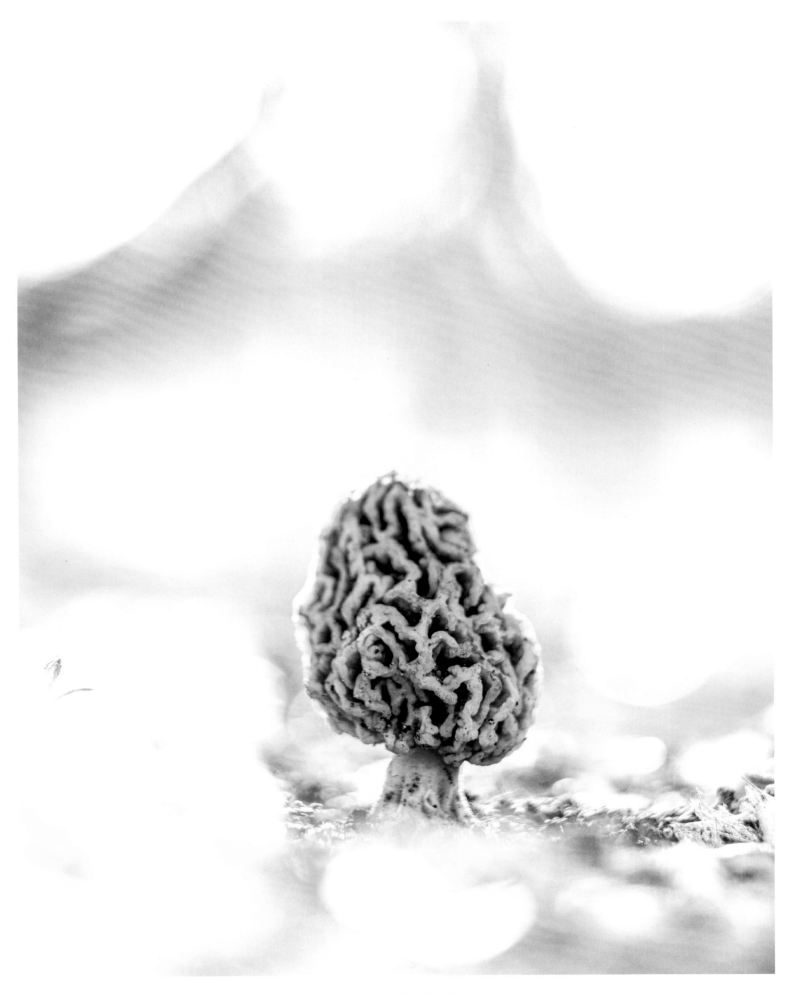

Common morel | Gemeine Morchel *Morchella vulgaris*

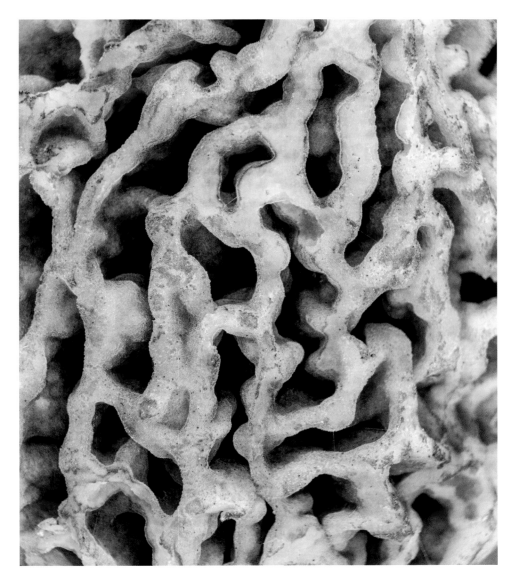

Common morel | Gemeine Morchel *Morchella vulgaris*

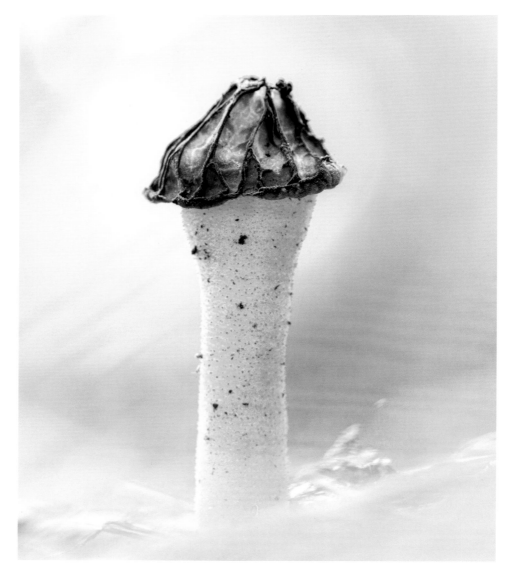

Half-free morel | Käppchen-Morchel *Mitrophora semilibera*

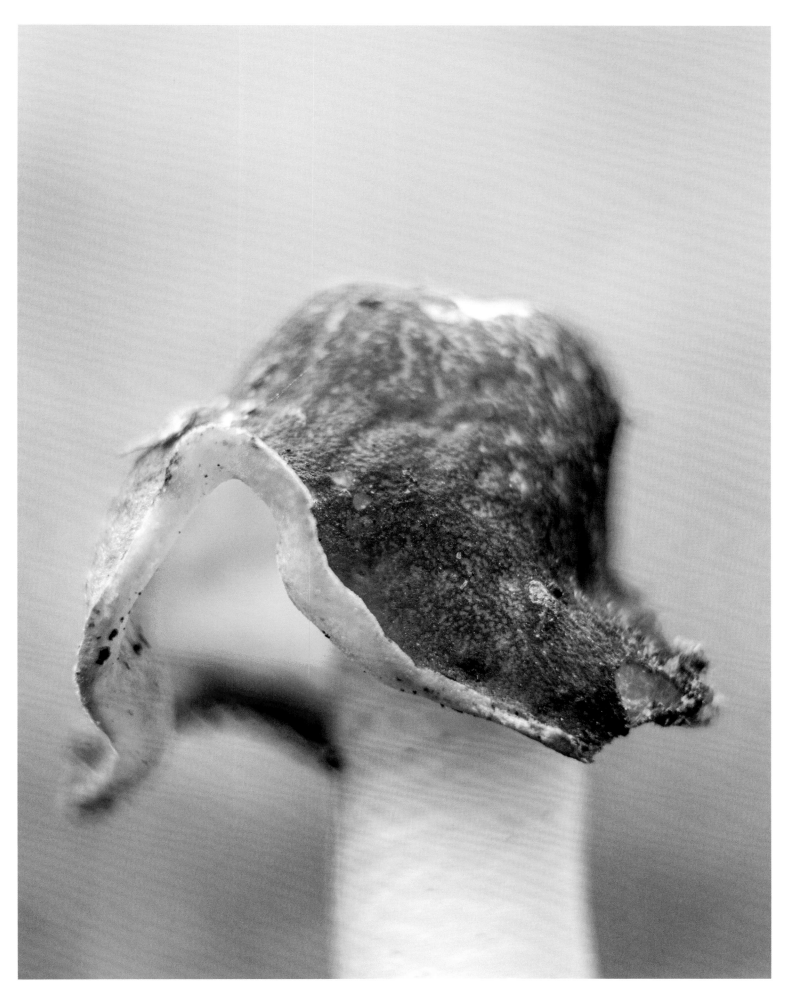

Thimble morel | Glockenverpel *Verpa conica*

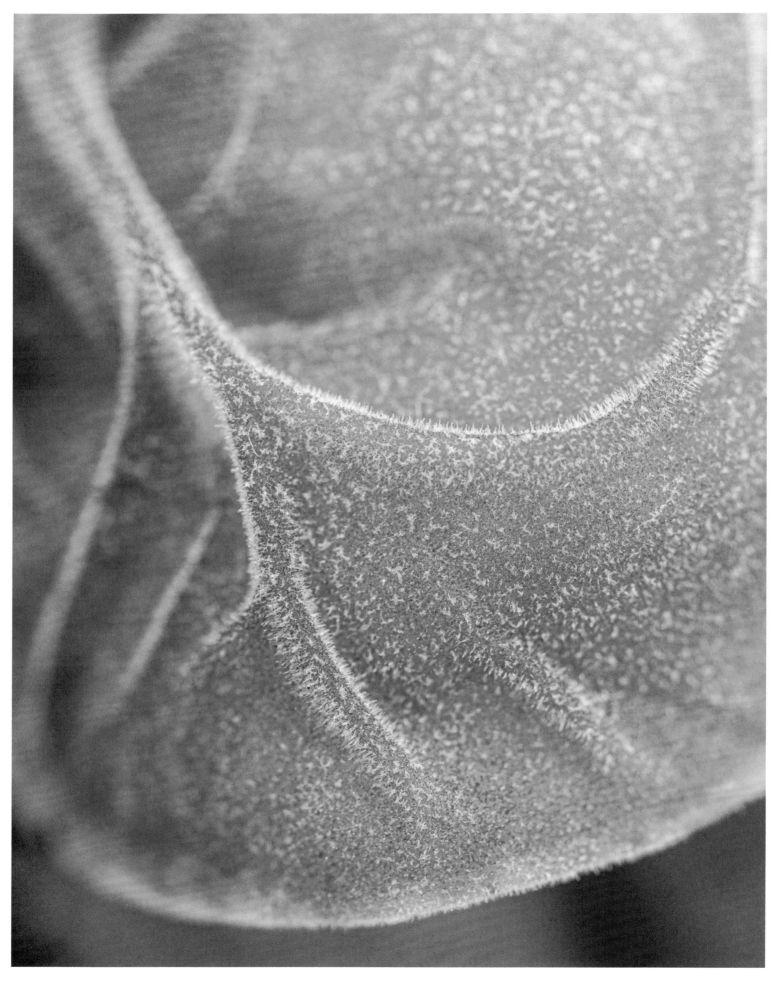

Jelly ear | Judasohr *Auricularia auricula-judae*

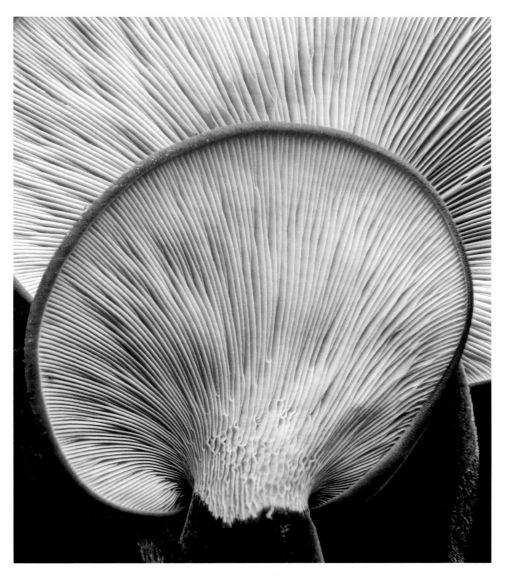

Velvet roll-rim | Samtfußkrempling *Tapinella atrotomentosa*

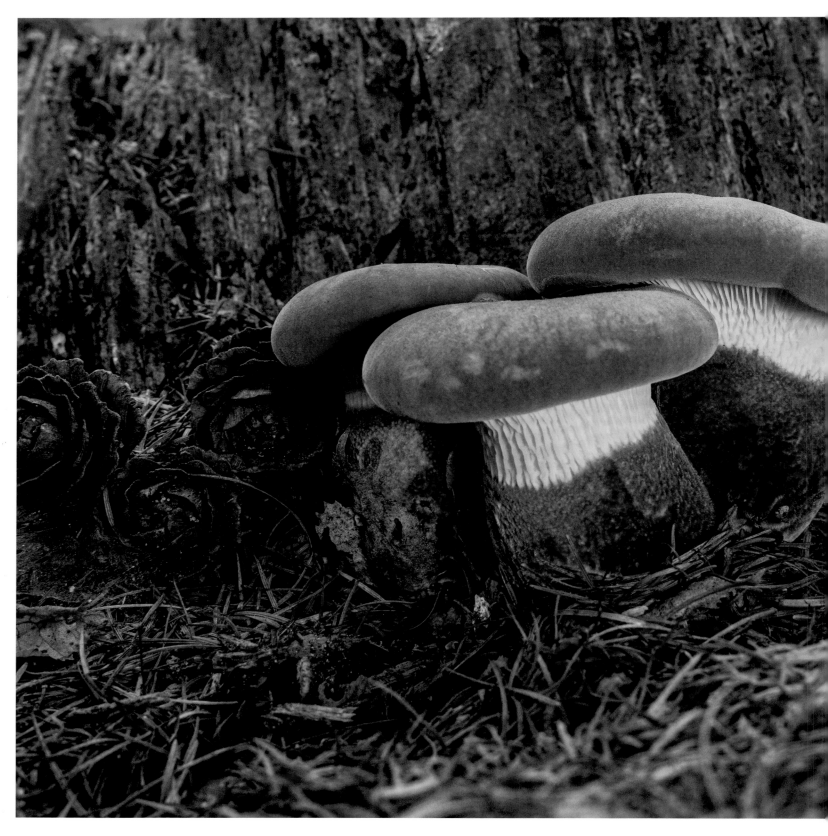

Velvet roll-rim | Samtfußkrempling *Tapinella atrotomentosa*

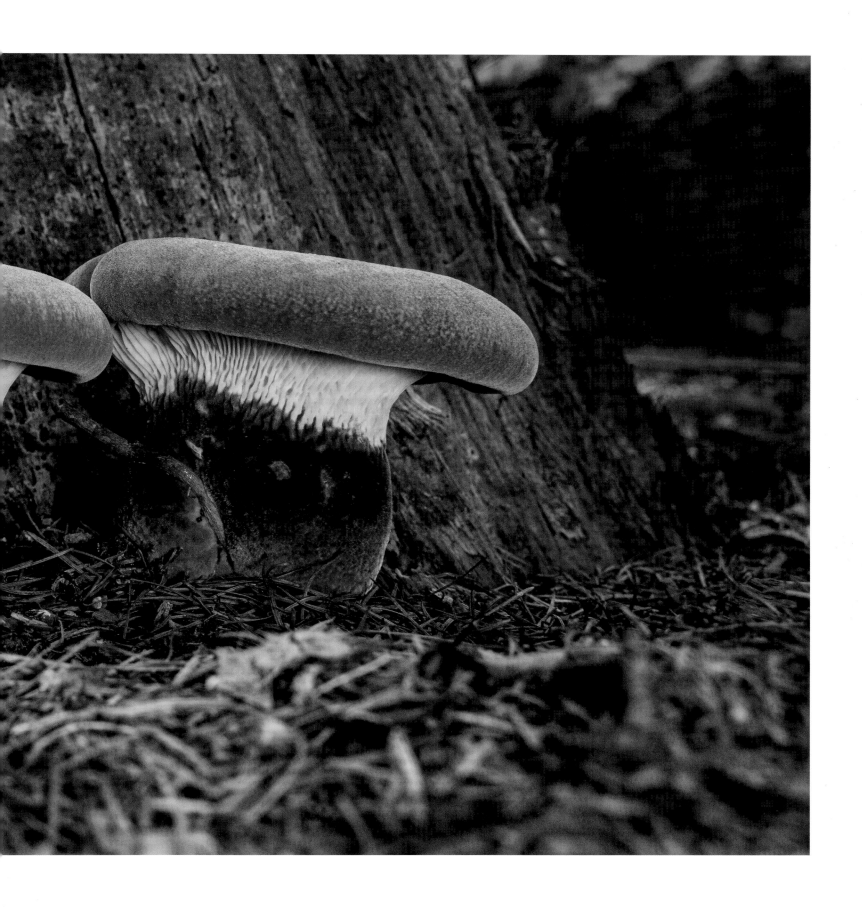

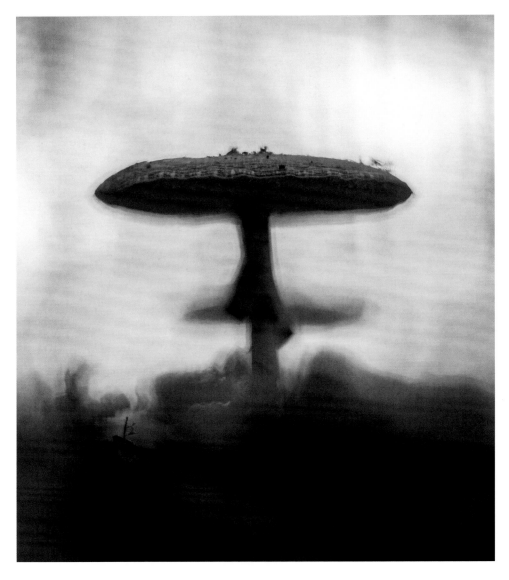

Death cap | Grüner Knollenblätterpilz *Amanita phalloides*

DANGER
GEFAHR

While many varieties of mushrooms are edible, some are poisonous and even potentially fatal when consumed. Often, mushrooms appear to spring up from nowhere. They may grow from an egg-like fruiting body, like the common stinkhorn, whose "eggs" emit an unpleasant rotting odor. Their mysterious sudden appearance and poisonous nature, combined with their off-putting smell, have given rise to associations with the devil, which has resulted in occult-inspired names for many mushrooms: including Satan's bolete, the dotted stem bolete (known in Dutch as the "witches bolete"), and the death trumpet.

AMANITA PHALLOIDES IS A WIDESPREAD SPECIES AND IS ONE OF THE MOST POISONOUS MUSHROOMS ON THE PLANET

In the Netherlands, there are five varieties of mushrooms that are fatally poisonous to humans. Amanita phalloides is a widespread species and is one of the most poisonous mushrooms on the planet – as its common names of "death angel" and "death cap" suggest. This mushroom is responsible for about 90 percent of all cases of poisoning related to mushroom consumption, and it grows in almost all parts of the world.

Communication around the topic of mushrooms has improved exponentially in recent years and members of the public are regularly warned not to eat foraged mushrooms if they don't possess the knowledge and expertise to identify them with complete certainty. However, there are various historical cases where this mushroom has been deliberately administered, the most well-known of which is the poisoning of the Emperor Claudius. The Emperor's wife Julia Agrippina

Viele Pilzarten sind zwar essbar, aber einige sind giftig und können beim Verzehr sogar tödlich sein. Oft scheinen Pilze aus dem Nichts aufzutauchen. Sie können aus einem eiförmigen Fruchtkörper wachsen, wie die Gemeine Stinkmorchel, deren „Eier" einen unangenehmen Fäulnisgeruch verströmen. Ihr rätselhaftes plötzliches Auftauchen und ihre Giftigkeit in Verbindung mit ihrem unangenehmen Geruch haben zu Assoziationen mit dem Teufel geführt, was zu okkultistisch inspirierten Namen für viele Pilze geführt hat: Satanspilz, Hexenröhrling oder Totentrompete.

In den Niederlanden gibt es fünf Giftpilze, deren Genuss zum Tod führen kann. Der Grüne Knollenblätterpilz ist weit verbreitet –und einer der giftigsten Pilze der Welt. Er trägt im Englischen den Spitznamen „death angel" oder „death cap", also Todesengel oder Todeshaube. Das verheißt nichts Gutes. Dieser Pilz ist für etwa 90 Prozent aller Vergiftungsfälle im Zusammenhang mit dem Verzehr von Pilzen verantwortlich und kommt in fast allen Teilen der Welt vor.

DER GRÜNE KNOLLENBLÄTTERPILZ IST WEIT VERBREITET – UND EINER DER GIFTIGSTEN PILZE DER WELT

Die Kommunikation rund um das Thema Pilze hat sich in den letzten Jahren verbessert, und die Öffentlichkeit wird regelmäßig vor dem Verzehr gesammelter Pilze gewarnt, wenn sie nicht über das Wissen und die Erfahrung verfügt, um sie mit absoluter Sicherheit zu identifizieren. Es gibt jedoch mehrere historische Fälle, in denen giftige Pilze absichtlich verabreicht wurden, wobei der bekannteste Fall die Vergiftung des Kaisers Claudius ist. Dessen Frau Julia Agrippina Minor wollte Nero, ihren Sohn aus einer früheren Ehe, auf dem Kaiserthron sehen. Claudius aß gerne Pilze und ließ sich unwissentlich den Knollenblätterpilz

Minor wanted to help Nero – her son from a previous marriage – become emperor. Claudius loved mushrooms and thought the death cap was delicious. In films, we often see people immediately collapse after consuming a portion of poisonous mushrooms, but in reality, death by mushroom takes days. Initially, the body exhibits very little reaction, but by around six hours later, poisonous amatoxin is fatally attacking the victim. Just 40 grams of this substance is enough to poison the liver, causing vomiting, severe abdominal pain, and sweating as well as labored breathing. Often, the patient appears to enter a phase of recovery, which can mislead physicians and the patient, causing them to believe that the worst of the reaction has passed. However, the victim can enter the fatal phase of poisoning as many as four days after the initial reaction – and this is when the kidneys and liver suffer irreparable damage. The patient eventually falls into a coma, and 30 percent will not survive.

All over the world, people die from consuming poisonous mushrooms, including the Netherlands. In some cases, patients can be saved with a liver and/or kidney transplant. In spite of increased public awareness, poisoning rates are on the rise, particularly among labor migrants who are often used to foraging for mushrooms in their home countries. In the Netherlands, picking wild mushrooms is generally prohibited by law.

schmecken. In Filmen sieht man oft, wie Menschen nach dem Verzehr einer Portion giftiger Pilze sofort zusammenbrechen, aber in Wirklichkeit dauert der Tod durch Pilze Tage. Zunächst zeigt der Körper kaum eine Reaktion, aber nach etwa sechs Stunden haben die Amatoxine (so heißen die Giftstoffe des Knollenblätterpilzes) ihre volle Wirkung entfaltet. Etwa 40 Gramm reichen aus, um die menschliche Leber zu vergiften und Erbrechen, starke Bauchschmerzen, Schweißausbrüche und Atemnot zu verursachen. Oft gibt es eine symptomlose Zwischenphase, was Ärzte und Patienten in die Irre führen kann, da sie glauben, das Schlimmste der Reaktion sei vorüber. Allerdings kann das Opfer bis zu vier Tage nach der ersten Reaktion in die tödliche Phase der Vergiftung eintreten, in der die Nieren und die Leber irreparabel geschädigt werden. Der Patient fällt schließlich in ein Koma – 30 Prozent überleben nicht.

Überall auf der Welt sterben Menschen nach dem Verzehr von Giftpilzen, auch in den Niederlanden. In einigen Fällen können die Patienten durch eine Leber- und/oder Nierentransplantation gerettet werden. Trotz der zunehmenden Sensibilisierung der Öffentlichkeit steigt die Zahl der Vergiftungen, insbesondere bei Arbeitsmigranten, die in ihren Heimatländern häufig Pilze sammeln. In den Niederlanden ist das Sammeln von Wildpilzen im Allgemeinen gesetzlich verboten.

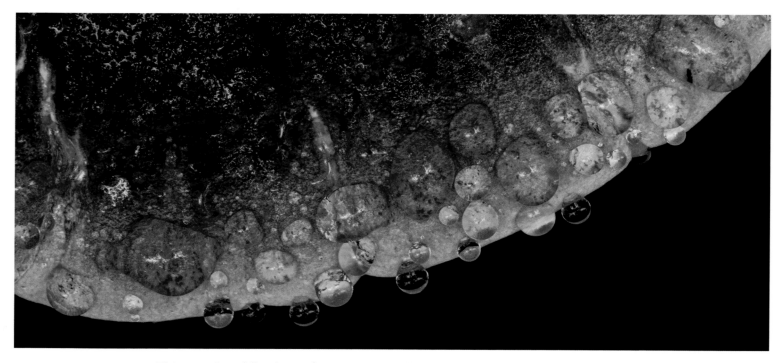

This page: **Late fall polypore** | Diese Seite: **Laubholzharzporling** *Ischnoderma resinosum*

Right page: **Fly agaric** | Rechte Seite: **Fliegenpilz** *Amanita muscaria*

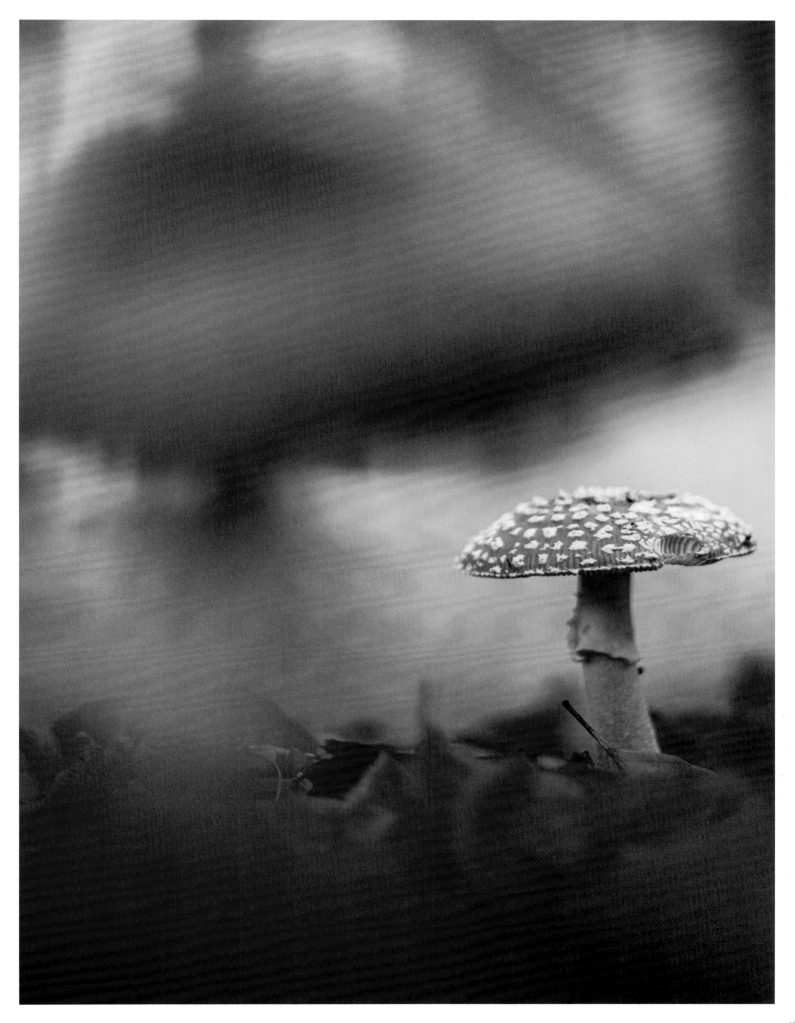

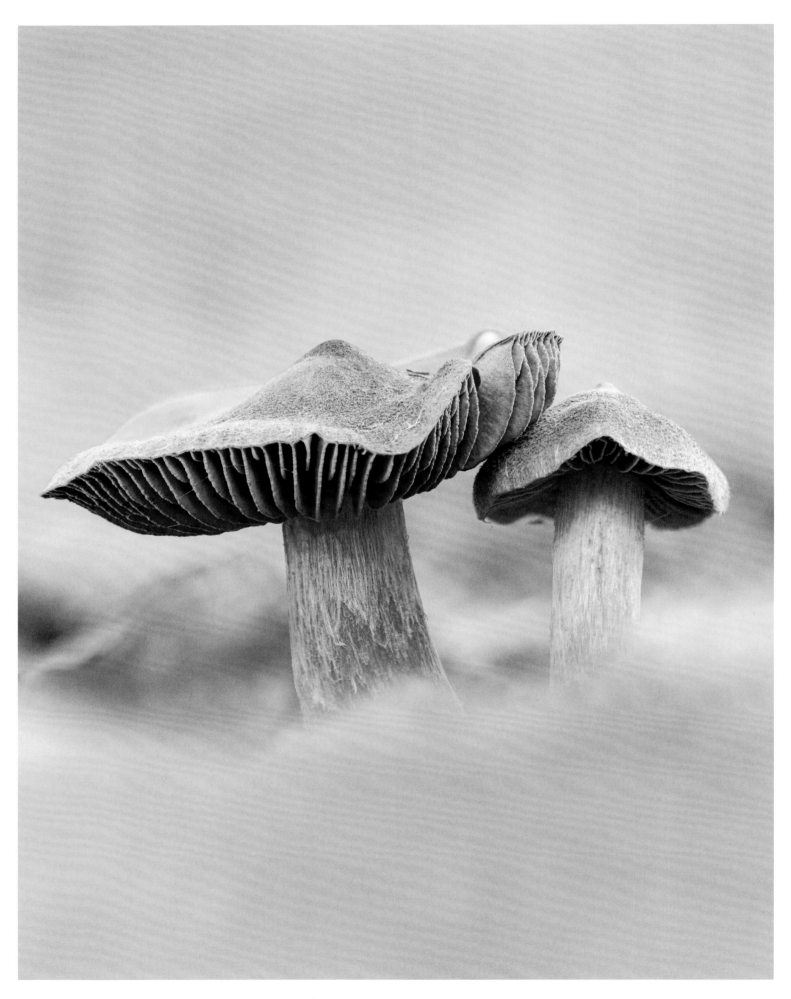

Deadly webcap | Spitzgebuckelter Raukopf *Cortinarius rubellus*

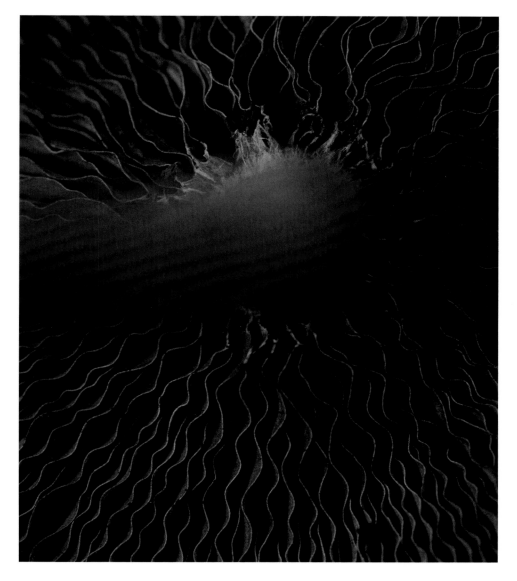

Dark honey fungus | Dunkler Hallimasch *Armillaria ostoyae*

Following page: **Fly agaric** | Nächste Seite: **Fliegenpilz** *Amanita muscaria*

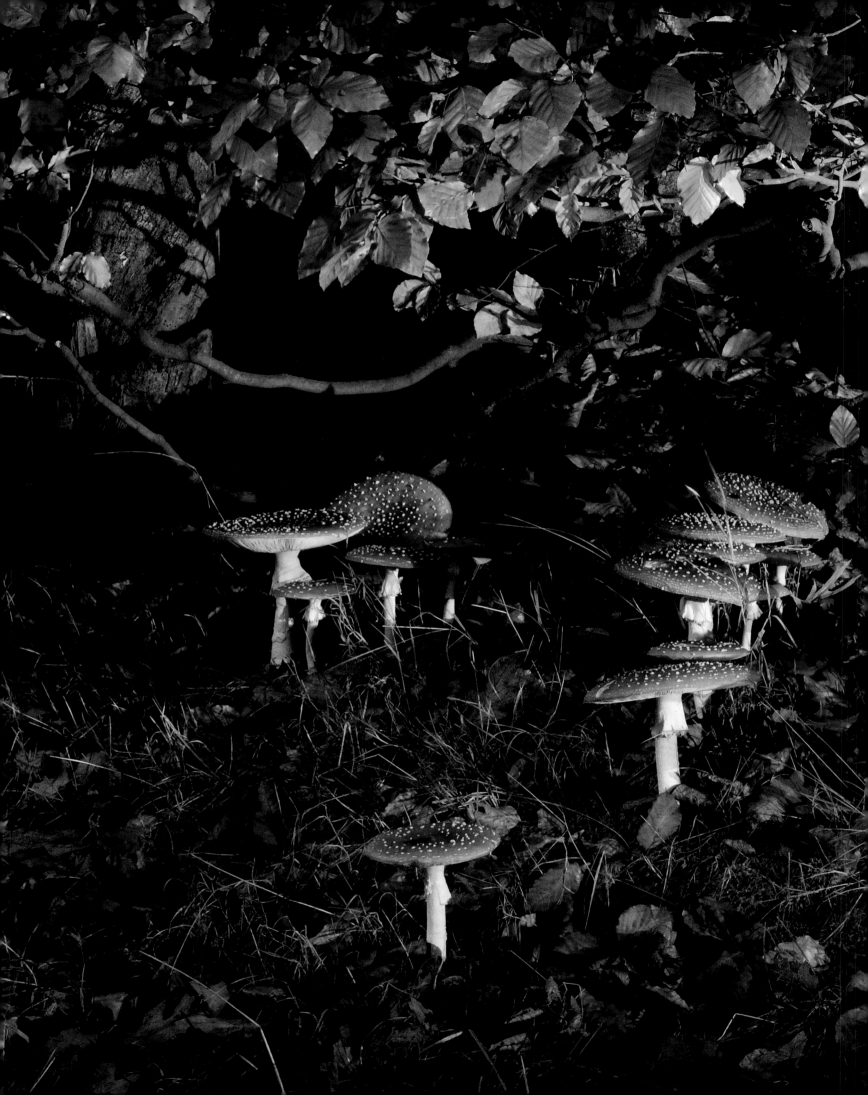

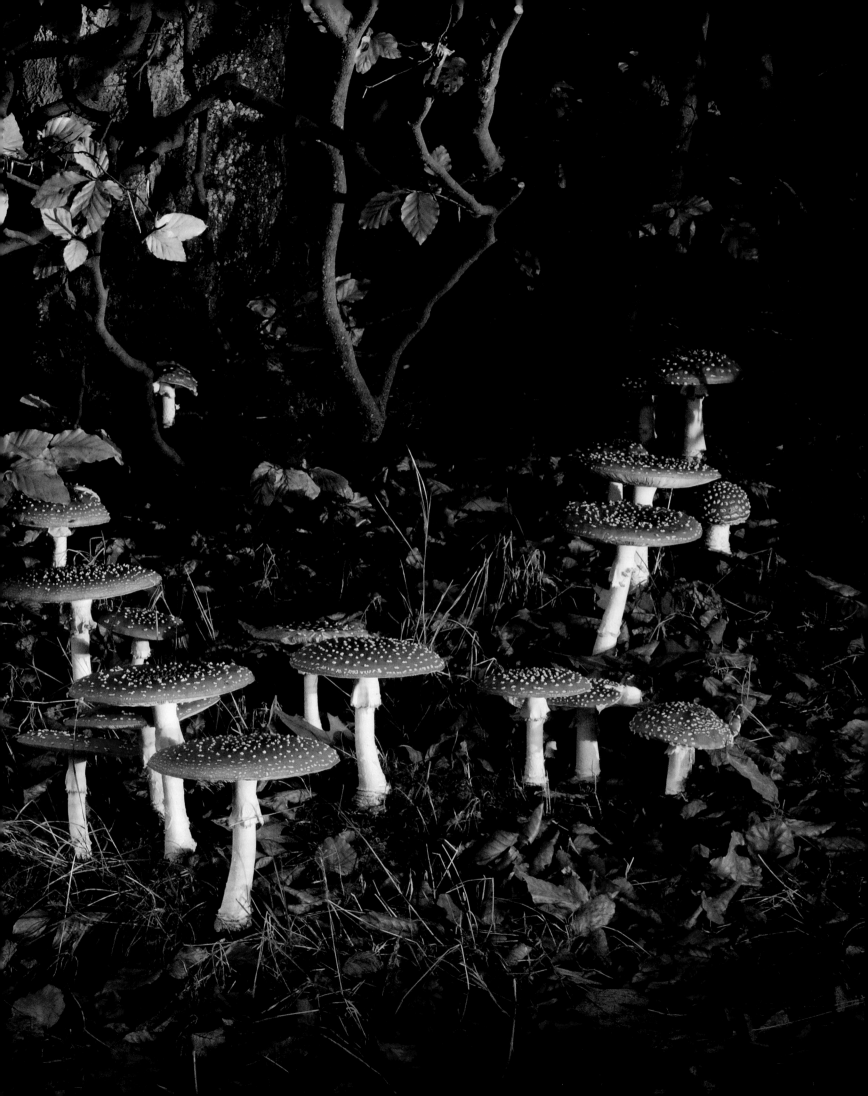

Fly agaric | Fliegenpilz *Amanita muscaria*

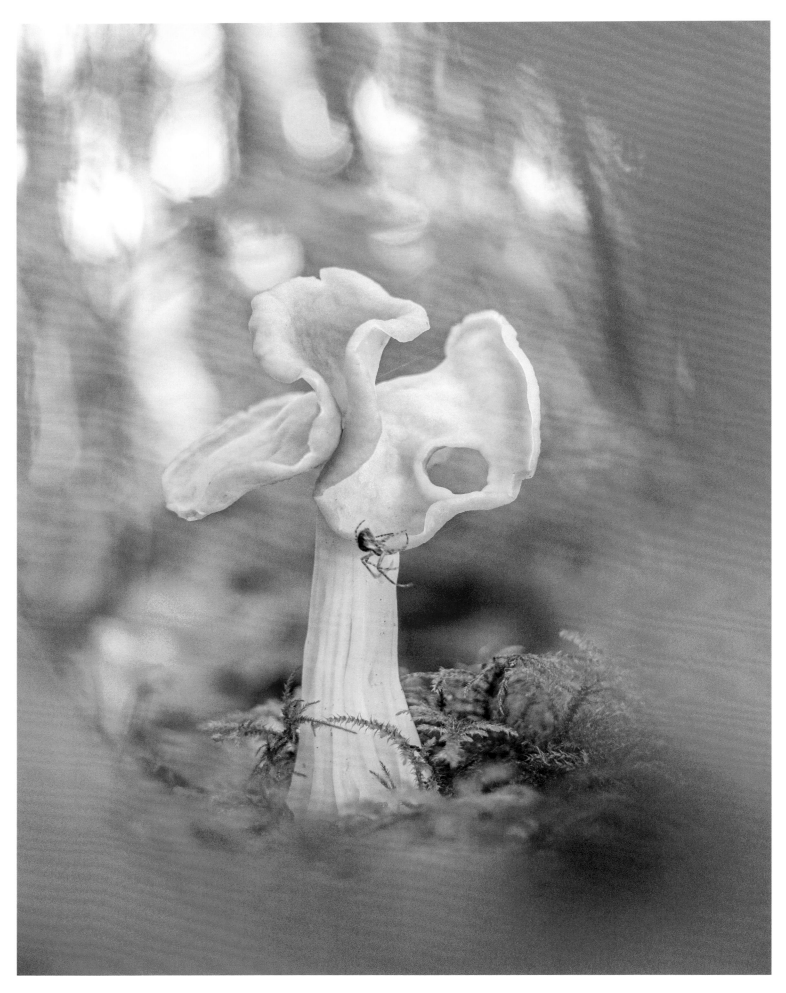

White saddle | Herbst-Lorchel *Helvella crispa*

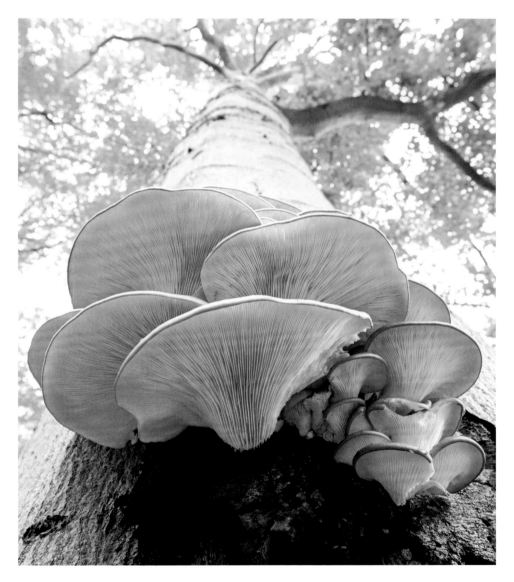

Oyster mushroom | Austern-Seitling *Pleurotus ostreatus*

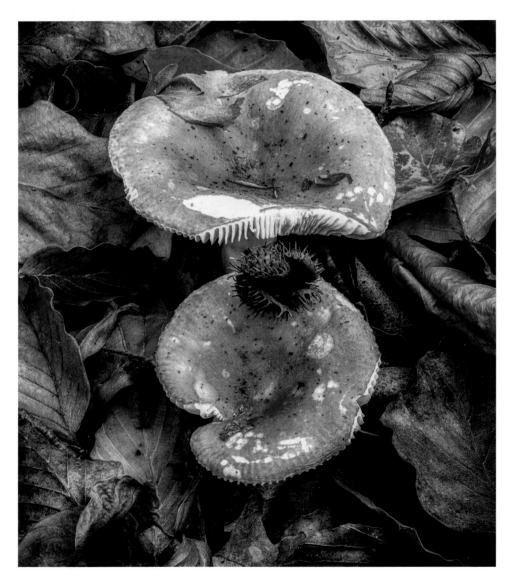

Sickener | Kirschroter Speitäubling *Russula emetica*

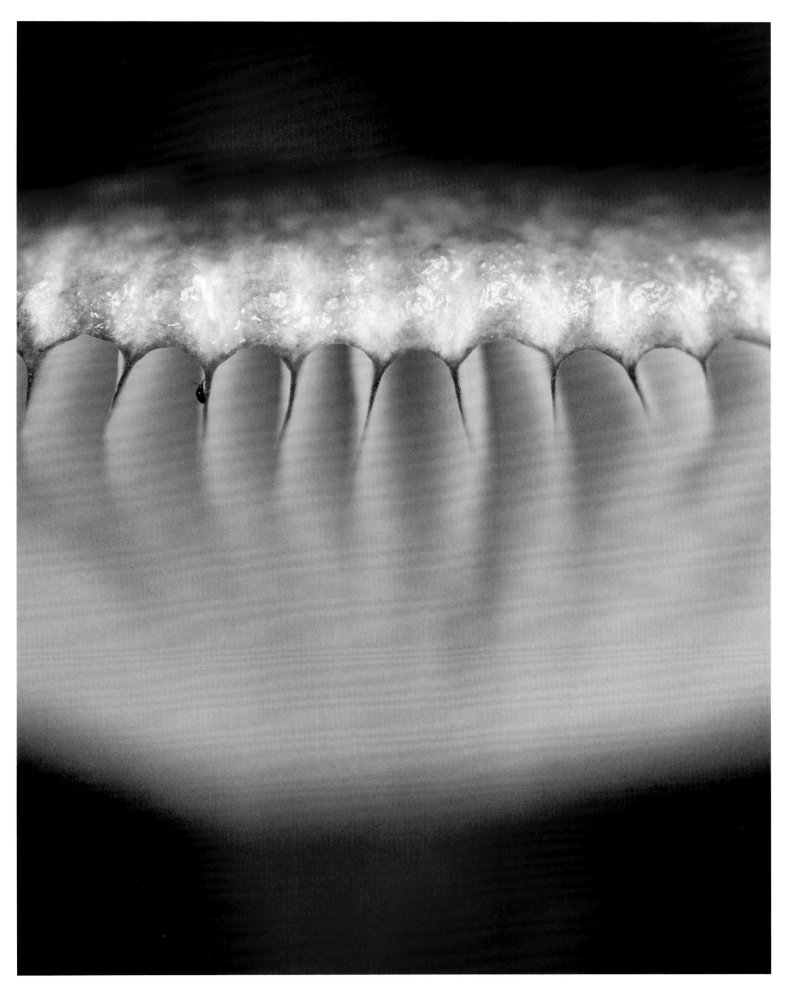

Bloody brittlegill | Blut-Täubling *Russula sanguinea*

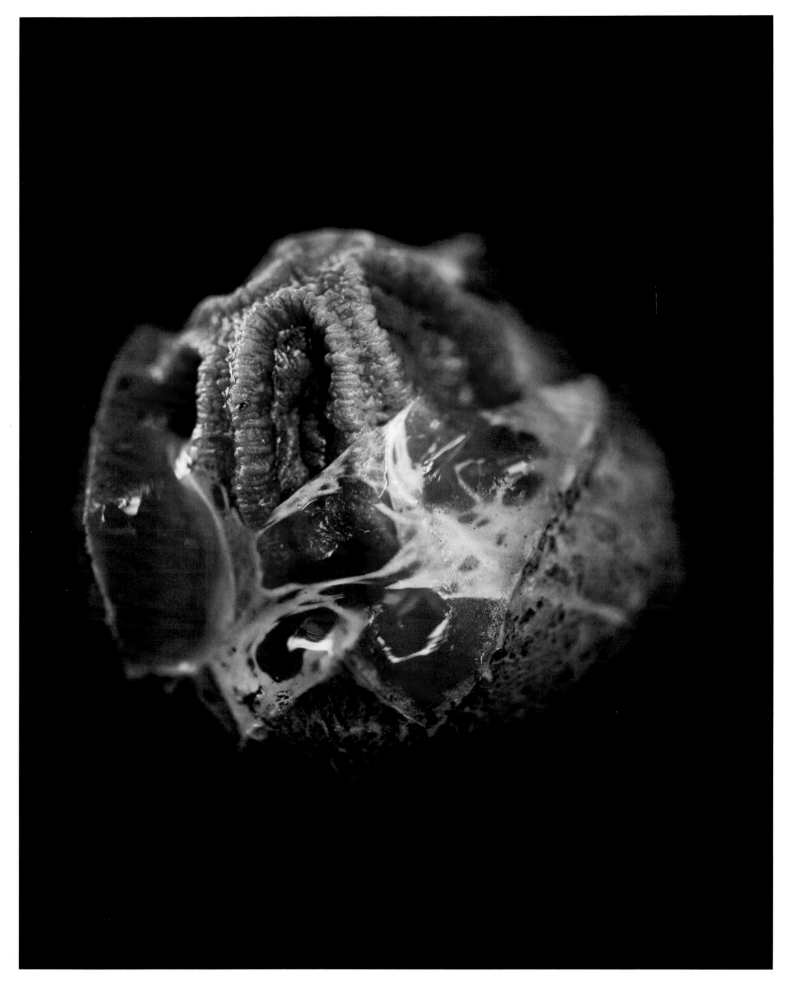

Devil's fingers | Tintenfischpilz *Clathrus archeri*

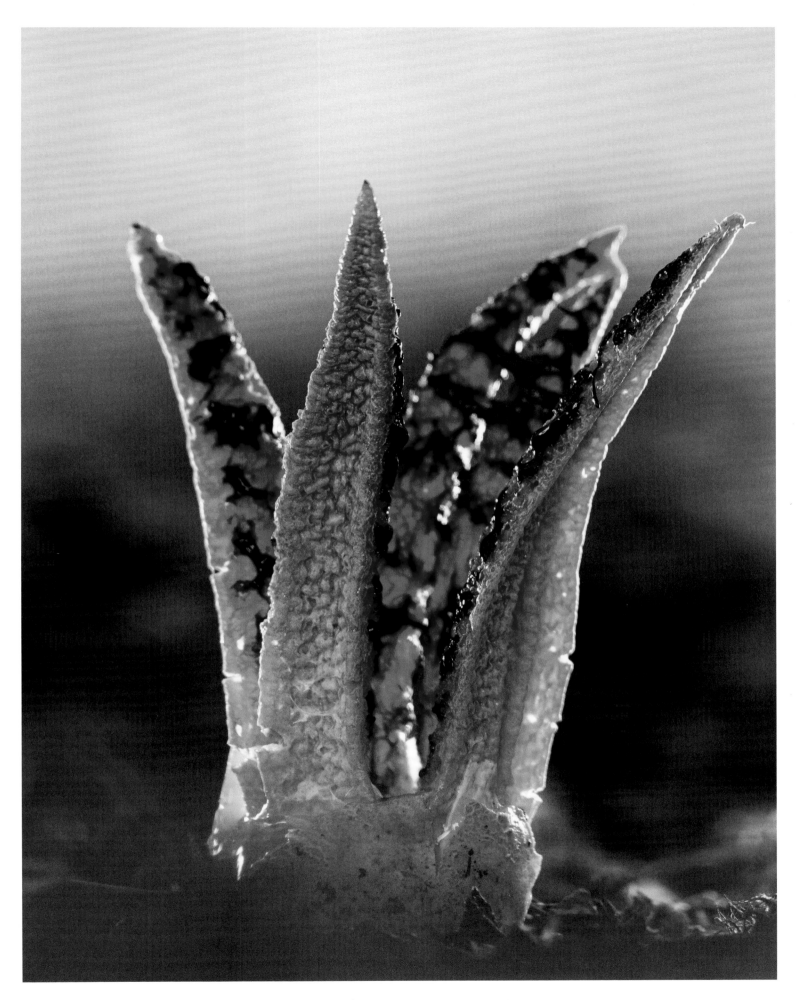

Devil's fingers | Tintenfischpilz *Clathrus archeri*

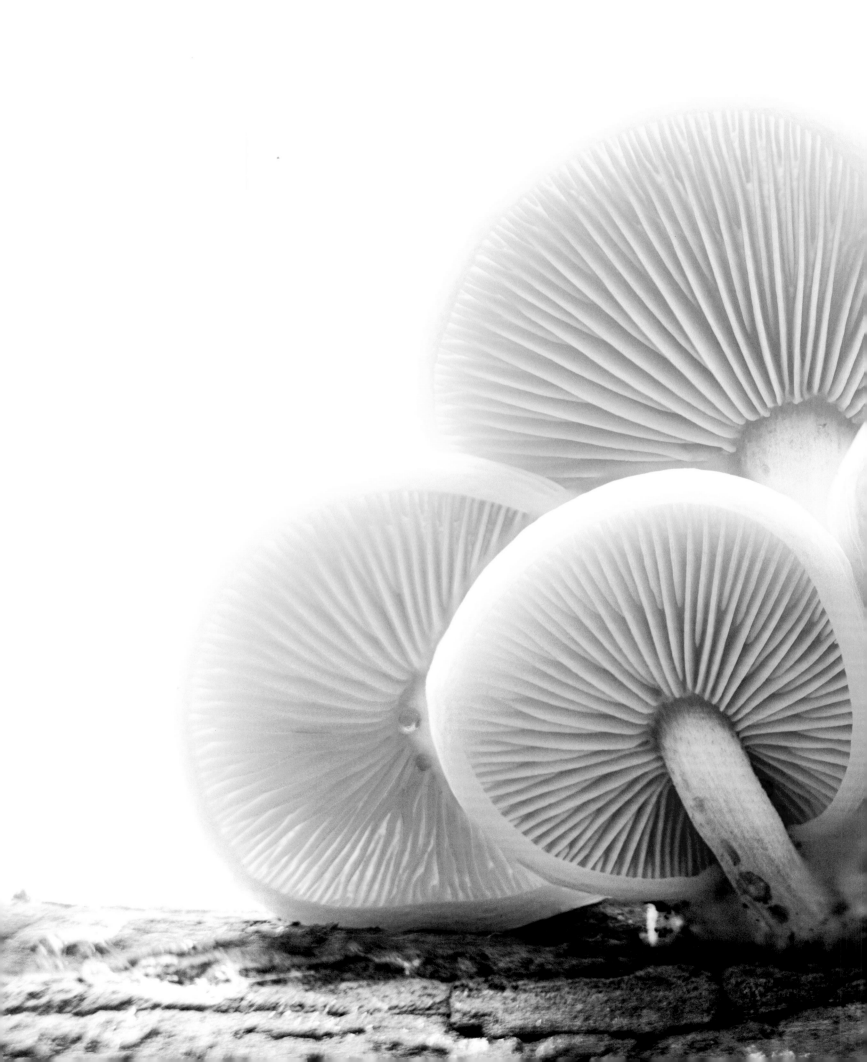

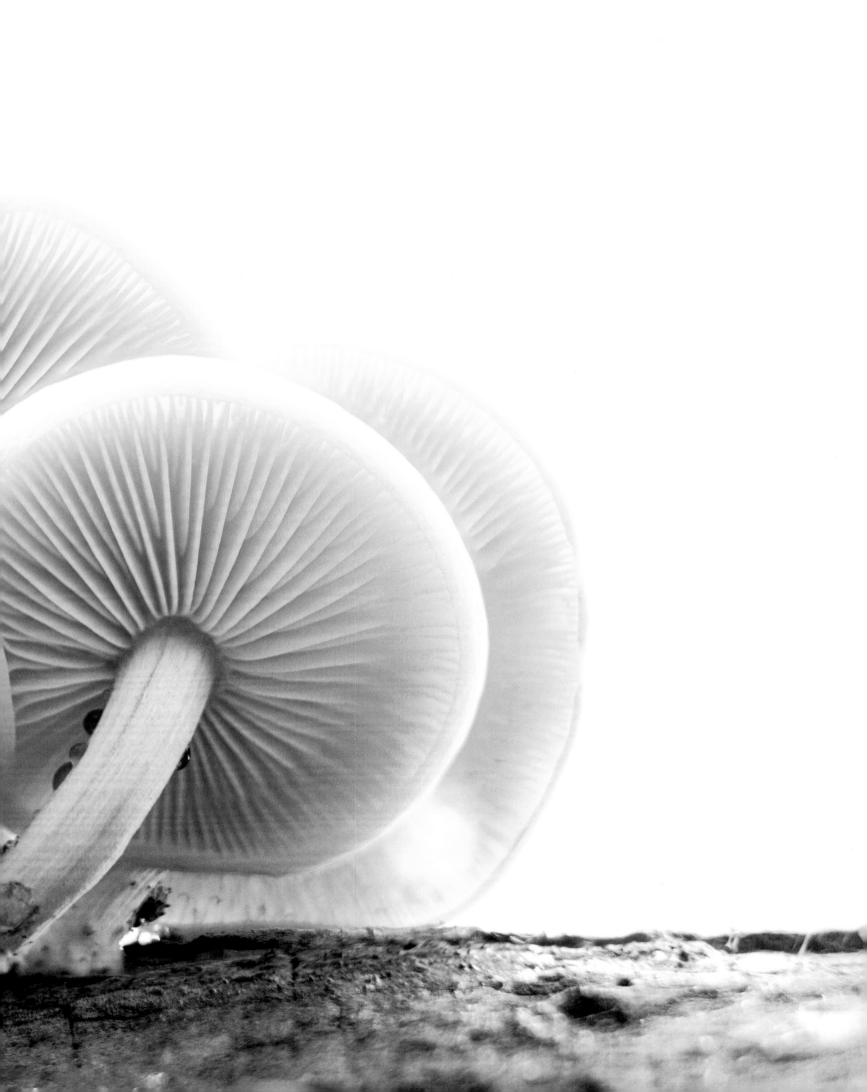

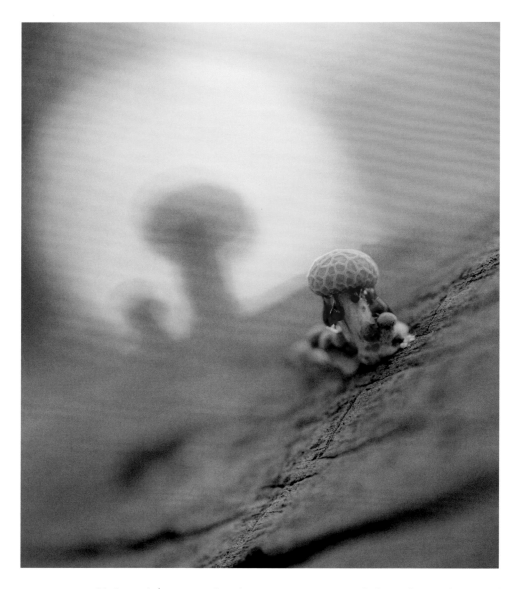

This and previous page: **Wrinkled peach** | Diese und vorherige Seite: **Orangerötlicher Adernseitling** *Rhodothus palmatus*

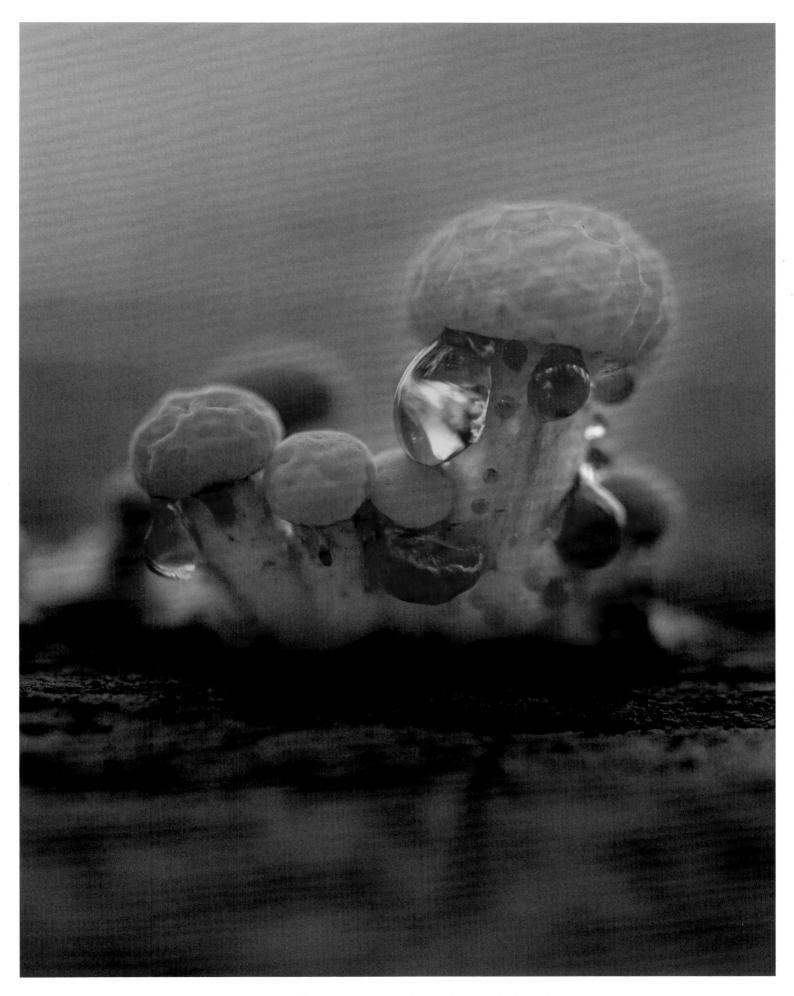

Wrinkled peach | Orangerötlicher Adernseitling *Rhodothus palmatus*

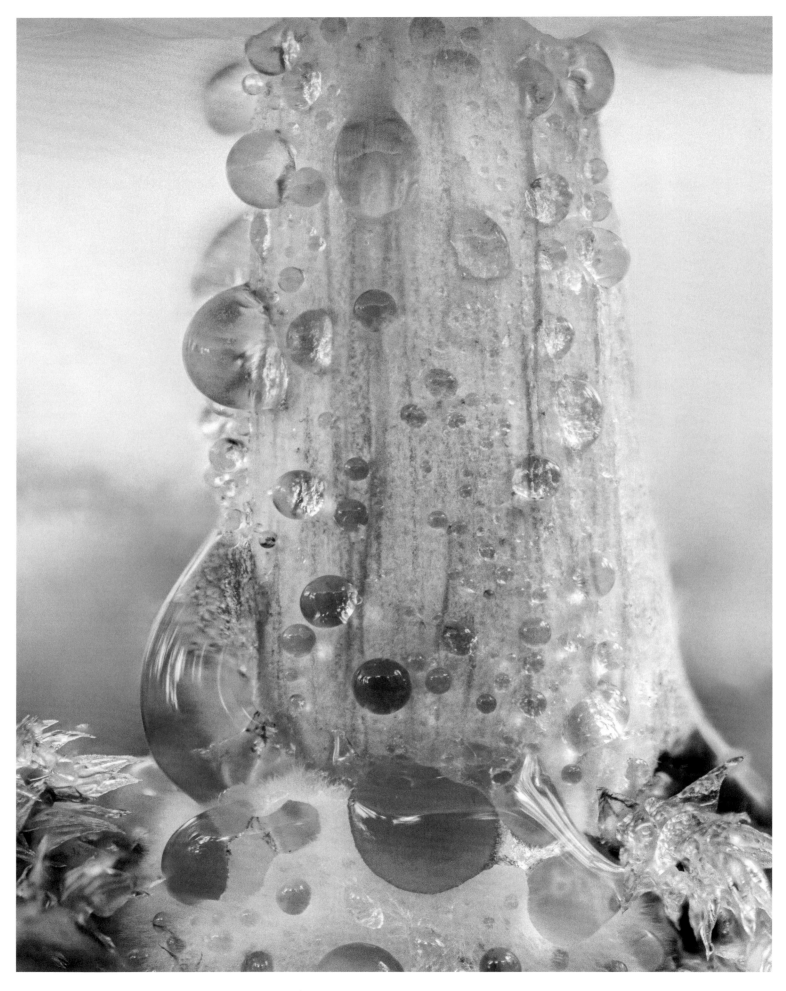

Wrinkled peach | Orangerötlicher Adernseitling *Rhodothus palmatus*

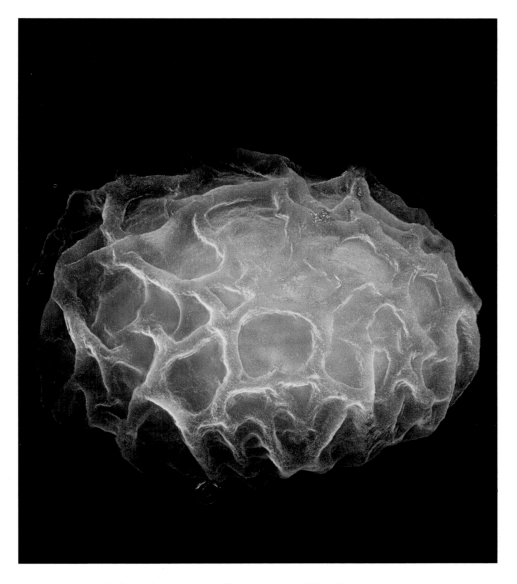

Wrinkled peach | Orangerötlicher Adernseitling *Rhodothus palmatus*

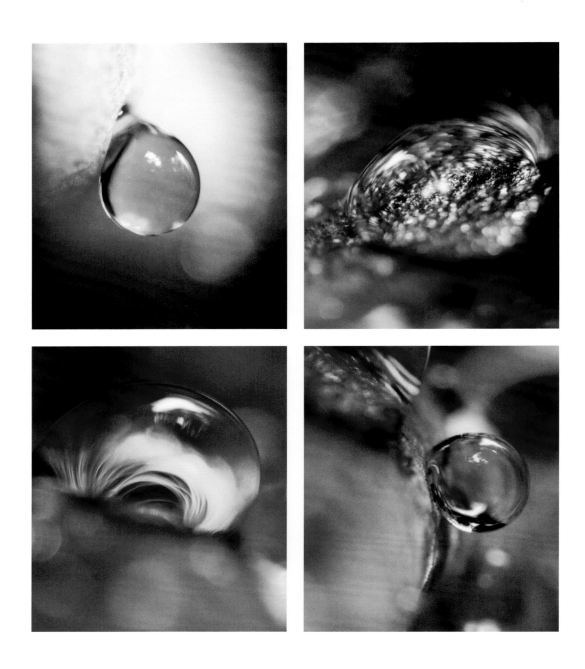

Late fall polypore | Laubholzharzporling *Ischnoderma resinosum*

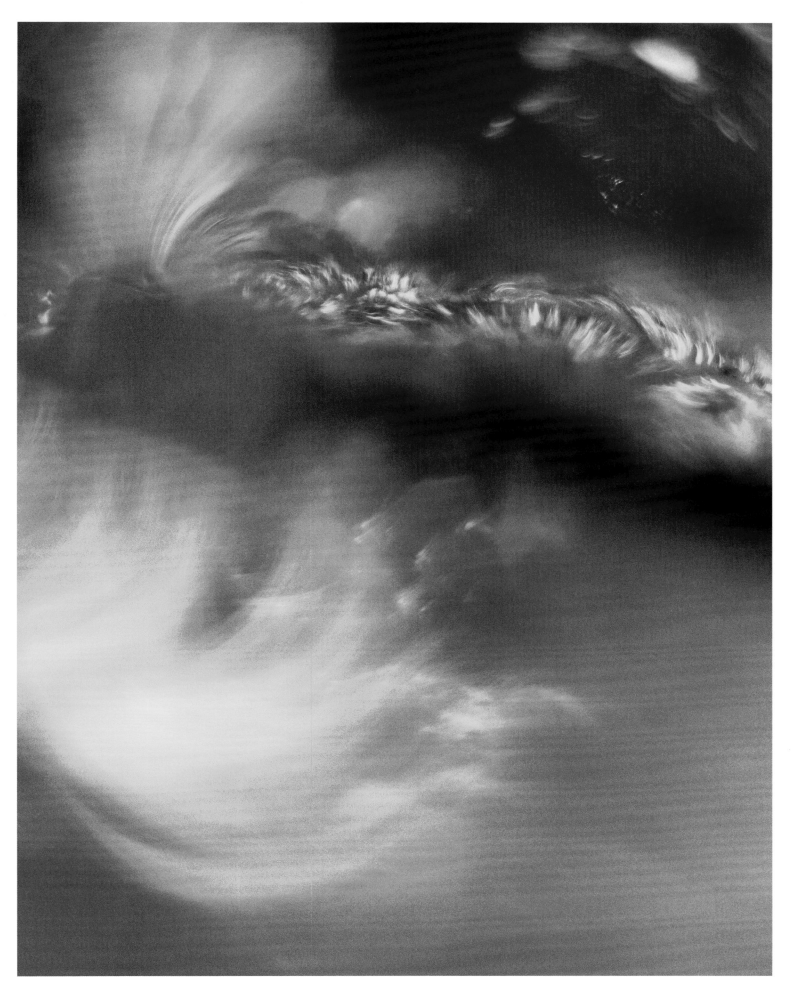

Late fall polypore | Laubholzharzporling *Ischnoderma resinosum*

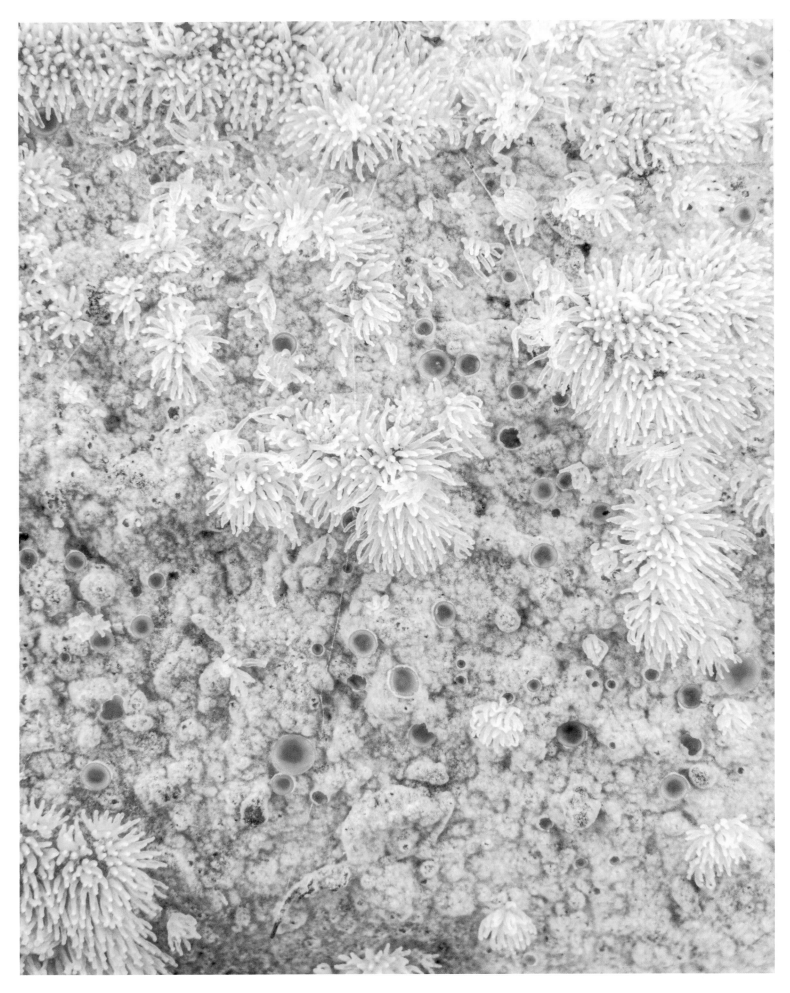

Ceratiomyxia fructiculosa | Geweihförmiger Schleimpilz *Ceratiomyxia fructiculosa*

SLIME MOLDS
SCHLEIMPILZE

Here's a wonder of the world that you might not have thought of before: slime mold. A fascinating and mysterious natural phenomenon, slime mold was initially classified as a fungus. However, as researchers applied increasingly advanced techniques to the study of this group, they found themselves unable to place it firmly in either the plant or

SLIME MOLDS CANNOT BE CLASSED AS ANIMALS, PLANTS, OR FUNGI

animal kingdom. Slime mold produces spores – but that's where its fungal properties end. Now subcategorized as myxomycota and dictyostela, slime molds cannot be classed as animals, plants, or fungi, and scientists are still searching for the correct classification.

Slime mold is actually a shapeless mass of plasmodium containing a large number of nuclei. These nuclei are coated with a tough slime that is left behind as the mold travels. Slime molds form spores, which develop into cells without cell walls. Some of these cells have flagella, while others do not. The separate cells divide and eventually fuse, while the nuclei remain together in the slimy plasmodium. During the mold's mature stage, when spores are formed, the slime develops ball-like structures known as sporangia, which can appear in different colors and sometimes sit atop stalks. These structures are so small that you need a magnifying glass or even a microscope to see them properly.

Some slime molds are visible to the naked eye; dog vomit slime mold, a yellow slimy mass that appears on tree trunks or branches, belongs to this category. Conversely, you may also come across the far more attractive (not to mention attractively named) coral slime and Badhamia utricularis during a stroll through the woods.

Wunder gibt es immer wieder. Dies gilt auch für Schleimpilze. Dieses faszinierende und geheimnisvolle Naturphänomen wurde zunächst als Pilz eingestuft. Als die Forscher jedoch immer fortschrittlichere Techniken zur Untersuchung dieser Gruppe anwandten, konnten sie sie weder dem Pflanzen- noch dem Tierreich zuordnen. Schleimpilze produzieren zwar Sporen, aber hier endet – dem Namen zum Trotz – die Ähnlichkeit mit Pilzen. Die Schleimpilze, die heute als Myxomycota und Dictyostela unterteilt werden, können weder zu den Tieren noch zu den Pflanzen oder Pilzen gezählt werden, und die Wissenschaft ist immer noch auf der Suche nach der richtigen Klassifizierung.

SCHLEIMPILZE KÖNNEN WEDER ZU DEN TIEREN NOCH ZU DEN PFLANZEN ODER PILZEN GEZÄHLT WERDEN

Ein Schleimpilz ist eigentlich eine unförmige Masse, ein Plasmodium mit vielen Zellkernen, die von einem zähen Schleim umhüllt sind, der zurückbleibt, wenn der Pilz wandert. Ein Schleimpilz bildet Sporen, aus welchen sich Zellen ohne Zellwand entwickeln. Einige dieser Zellen haben Geißeln, andere nicht. Die einzelnen Zellen teilen sich und verschmelzen schließlich, während die Zellkerne in dem schleimigen Plasmodium zusammenbleiben. Im adulten Stadium, wenn Sporen gebildet werden, entwickelt der Schleim kugelartige Strukturen, die in verschiedenen Farben erscheinen können und manchmal auf Stielen sitzen. Diese Strukturen sind so klein, dass man eine Lupe oder sogar ein Mikroskop braucht, um sie zu sehen.

Manche Schleimpilze sind jedoch mit bloßem Auge zu erkennen, wie zum Beispiel die Hexenbutter, eine gelbe glibberige Masse auf Baumstämmen oder Ästen. Bei einem Spaziergang im Wald können Sie auch auf den weitaus attraktiveren

Slime molds feed by building a network of fine "threads", forming a natural work of art that you'll be able to spot on rotted tree trunks in the forest, if you know what to look for. Slime molds always take the shortest route to their source of nutrients, but scientists do not yet fully understand how this process works. Just like in the symbiotic world of mycorrhizas and plants, we still have a lot to learn. However, we do know that slime molds don't have brains like humans and animals, nor do they have the senses that we're familiar with. And yet slime molds do seem to be capable of "thinking" – a fact that continues to puzzle scientists to this day.

Geweihförmigen Schleimpilz treffen, einen Vertreter der Gattung Badhamia.

Schleimpilze finden ihre Nahrung auf geheimnisvolle Weise, indem sie eine Art Netz aufbauen, das ein Kunstwerk für sich ist. Mit einem geschulten Auge kann man solche Netze auf verrotteten Baumstämmen finden. Ein Schleimpilz sucht sich immer den kürzesten Weg zu seiner Nahrungsquelle. Wie das funktioniert, ist noch nicht geklärt. Ähnlich wie bei der Symbiose zwischen Mykorrhiza und Pflanzen liegt auch hier noch vieles im Dunkeln. Bekannt ist mittlerweile, dass Schleimpilze weder ein Gehirn haben wie Menschen und Tiere noch über die uns bekannten Sinne verfügen. Und doch scheinen sie in der Lage zu sein, zu „denken" – eine Tatsache, die Wissenschaftler bis heute vor Rätsel stellt.

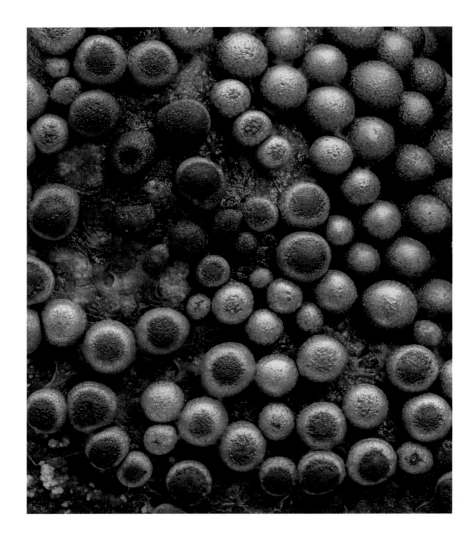

This and right page: **Cribraria aurantiaca** | Diese und rechte Seite: **Cribraria aurantiaca** *Cribraria aurantiaca*

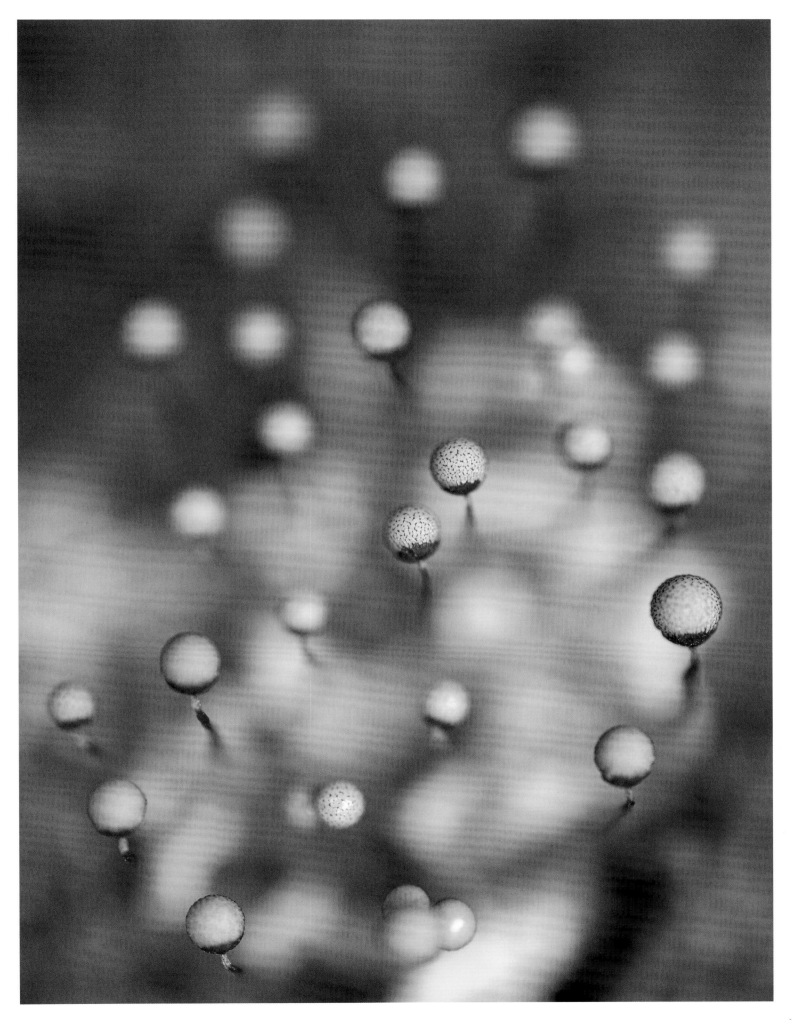

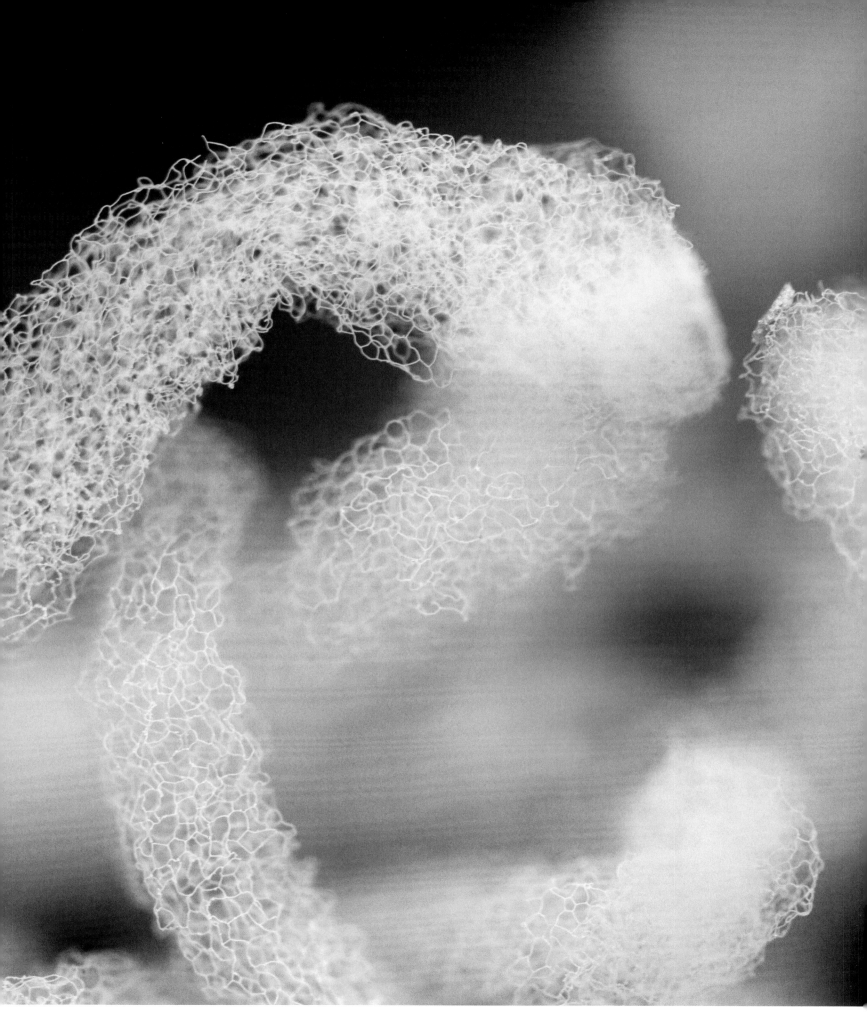

Arcyria obvelata | Nickender Kelchstäubling *Arcyria obvelata*

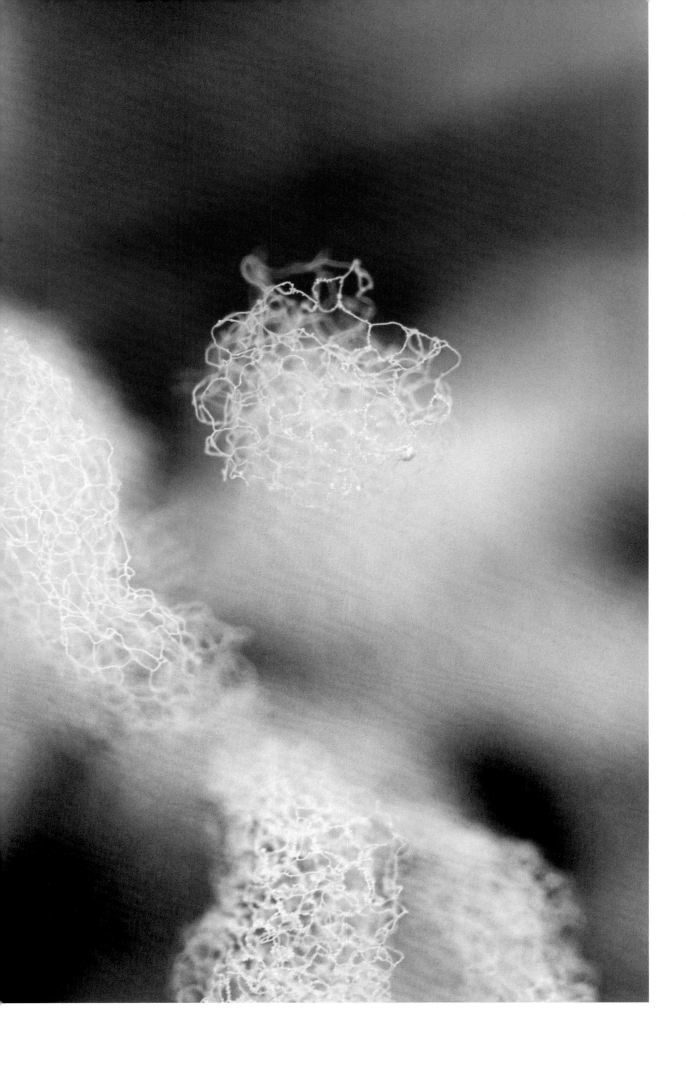

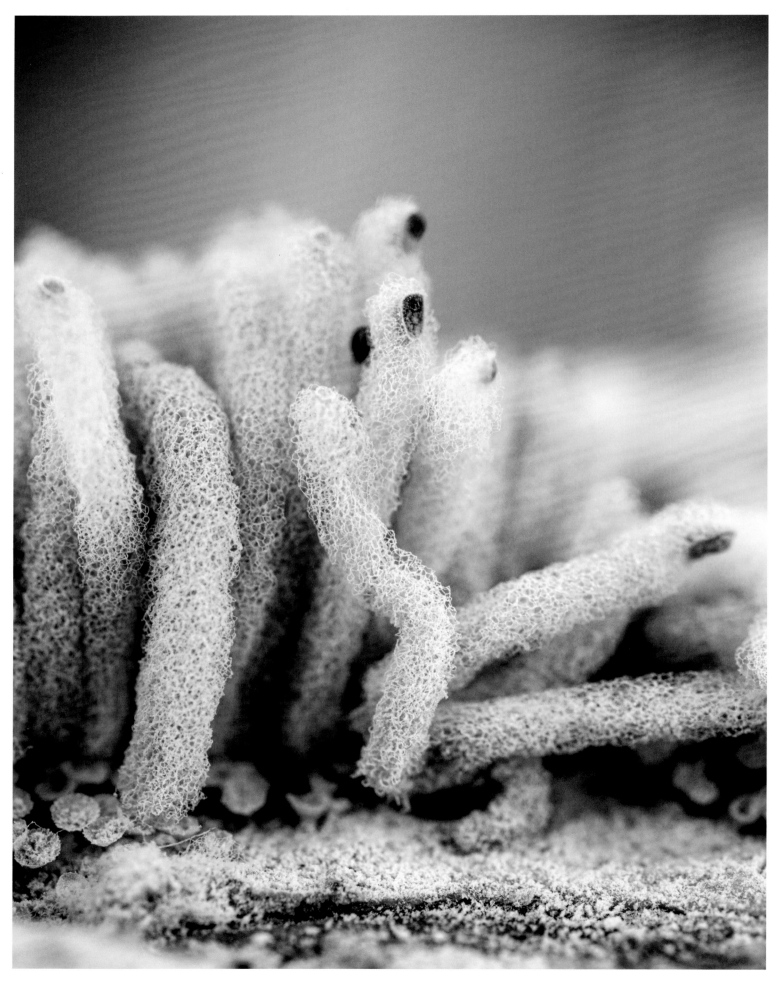

Arcyria obvelata | Nickender Kelchstäubling *Arcyria obvelata*

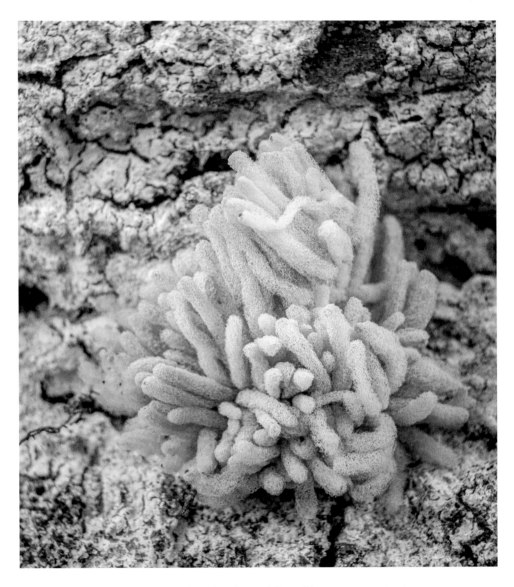

Arcyria obvelata | Nickender Kelchstäubling *Arcyria obvelata*

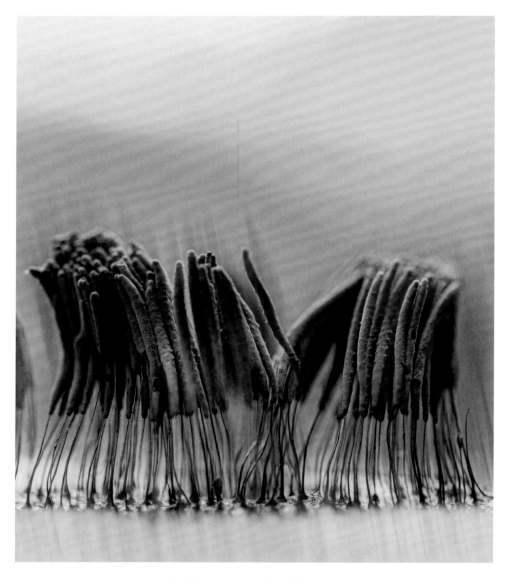

Stemonitis axifera | Kurzes Fadenkeulchen *Stemonitis axifera*

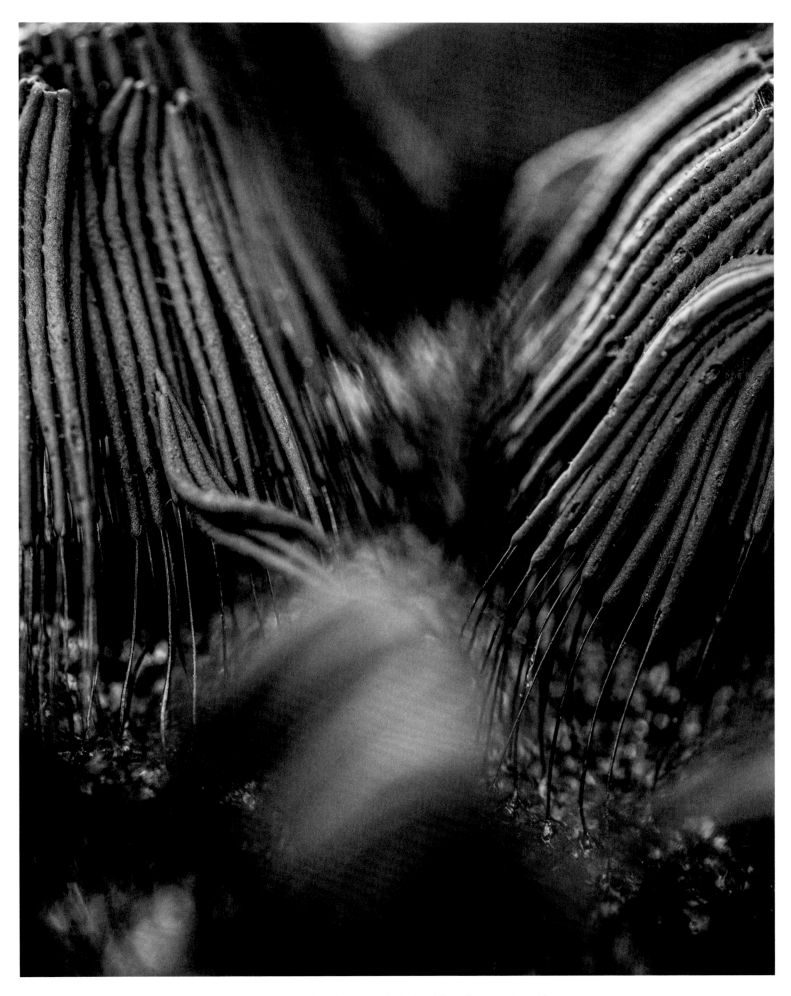

Stemonitis axifera | Kurzes Fadenkeulchen *Stemonitis axifera*

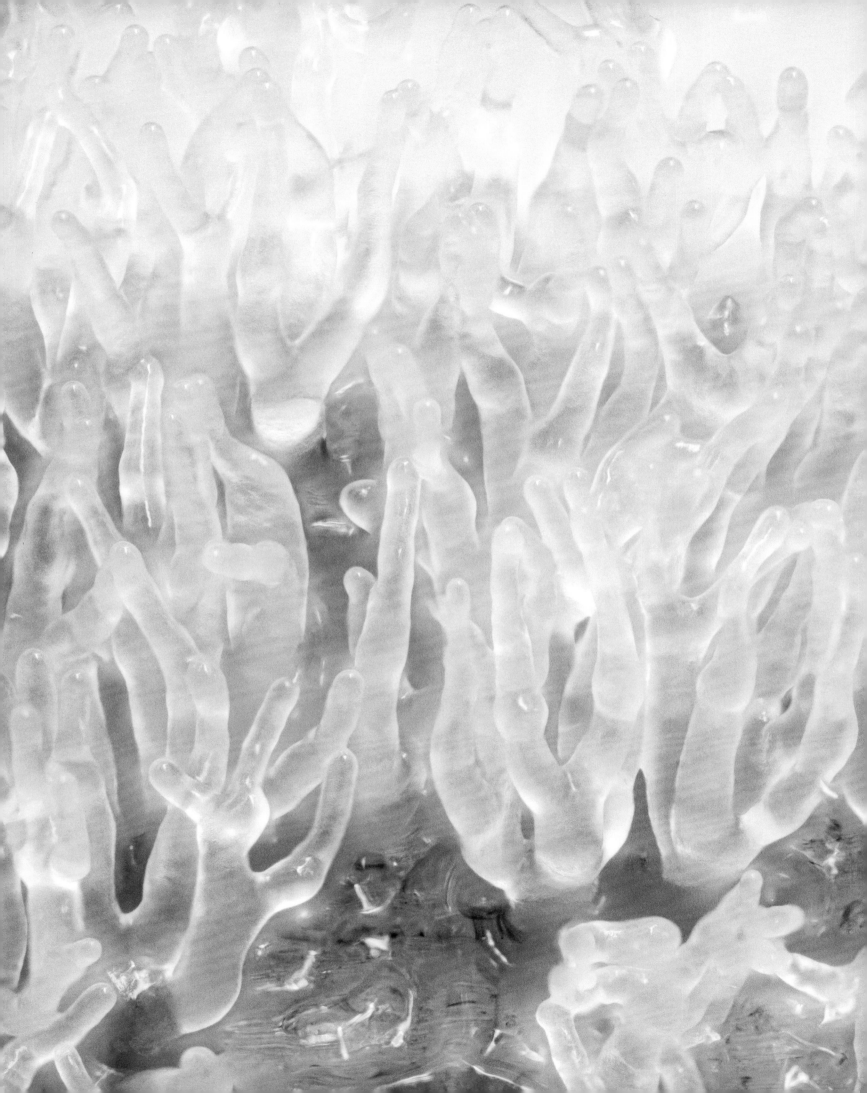

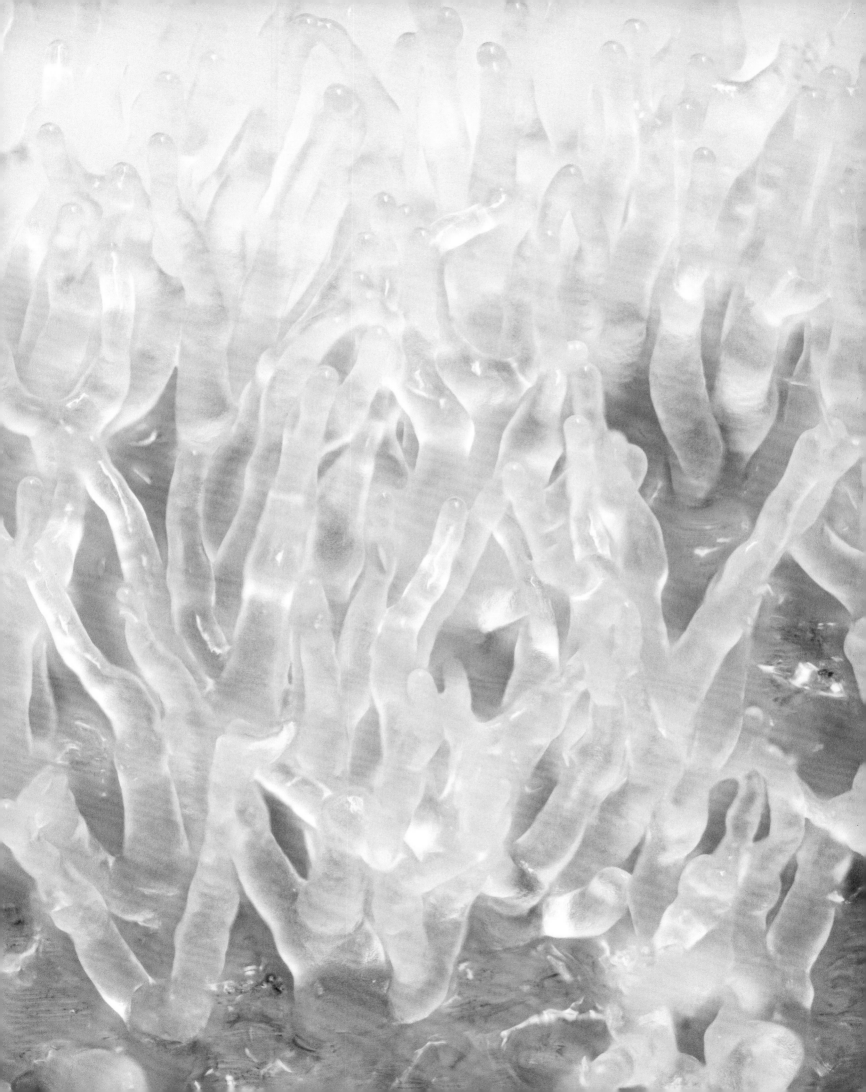

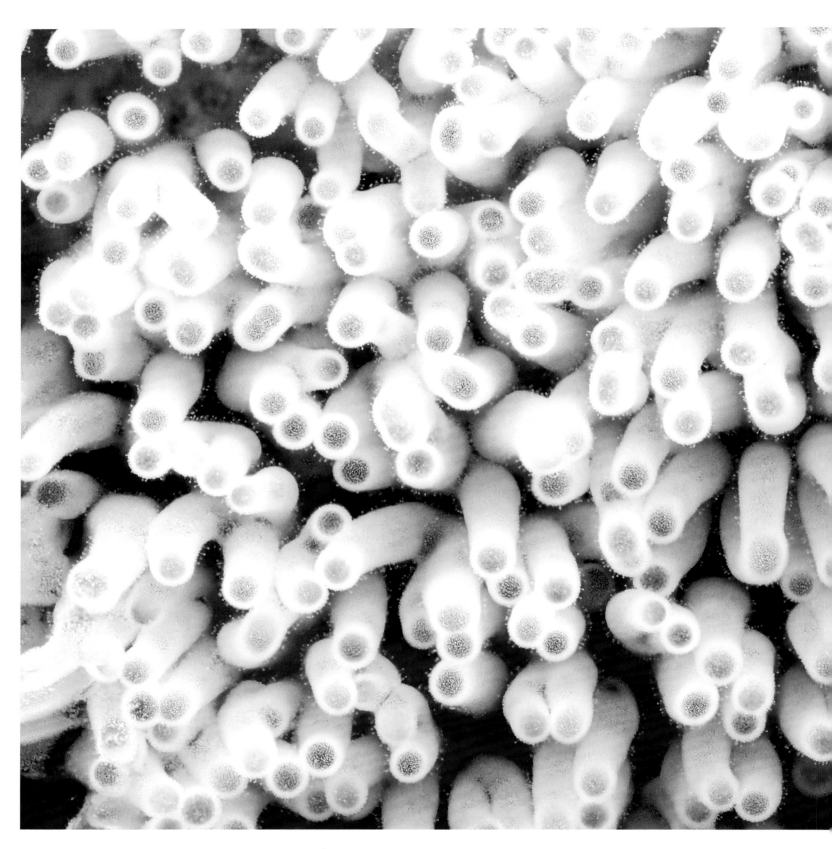

This and previous page: **Honeycomb coral slime mold** | Diese und vorherige Seite: **Geweihförmiger Schleimpilz** *Ceratiomyxia fructiculosa*

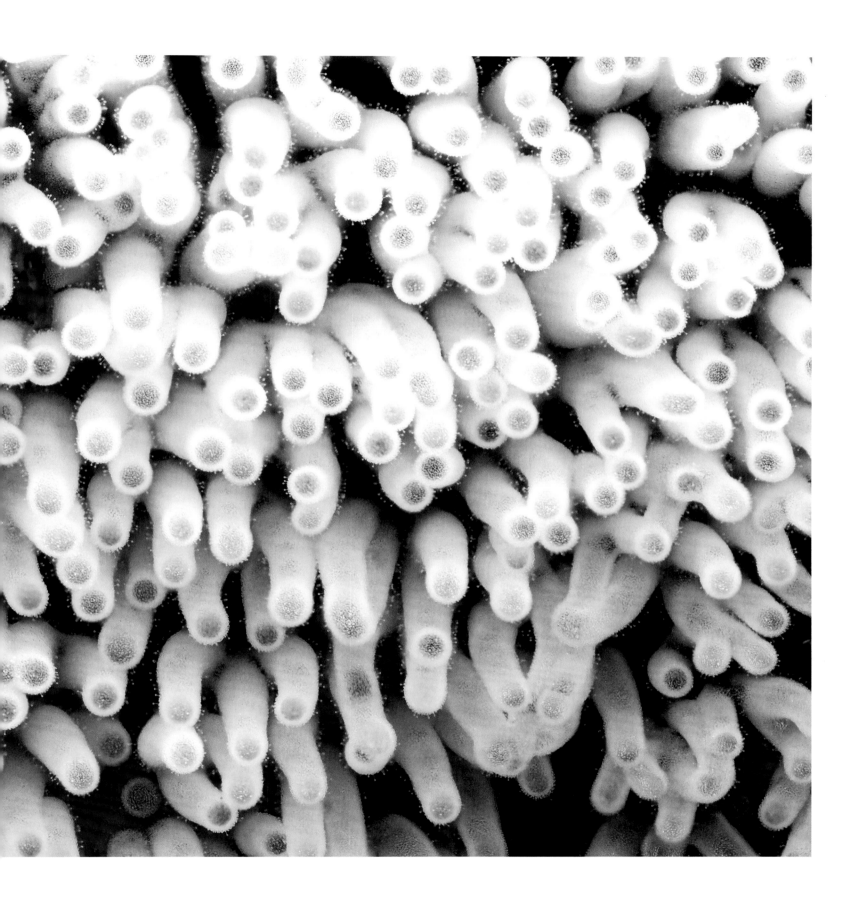

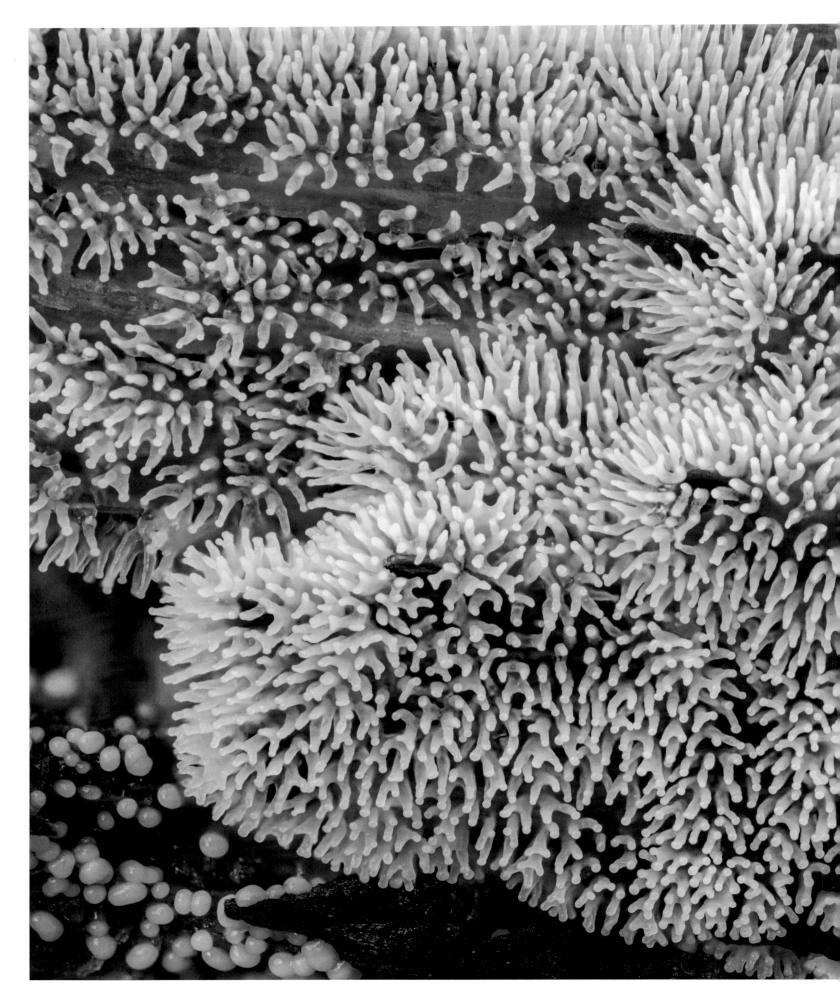

Yellow honeycomb coral slime mold | Geweihförmiger Schleimpilz (Gelbe Variante) *Ceratiomyxia fructiculosa*

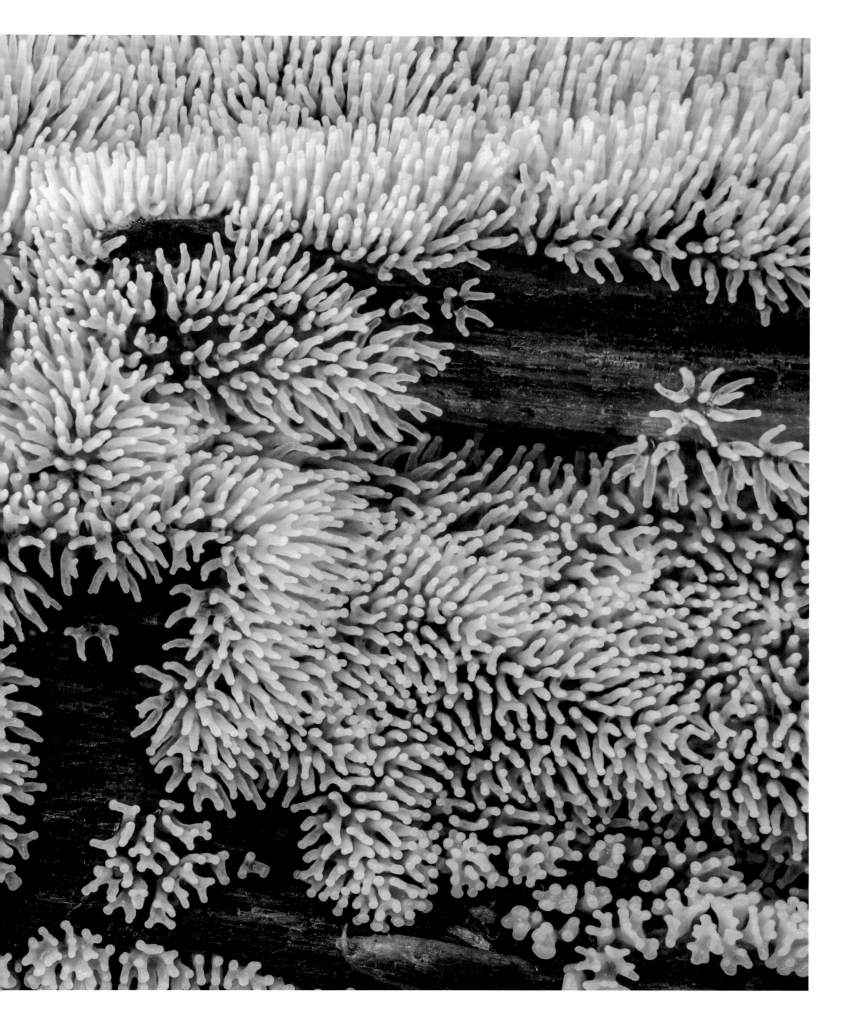

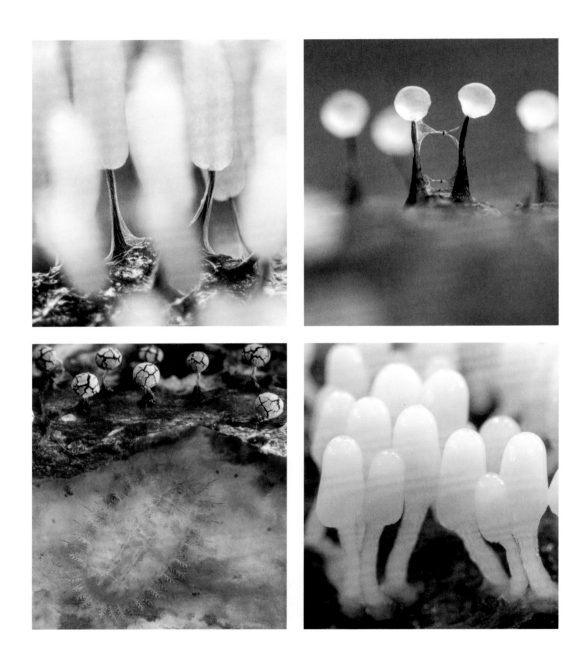

From top left to bottom right | Von links oben nach rechts unten:
Stemonitopsis typhinas | Glänzendes Fadenkeulchen *Stemonitopsis typhinas*
Comatricha nigra | Schiefergraues Fadenkügelchen *Comatricha nigra* / Physarum spec. | Physarum (Schleimpilz-Gattung) *Physarum spec.*
Arcyria cinerea | Grauer Kelchstäubling *Arcyria cinerea*

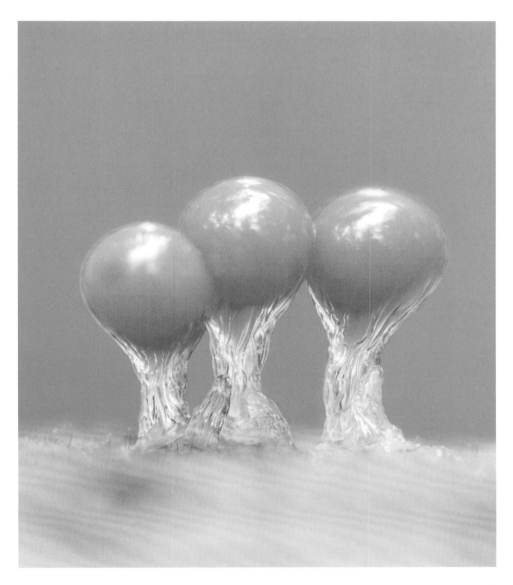

Trichia decipiens | Gestielter Kelchstäubling *Trichia decipiens*

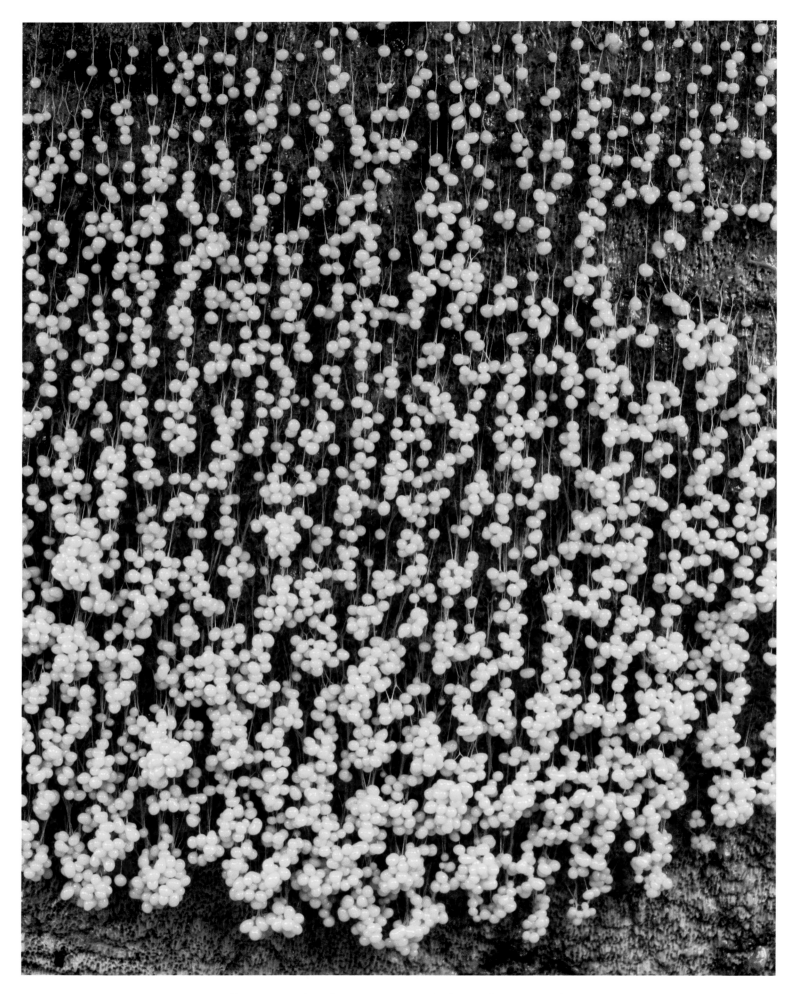

Badhamia utricularis | Verzweigter Hautbecher *Badhamia utricularis*

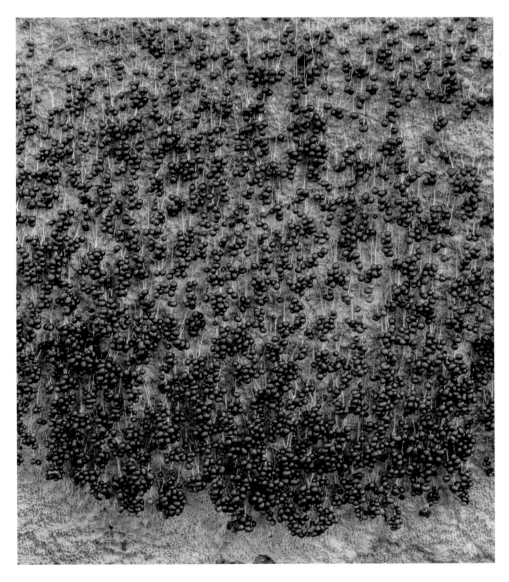

Badhamia utricularis | Verzweigter Hautbecher *Badhamia utricularis*

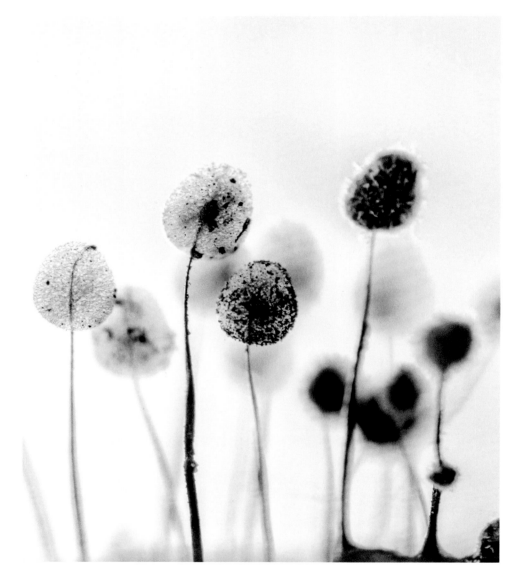

Comatricha nigra | Schiefergraues Fadenkügelchen *Comatricha nigra*

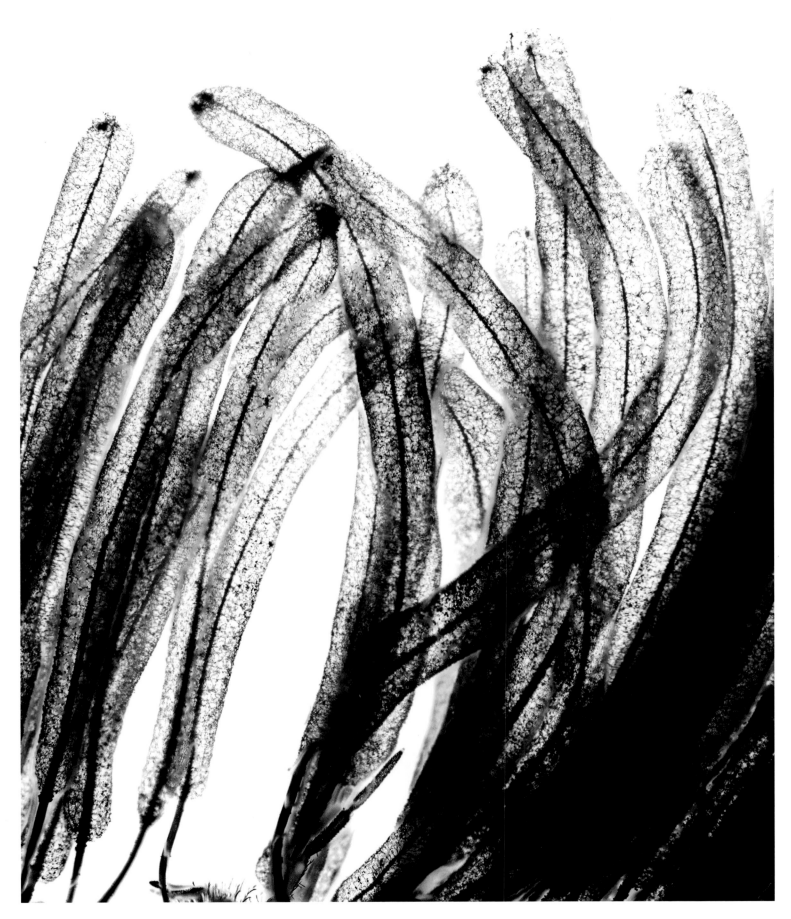

Stemonitis axifera | Kurzes Fadenkeulchen *Stemonitis axifera*

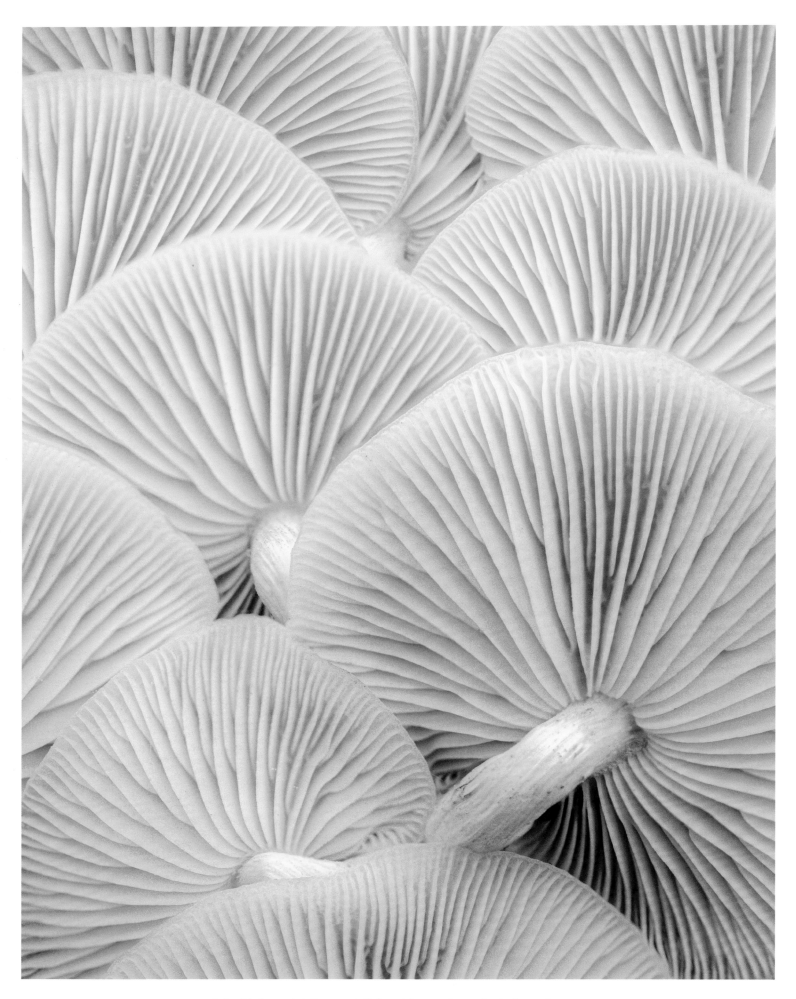

Wrinkled peach | Orangerötlicher Adernseitling *Rhodothus palmatus*

PHOTOGRAPHY
FOTOGRAFIE

When it comes to photographing mushrooms, we have a virtually unlimited array of technology at our disposal. On location, too, the process is relatively straightforward because our subject is static. I use many different tools to photograph these often-hidden wonders in diverse and interesting ways. First and foremost, you need a few different lenses to highlight the many different facets of your subject.

DIFFERENT APPROACHES TO PHOTOGRAPHING MUSHROOMS BECOME EVIDENT IN THE RESULTING IMAGES

In this project, my most frequently used lenses were the Laowa 100-mm lens with 2:1 magnification and the Laowa 25-mm lens with 5:1 magnification. The handy 25-mm lens was primarily used to shoot close-ups of my most miniscule subjects, and it is an absolute must-have for photographing the tiniest details of slime molds.

Virtually all of my photographs are taken using a Benro Bat tripod. Made from lightweight carbon, the tripod can be inverted so that you can maneuver your camera toward your target at ground level with maximum stability and accuracy. This setup enables you to add a focusing rail, which allows you to adjust your focus with complete precision. The superior stability of this equipment gives you access to all of the settings you'll need. A tripod also makes it much easier to set up your composition exactly how you want it, as even the tiniest amount of movement could produce an entirely different result to what you envisaged. Photos without any depth of field – shot using an aperture of f/2.8, for example – don't always require the use of a tripod. Different approaches to photographing mushrooms become evident in the resulting images. Modern cameras are highly

Die technischen Möglichkeiten zum Fotografieren von Pilzen sind grenzenlos. In diesem Bereich gibt es praktisch keine Einschränkungen, da das Objekt stets an seinem Platz bleibt. Ich habe Koffer voller technischer Hilfsmittel eingesetzt, um die oft verborgenen Wunder auf vielfältige und interessante Weise zu erfassen. In erster Linie braucht man einige verschiedene Objektive, um die vielen Facetten des Motivs hervorzuheben.

Das 100-mm-Objektiv von Laowa mit einem Vergrößerungsverhältnis von 2:1 und das 25-mm-Objektiv mit einem Vergrößerungsverhältnis von 5:1 waren die bei diesem Projekt am häufigsten verwendeten Objektive. Das handliche 25-mm-Objektiv habe ich vor allem verwendet, um kleine Motive scharf abzubilden. Für Schleimpilze, die winzig sind, ist diese Linse ein Muss.

DIE VIELFALT DER BILDER BASIERT AUF UNTERSCHIEDLICHSTEN HERANGEHENSWEISEN

Fast alle Fotos wurden mit einem Stativ aus der Benro Bat-Serie aufgenommen. Dieses leichte Karbonstativ kann umgedreht werden, so dass die Kamera mit maximaler Stabilität und Genauigkeit auf das Motiv am Boden ausgerichtet werden kann. Mit einem solchen Aufbau ist es möglich, einen weiteren Makroschlitten hinzuzufügen, der exaktes Fokussieren ermöglicht. Aufgrund seiner großen Stabilität kann man nahezu unbegrenzte Einstellungen vornehmen. Mit einem Stativ ist es auch viel leichter, eine Komposition genau festzulegen – schließlich erzeugt bereits eine minimale Verschiebung schnell ein völlig anderes Bild. Für Fotos ohne Tiefenschärfe, zum Beispiel mit einer Blende von f/2.8, ist ein Stativ nicht immer erforderlich. Die Vielfalt der Bilder basiert auch auf unterschiedlichsten Herangehensweisen. Kameras haben sich technisch erheblich weiterentwickelt, das trifft insbesondere auf die

technical pieces of equipment, and the system camera that I have been using for some time now is no exception. Even though noise no longer presents an issue regardless of your settings, I still primarily use low ISO settings – simply because I can and because it has no impact on the end results.

I choose my lens out in the field. If there's a lot of space around my subject, I sometimes opt to reflect that in my composition. A 200-mm lens with an aperture setting of f/2.8 will produce a soft background, as seen in the image on page 12. If I want to soften up the image even more, as I've done in the photographs on pages 184/185, then I use my 40-year-old 50-mm Fujinon lens.

This approach is the complete opposite of what I do when I want my image to be as sharp as possible; in these situations, I use focus stacking. This process uses software to layer separate photos on top of one another, which enables you to achieve extremely sharp images with millimeter precision. Generally, the photographer takes a large number of photos of the same subject, gradually shifting the focus each time. The image on page 145 shows a wrinkled peach mushroom that measures at most three centimeters across; I took over 400 RAW photos of this mushroom and stacked them to create a single, super-sharp image.

Systemkamera zu, mit der ich seit einiger Zeit fotografiere. Obwohl das Rauschen selbst bei hohen ISO-Einstellungen nicht mehr ins Gewicht fällt, verwende ich hauptsächlich niedrige. Einfach, weil es machbar ist und das Endergebnis nicht beeinflusst.

Die Wahl des Objektivs treffe ich vor Ort. Wenn es um mein Motiv herum viel Platz gibt, entscheide ich mich manchmal dafür, dies in der Bildkomposition widerzuspiegeln. Ein 200-mm-Objektiv mit einer Blendeneinstellung von f/2.8 erzeugt einen weichen, sanften Hintergrund, wie auf Seite 12 gezeigt. Wenn ich mich für eine noch weichere Zeichnung im Bild entscheide, wie auf den Seiten 184/185, verwende ich zu diesem Zweck ein über 40 Jahre altes 50-mm-Fujinon-Objektiv.

Das genaue Gegenteil stellen die Motive dar, bei denen maximale Schärfe gewünscht ist. Hier verwende ich die Technik des Focus Stacking. Bei diesem Verfahren werden mit Hilfe einer Software einzelne Fotos übereinandergelegt, wodurch sich extrem scharfe Bilder mit Millimetergenauigkeit erzielen lassen. Ich nehme eine große Anzahl von Fotos desselben Motivs auf und verschiebe dabei jedes Mal den Fokus. Beim Orangerötlichen Adernseitling auf Seite 145, der gerade einmal einen Durchmesser von drei Zentimetern hat, wurden über 400 Fotos im RAW-Format zu einem einzigen superscharfen Bild zusammengefügt.

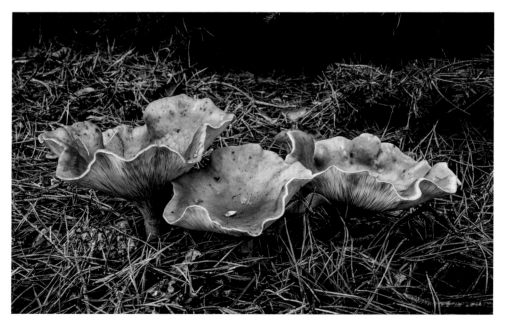

This page: **Tawny funnel** | Diese Seite: **Fuchsiger Rötelritterling** *Lepista flaccida*
Right page: **Scarletina bolete** | Rechte Seite: **Flockenstieliger Hexenröhrling** *Neoboletus erythropus*

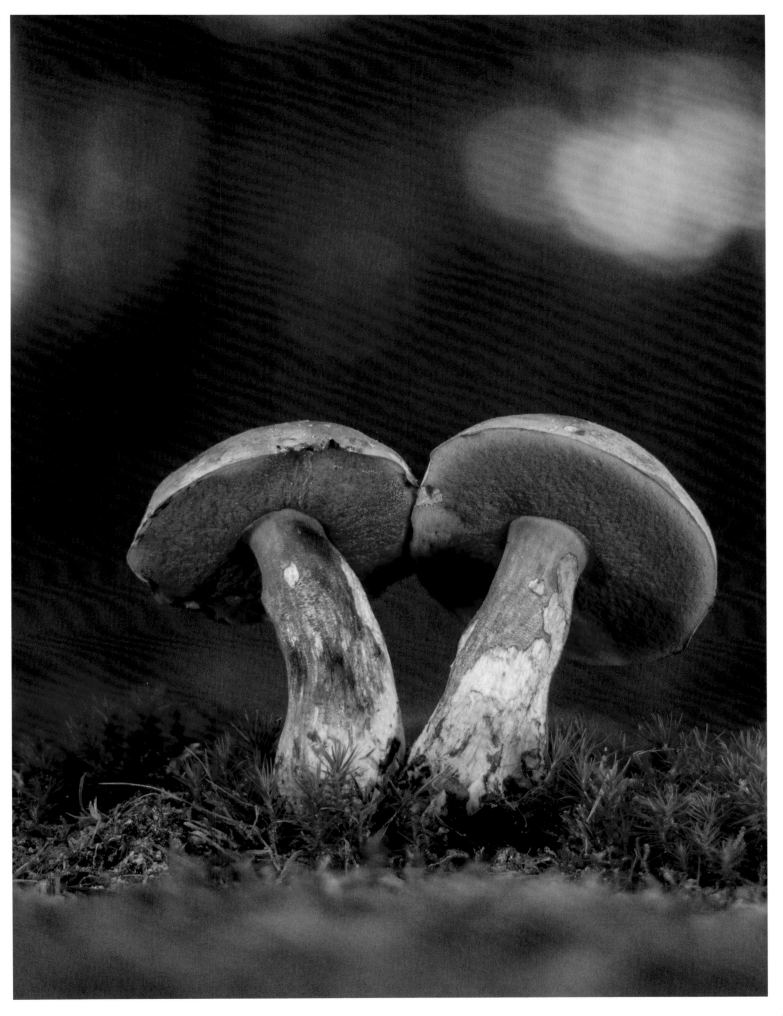

Verdigris roundhead | Grünspanträuschling *Stropharia aeruginosa*

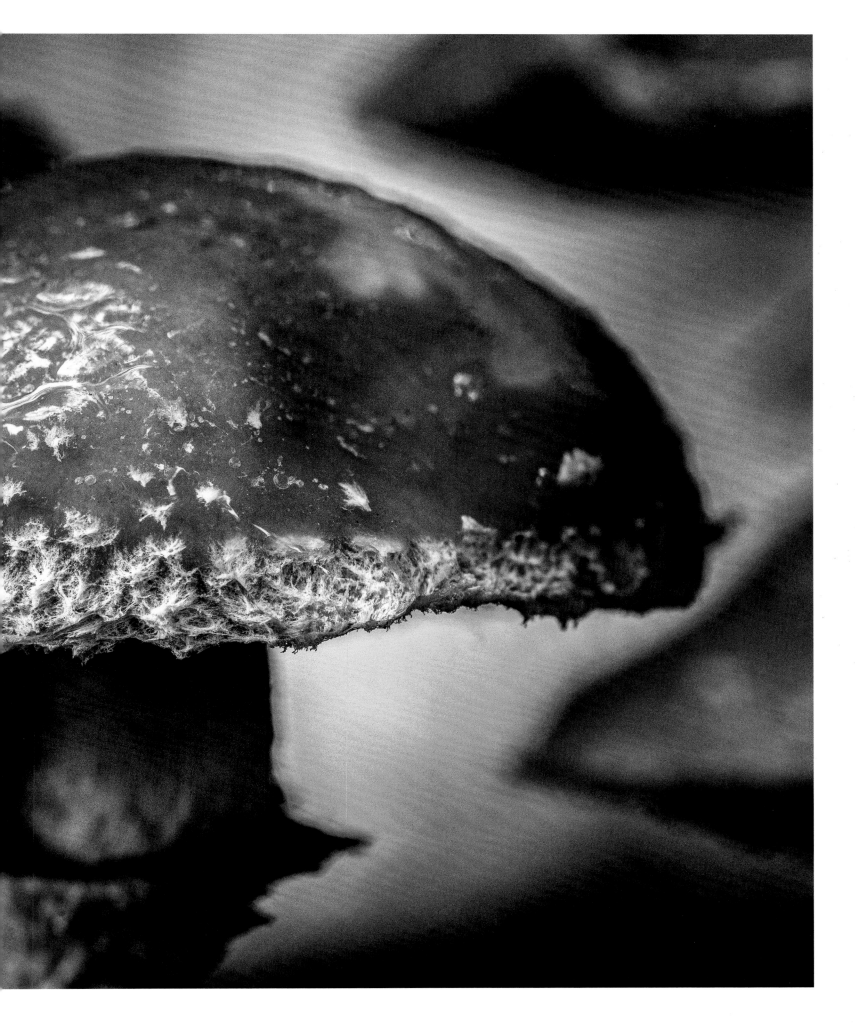

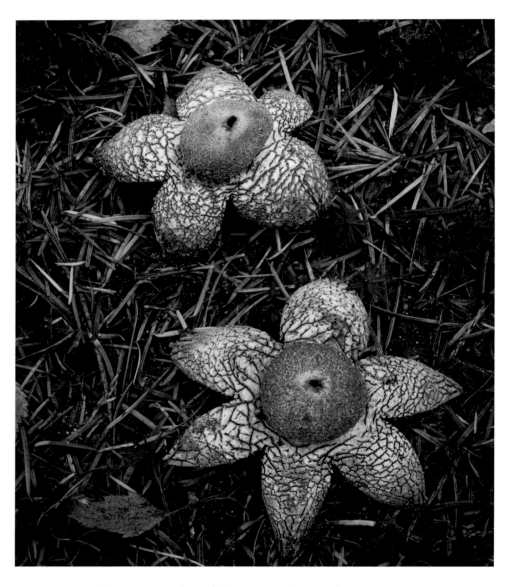

Barometer earthstar | Wetterstern *Astraeus hygrometricus*

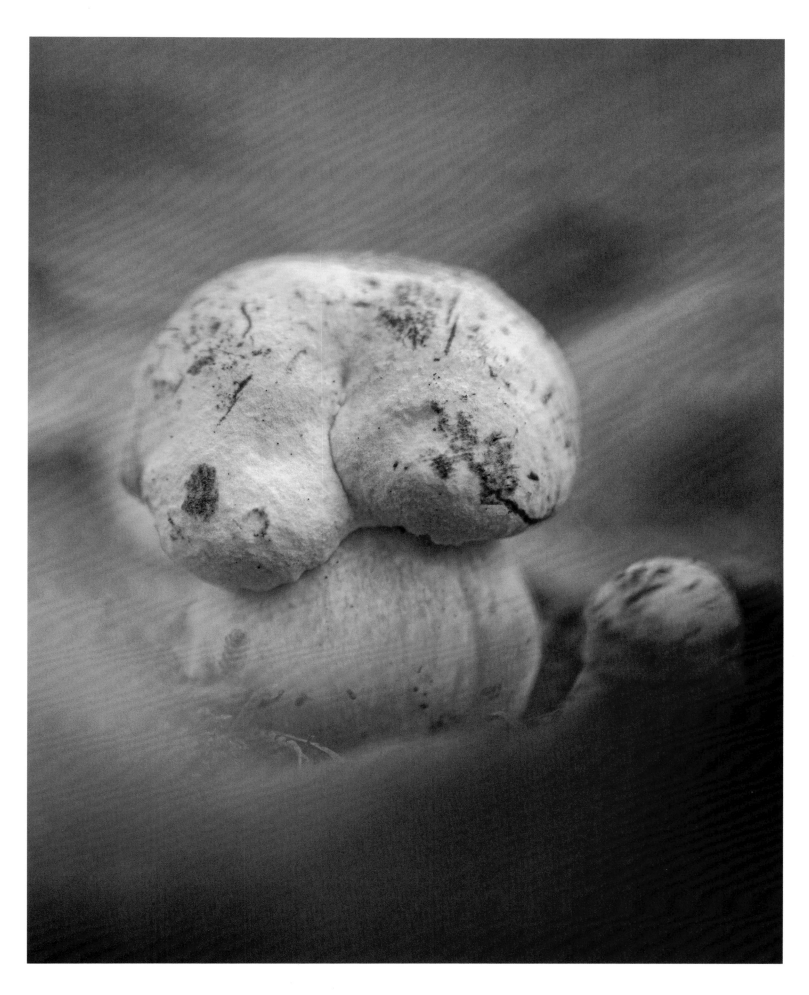

Yellow bolete | Falscher Schwefelröhrling *Neoboletus erythropus forma pseudosulphureus*

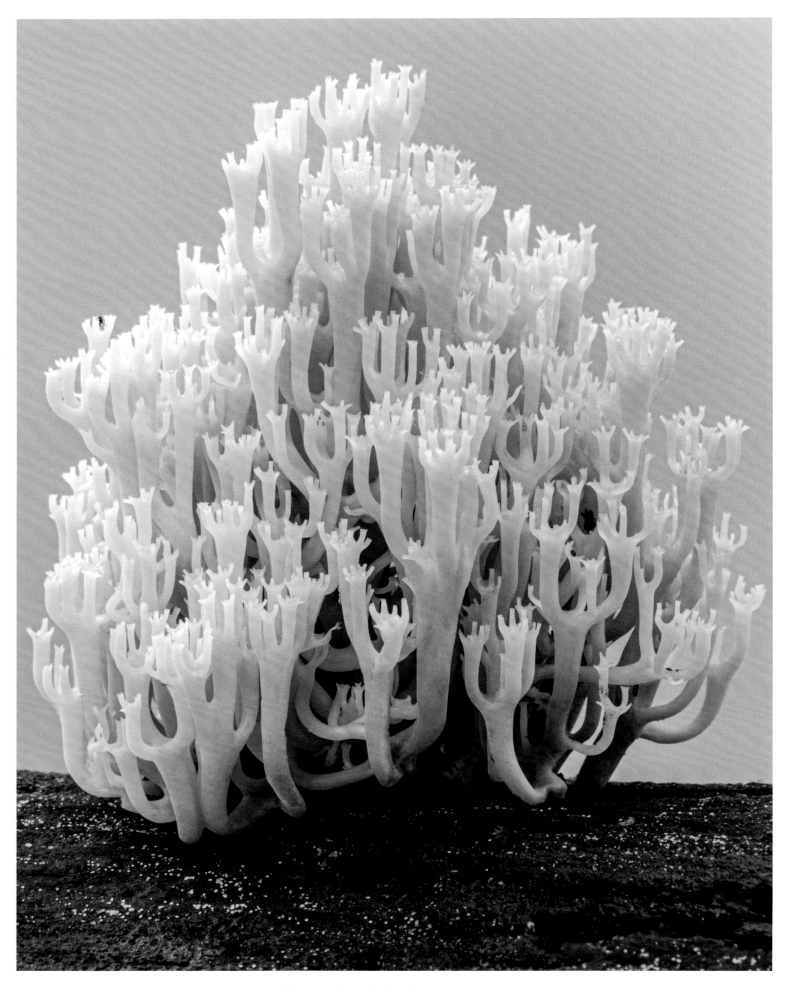

Candelabra coral | Becherkoralle *Artomyces pyxidatus*

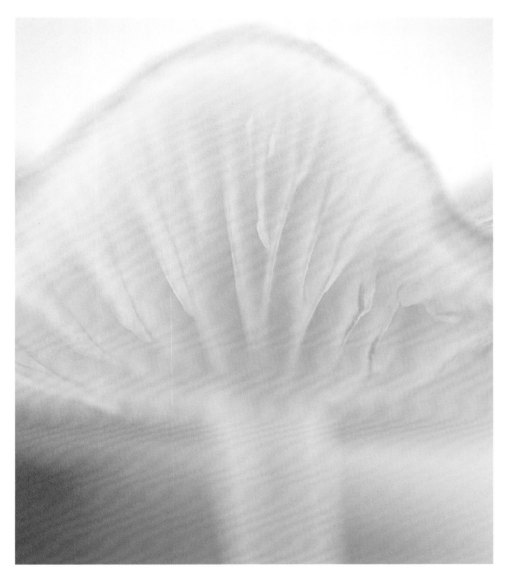

Tawny grisette | Rotbrauner Streifling *Amanita fulva*

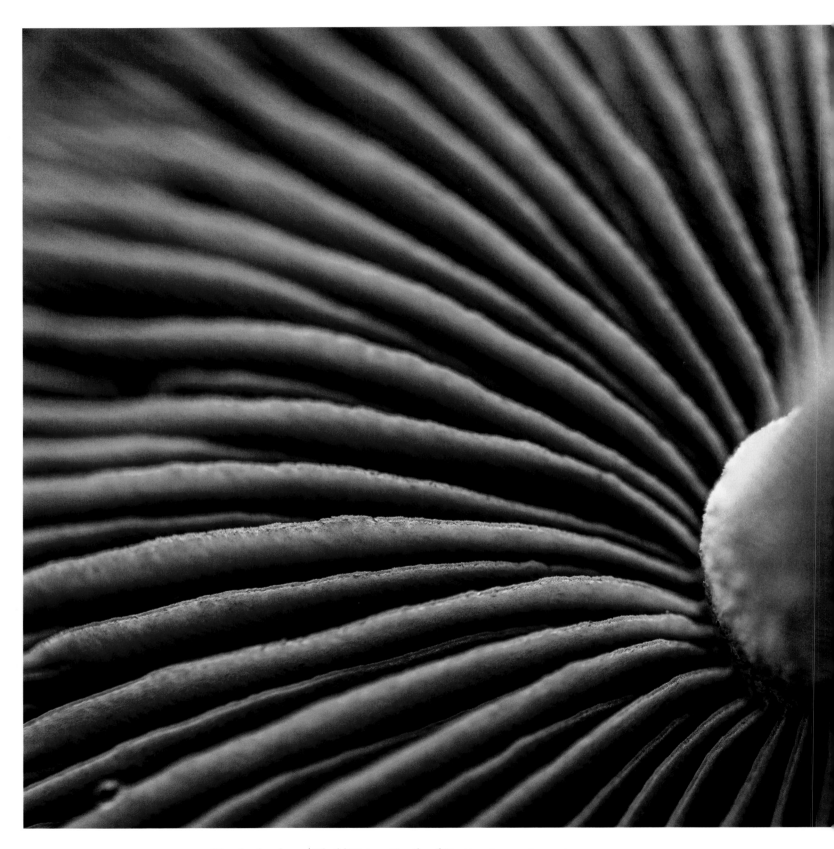

Bloodred webcap | Blutblättriger Hautkopf *Cortinarius semisanguineus*

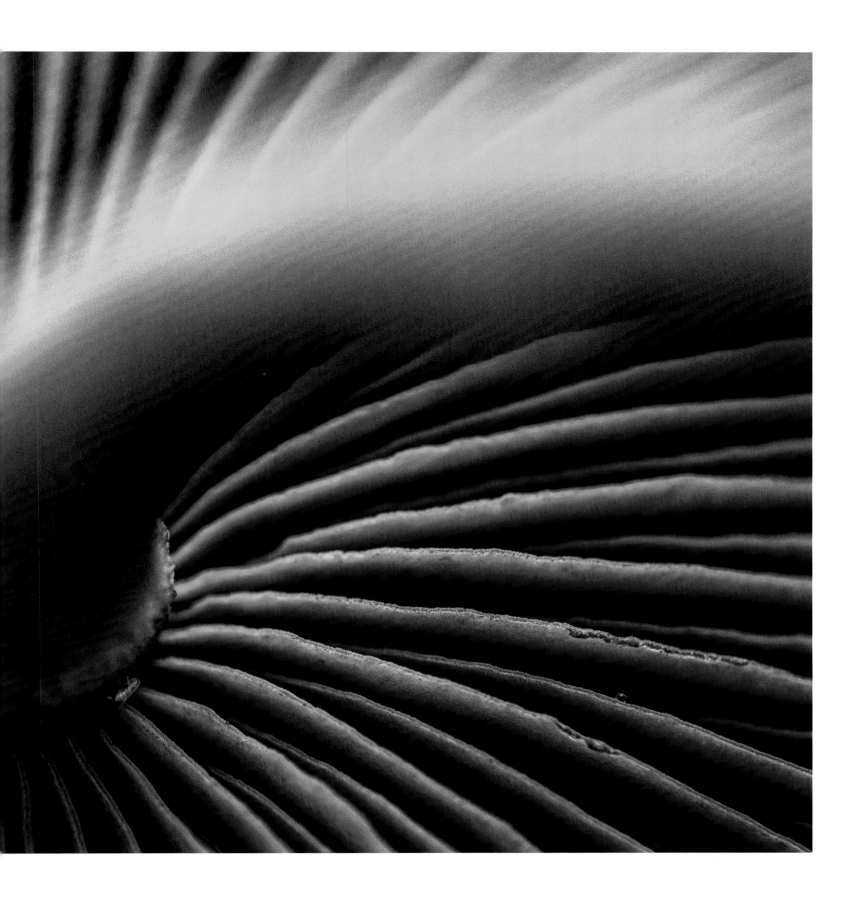

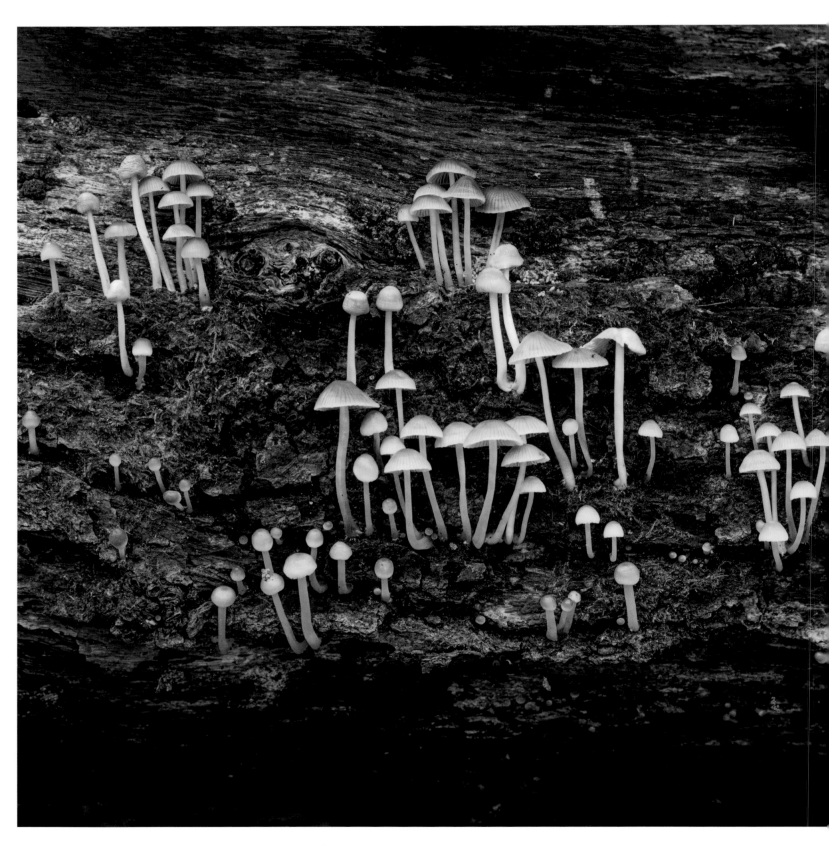

Yellow leg bonnet | Dehnbarer Helmling *Mycena epipterygioides*

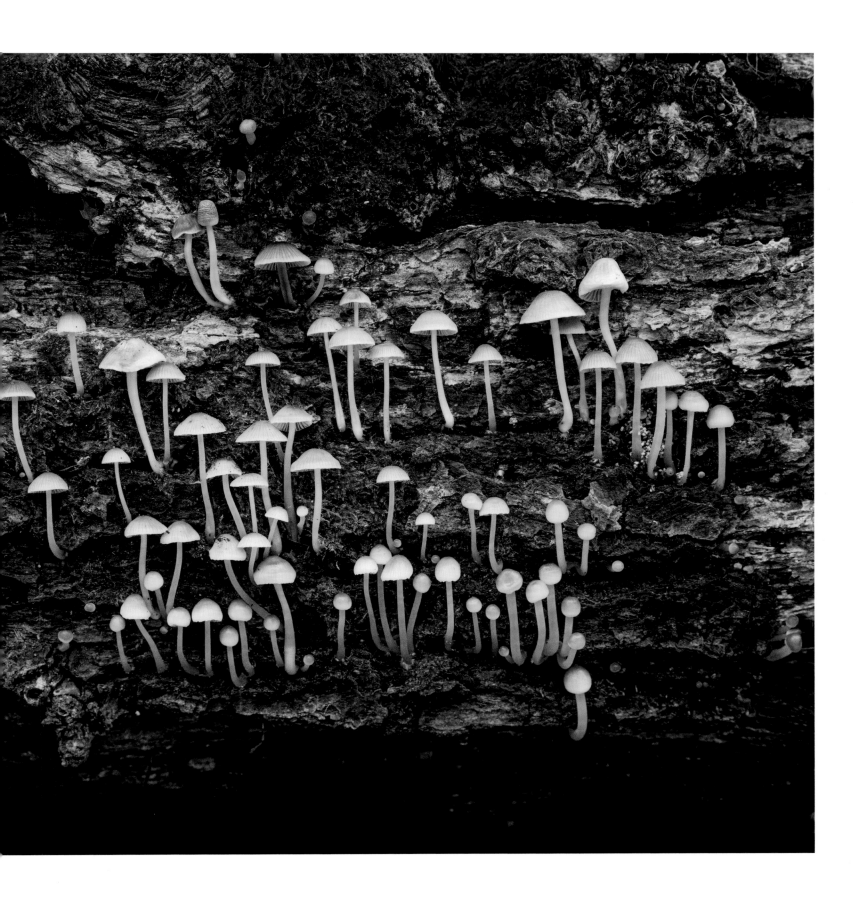

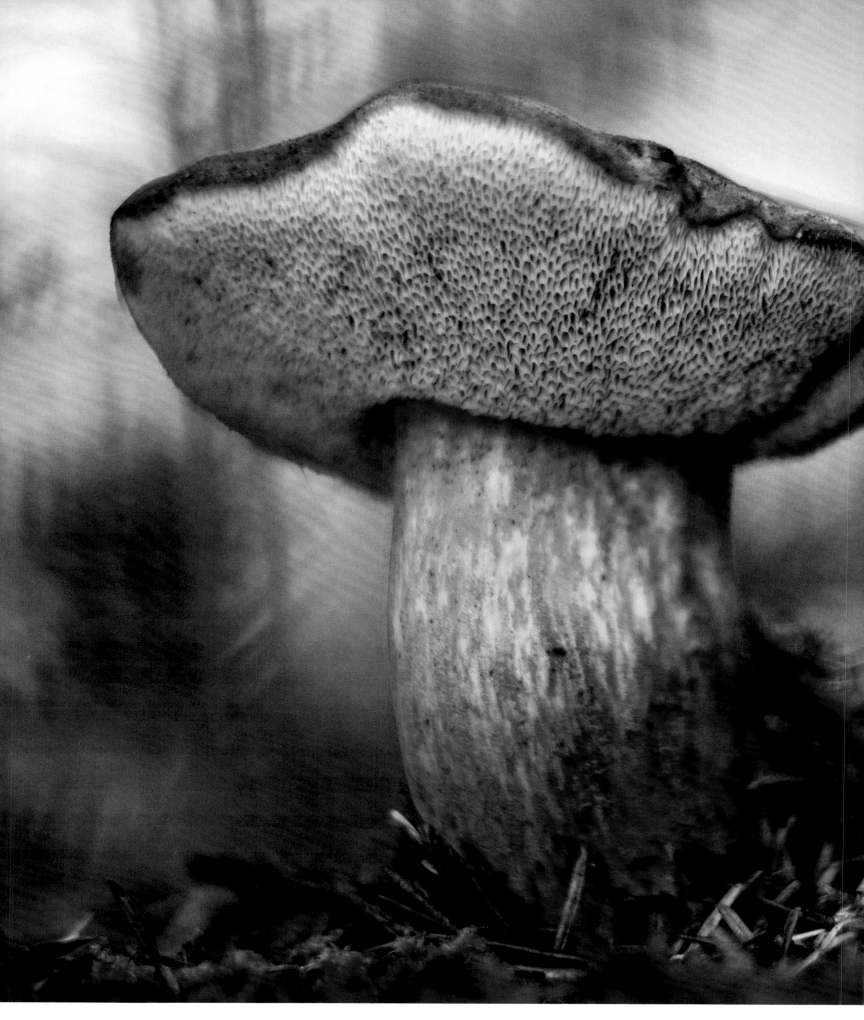

Bay bolete | Maronenröhrling *Imleria badia*

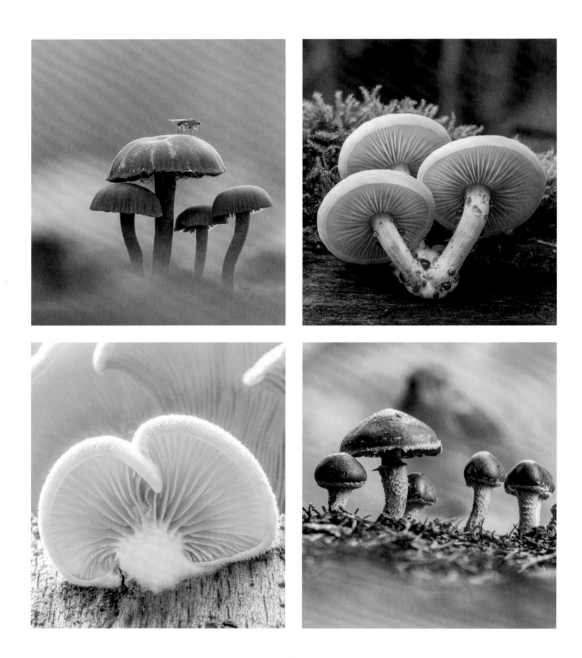

From top left to bottom right / Von links oben nach rechts unten:

Amethyst deceiver | Violetter Lacktrichterling *Laccaria amethystina* / Wrinkled peach | Orangerötlicher Adernseitling *Rhodothus palmatus*

Orange mock oyster | Orangeseitling *Phyllotopsis nidulans* / Verdigris roundhead | Grünspanträuschling *Stropharia aeruginosa*

IN CONCLUSION
RÜCKBLICK

So, here we are: a book about mushrooms. Who would have thought there was so much to say! I heard comments like this constantly from the moment I announced my intention to create this book.

In the foreword, I talked about how I became so fascinated by the fungal world all around us and how my passion developed into an obsession. The impetus for this book came unexpectedly, when Aart Aarsbergen (editor-in-chief for the Dutch edition of National Geographic between 2001 and 2018) encouraged me to "at least think about" writing a book all about mushrooms. I didn't see this project coming, but when the opportunity arose I grabbed it with both hands – and this book is the result.

I DIDN'T SEE THIS PROJECT COMING, BUT WHEN THE OPPORTUNITY AROSE I GRABBED IT WITH BOTH HANDS

I would also like to thank Robbert Vermue, editor-in-chief for the Dutch/Belgian edition of National Geographic, who generously dedicated space to my mushroom project in his magazine. After that edition was published, magazines in Norway, Sweden, Germany and the Netherlands also began to feature my photography and my project.

Of the thousands of species of mushrooms out there, I made a wishlist of the ones I absolutely had to feature in this book. Some mushrooms had to be crossed off the list because they looked a little too similar to other varieties that just had the edge in terms of aesthetic appeal. I haven't indicated where each of the featured mushrooms grows, because their appearance can be unpredictable and sometimes they can disappear from an area seemingly without

Ein Buch über Pilze – wie kommt man darauf? Diese Bemerkung bekomme ich ständig zu hören, seit ich es mir zum Ziel gesetzt habe, ein solches Buch zu veröffentlichen.

Im Vorwort habe ich bereits erwähnt, wie es zu diesem Sujet kam und wie meine Begeisterung entstand. Es war jedoch Aart Aarsbergen (Chefredakteur der niederländischen Ausgabe von National Geographic von 2001 bis 2018), der mich dazu drängte, „kurz" einmal über ein Pilzebuch nachzudenken. Ich habe dieses Projekt nicht kommen sehen, aber als sich die Gelegenheit ergab, habe ich sie mit beiden Händen ergriffen – das Ergebnis ist dieses Buch über die unentbehrliche Welt der Pilze.

Mein aufrichtiger Dank geht auch an Robbert Vermue, Chefredakteur von National Geographic, Ausgabe Niederlande/Belgien, der meinem Pilzprojekt vorbehaltlos Platz in der Zeitschrift eingeräumt hat. Nach der Veröffentlichung dieser Ausgabe berichteten auch Zeitschriften in Norwegen, Schweden, Deutschland und den Niederlanden über meine Fotos und mein Projekt.

ICH HABE DIESES PROJEKT NICHT KOMMEN SEHEN, ABER ALS SICH DIE GELEGENHEIT ERGAB, HABE ICH SIE MIT BEIDEN HÄNDEN ERGRIFFEN

Von den Tausenden von Pilzarten, die es da draußen gibt, habe ich eine Wunschliste derjenigen erstellt, die ich unbedingt in diesem Buch vorstellen wollte. Manch ein Vertreter seiner Gattung musste jedoch einem Exemplar weichen, dass eben noch ein klein wenig attraktiver aussah. Ich habe nicht angegeben, wo jeder der vorgestellten Pilze wächst, weil ihr Auftreten unvorhersehbar sein kann und sie manchmal scheinbar grundlos aus einem Gebiet wieder verschwinden. Bewusst

reason. I deliberately opted to create a book that emphasizes the innate beauty of the mushrooms, which is why the photographs aren't accompanied by reams of detailed information. However, I have included the scientific and common names of the mushrooms depicted in each image.

While I was out in the field, other photographers, mushroom aficionados and nature lovers shared their passion with me. Thank you to each and every one of you, and my special thank goes to those who shared their discoveries and knowledge with me: Gio van Bernebeek, Rob Chrispijn, Menno Boomsluiter, Tjerk Busstra, Bart Horvers, Rob van Keulen, Laurens van der Linde, Carolien Londerman, Walter van Os, Marjolein Tschur, Wob Veenhoven, Inge van Westen, and my brother Arie Vermeer.

wurde der Schwerpunkt auf die optische Schönheit gelegt, weshalb ich keine ausführlichen Texte zu den Fotos verfasst habe. Natürlich ist bei jedem Bild der deutsche und der wissenschaftliche Name angegeben.

Während ich in der Natur unterwegs war, teilten andere Fotografen, Pilzkenner und Naturliebhaber ihre Leidenschaft mit mir. Insbesondere möchte ich hier folgenden Personen danken, die einen tollen Fund oder ihr Wissen mit mir geteilt haben (ich hoffe, ich habe niemanden vergessen): Gio van Bernebeek, Rob Chrispijn, Menno Boomsluiter, Tjerk Busstra, Bart Horvers, Rob van Keulen, Laurens van der Linde, Carolien Londerman, Walter van Os, Marjolein Tschur, Wob Veenhoven, Inge van Westen – und meinem Bruder Arie Vermeer.

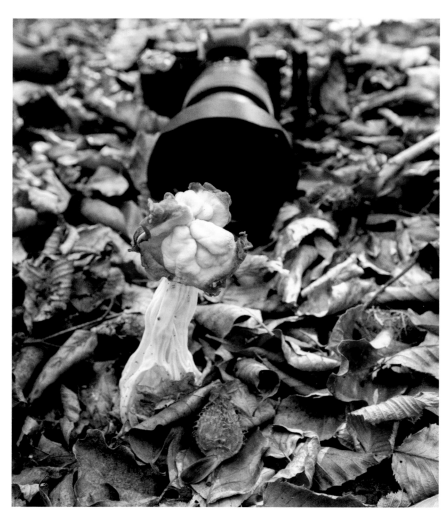

This page: **Trumpet chanterelle** | Diese Seite: **Trompeten-Pfifferling** *Cantharellus tubaeformis*
Right page: **Ear-pick fungus** | Rechte Seite: **Ohrlöffel-Stacheling** *Auriscalpium vulgare*
Following page: **Wine roundhead** | Nächste Seite: **Riesenträuschling** *Stropharia rugosoannulata*

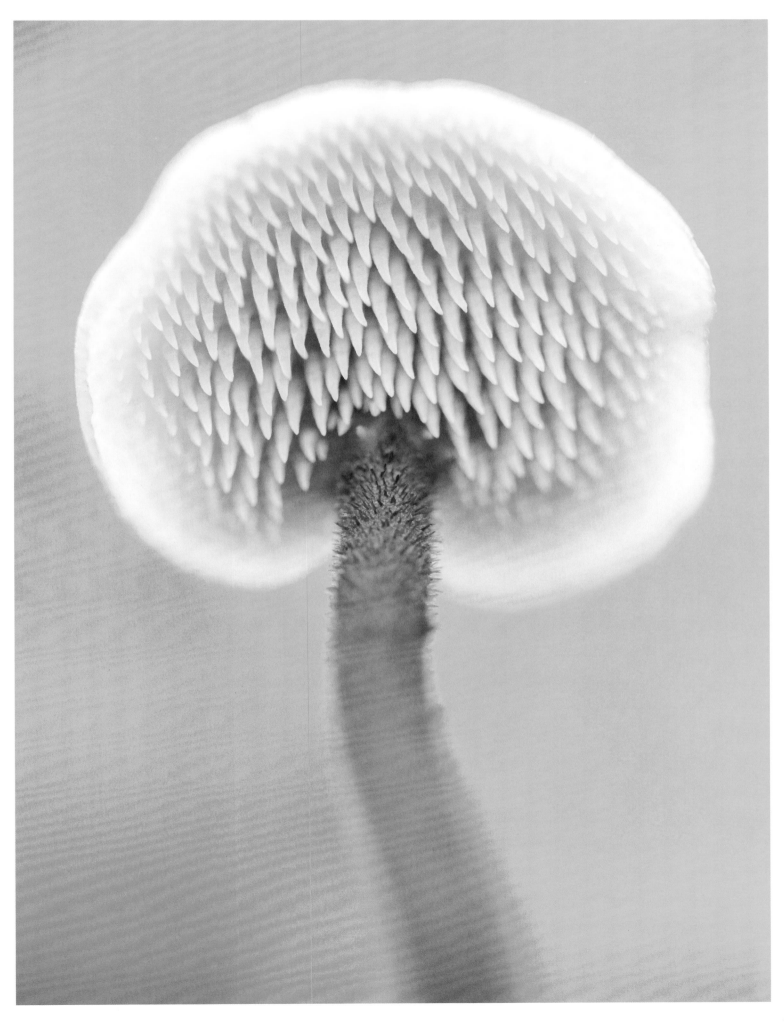

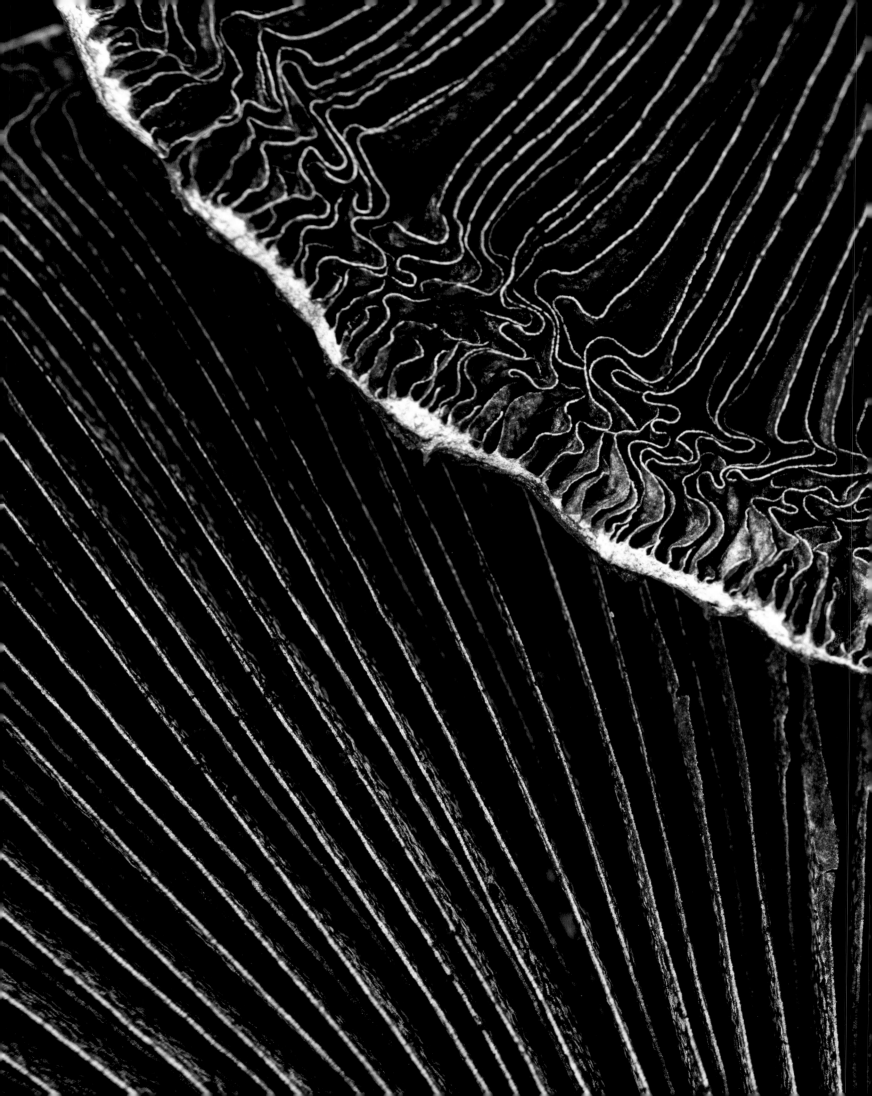

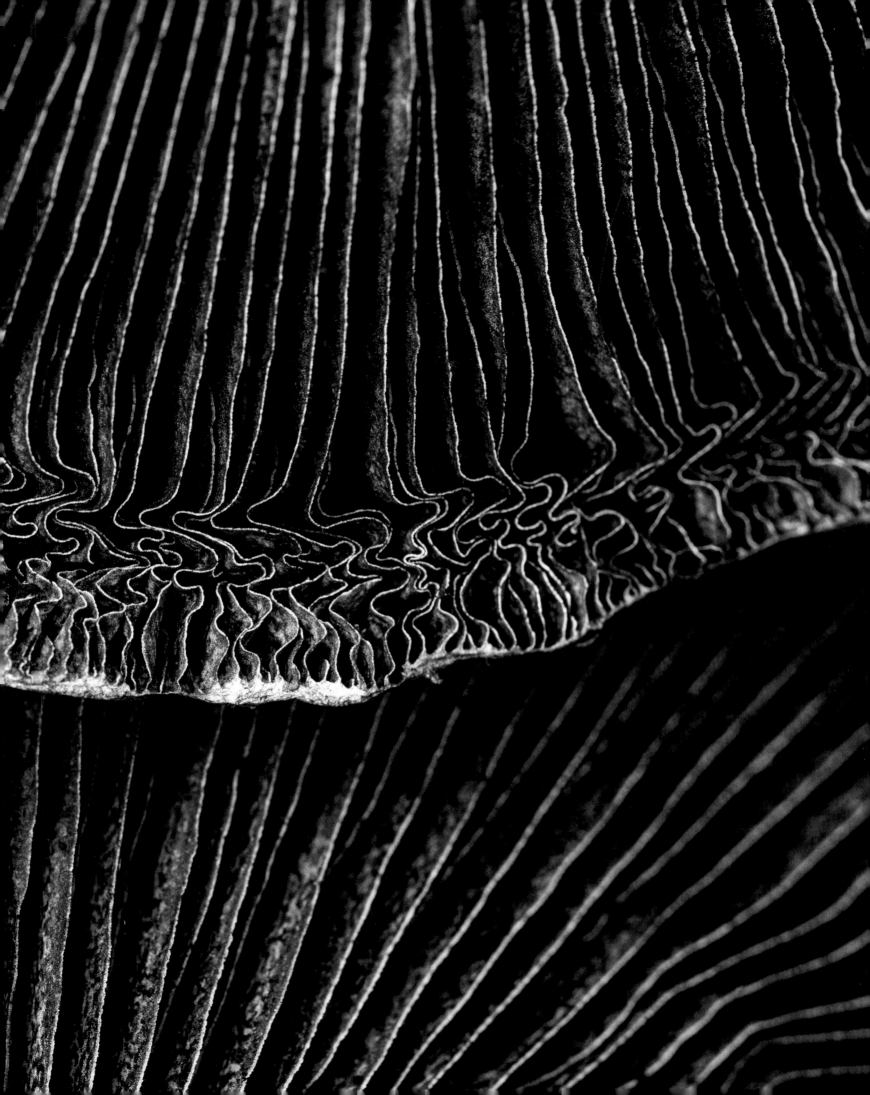

IMPRINT
IMPRESSUM

© 2023 teNeues Verlag GmbH

This book was originally published by Jan Vermeer Photography under the titel "Paddenstoelen" in the Netherlands in 2021.

The project was made possible in part by a financial grant from the Eye on Nature Foundation. www.oogopdenatuur.nl

Photographs: © 2023, Jan Vermeer Photography. All rights reserved. www.janvermeer.nl

Texts by Jan Vermeer
Translation of the mushroom names in English and German by Menno W. Boomsluiter

Main sources used: the last accepted English name list updated to April 2022 from the British Mycological Society (BMS). For the German names the Artenliste of the Deutsche Gesellschaft für Mykologie (DGfM). The scientific names are the accepted names of the Dutch Mycological Society (NMV). Downloaded on May 1rst, 2023.

Layout by Jens Grundei, teNeues Verlag
Translations of the texts by STAR Translations
Editorial Coordination by Luisa Krause-Rossa, teNeues Verlag
Production by Alwine Krebber, teNeues Verlag
Color Separation by Jens Grundei, teNeues Verlag

ISBN: 978-3-96171-510-7
Printed in Slovakia by Neografia
Library of Congress Number: 202393766

Published by teNeues Publishing Group

teNeues Verlag GmbH
Ohmstraße 8a
86199 Augsburg, Germany

Düsseldorf Office
Waldenburger Straße 13
41564 Kaarst, Germany
e-mail: books@teneues.com

Augsburg/München Office
Ohmstraße 8a
86199 Augsburg, Germany
e-mail: books@teneues.com

Press Department
presse@teneues.com

teNeues Publishing Company
350 Seventh Avenue, Suite 301
New York, NY 10001, USA
Phone: +1-212-627-9090
Fax: +1-212-627-9511

www.teneues.com

teNeues Publishing Group
Augsburg / München
Berlin
Düsseldorf
London
New York

teNeues